TEN SECRETS FOR TAKING

DYNAMIC
PHOTOGRAPHS

Gary Bernstein

with Vernon Gorter

HPBooks

DEDICATION

For my father, Arthur.

FOREWORD

Gary Bernstein owns a very nice camera. He takes
good pictures. What's more, he calls his mother
once a week. What more can I say?

Johnny Carson

Published by HPBooks
A division of Price Stern Sloan, Inc.
360 North La Cienega Boulevard, Los Angeles, California 90048

Copyright © 1988 Price Stern Sloan, Inc.
Printed in U.S.A., 1st Printing

Library of Congress Cataloging-in-Publication Data

Bernstein, Gary.
 Ten secrets for taking dynamic photographs.

 1. Photography. I. Gorter, Vernon. II. Title.
III. Title: 10 secrets for taking dynamic photographs.
TR145.B44 1988 770 87-31235
ISBN 0-89586-541-6

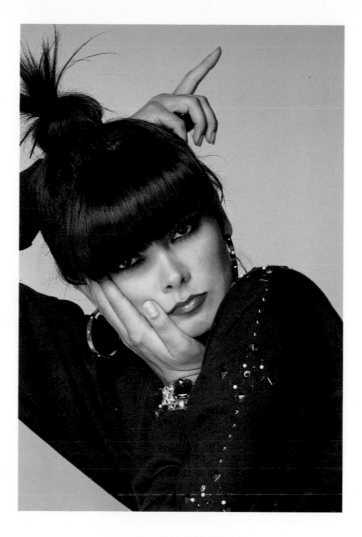

CONTENTS

INTRODUCTION

As you read this book, its title may change magically, at least in your mind. The word *secrets* will be transformed into *revelations*. And that's how it should be. The word *secret*, after all, has some very negative connotations. The dictionary equates it with *concealed, hidden, covert, clandestine, furtive* and *undercover*. But those definitions apply only to secrets that are kept, not those that are shared.

I have never liked to keep professional secrets. I enjoy sharing what I know, by lecturing, writing or simply advising on a one-to-one basis. I've learned, to my delight, that it is possible to help other photographers widen their techniques and capabilities without in any way jeopardizing one's own photographic uniqueness and integrity.

There are two distinct aspects to photography—the technical and the creative. Technical information can in no way be regarded as secret anyway. You can find it in books and magazines, at workshops and lectures ad infinitum—and almost ad nauseum. On the creative side, there are a lot of secrets. And perhaps the most significant one is this: You can never lose even a small part of your creativity by sharing it with others. And others can never steal your creativity from you; they can only enhance their own by listening to you.

Because I feel as passionately about photography today as I did the first day I picked up a camera, more than twenty years ago, and because I enjoy sharing my experiences, producing this book was a happy task for me.

I hope it will be an equal joy for you to read. Enjoy the pictures, but also analyze them and take note of the descriptive and explanatory text with each. As you learn about my techniques, my experiences, and my way of dealing with a wide variety of photographic problems, you will become better equipped to be a fine photographer.

One thing I can't share with you is what exactly makes my images so appealing commercially, enabling me to shoot for many of the most successful people and corporations. It's not that I don't *want* to tell you. The truth is that, most of the time, I don't quite understand how it works myself. All I know is that I have to

take photographs like birds have to fly. It's natural for me to do so.

If you happen to have that same compulsion in your nature, you'll have as much fun with this book as I have had. I think you'll find it a fund of useful information. But have no illusions—at the end you'll be on your own. The difference between success and failure, joy and dismay, will lie in your own creative spark. All I can hope to do is to help brighten a spark that is already there.

Anything that's creative tends to defy rationalization and organization. The creative process cannot be cleanly packaged like a parcel, with paper and string. In spite of its elusiveness, however, people tend to learn most easily when the process is organized.

People like rules that instruct in an orderly fashion. For example, the Ten Commandments were nothing more nor less than simple, easily remembered—if not always easily followed—instructions for leading a moral and good life.

The secrets discussed in this book represent ten key aspects of photography that have always been particularly important to me. Of course, there are many more secrets than just ten. And, within each of the secrets there is a mass of smaller secrets. But the ten forming the basis of this book constitute an organized approach to better people photography.

I love people, and I love to photograph them. Over the years, I've had the opportunity to leave my still-photography career for one in motion pictures and video. However, still photography offers me some very special things: It enables me to capture a single moment in time, and it provides the end result quickly and with modest equipment and technology.

I can shoot in the morning and have the finished result in my hand by the same afternoon. In the movie business,

I would need to work on a project for months before seeing the result. This speed is of no basic importance except that it happens to suit my personality. I like to shoot and see the result, and then shoot again—under totally different circumstances. It keeps me fresh and constantly interested.

However, speed and simplicity are secondary to the essential nature of still photography: It is a medium that allows an observant photographer to capture the very essence of a subject in a striking way. Maybe that's why many actors and actresses, who are familiar with being in front of movie and television cameras, nonetheless feel awkward in front of a still camera. They are not accustomed to having that "moment of truth" recorded.

To be a truly fine photographer of people, you must be genuinely interested in people and must be a persuasive and sensitive director. The camera, in the control of such a photographer, can penetrate the very soul. When the camera is in the hands of an inept photographer, the shooting experience as well as the resulting pictures tend to be as unenjoyable as a visit to the dentist.

My favorite photos have always been those that I've taken of my loved ones. After having photographed celebrities, distinguished personalities and top models for many years, this is still true. Because I like this intimate aspect of photography so much, and because I have learned that photos taken under similar conditions tend to be the best ones, I have had the wisdom to widen my circle of "loved-ones" over the years.

I have learned to see something beautiful and lovable in all my subjects. As *director,* I convince each subject that this is, indeed, the case. As *photographer,* I use my technique to achieve the best technical image. As a *sensitive and alert human being,* I cap-

ture on film the beautiful essence of each person—be it a top model or a grandmother, a rugged movie star or a child.

As the chapter heads indicate, this book is about photo technique, psychology, directing—and about the creative, artistic aspect of photography. A musician cannot be an inspiring performer until he has learned to master his technique and instrument. When the act of performing becomes second nature, then is the time for him to become a true artist.

It's the same in photography. Learn your basic technique, gain total control of your camera and film, organize your lighting and studio space, feel comfortable directing and stimulating your subjects. When all this becomes so natural that you don't have to think about it, learn to "fly." The beauty of the creative process is that, like flying, it gives us an added dimension. It's never finished and you can always say something new.

This is my third book for HPBooks. You may be familiar with the other two, *Pro Techniques of People Photography* and *Pro Techniques of Beauty and Glamour Photography.* Since those books appeared, I've photographed a lot of people, had a lot of new experiences and thought a lot. In this new book, I share some of that with you.

Before you get into the body of the book, let me remind you once again that creativity and artistry are very personal, indefinable and *fluid* things. Each reader will perceive what I say a little differently and each will apply what I recommend in a unique way. Regard the book as a friendly guide, not an inflexible rulebook.

Let your creative juices flow, be daring—and produce worthwhile photographs! Don't stifle your creativity by trying to neatly package it with paper and string!

EACH INDIVIDUAL IS UNIQUE

Every face has the same basic features: Eyes, mouth, nose, ears, cheeks, chin and usually the crowning glory, hair. I never cease to be astonished that, in spite of this standard "equipment," virtually every face in this world is individually recognizable.

Each face is unique, just as each mountain, lake or river is unique. If you were to photograph 200 people, you would get 200 totally different images. Even if you were to make a concentrated effort to make all your subjects look exactly the same, they would retain their distinct individualities.

Each *expression* is unique, too, just as each cloud formation over a mountain range is unique. You can photograph the same person over and over, and get a different result each time.

Sometimes the expression you capture will result from a temporary response to such causes as discomfort, cold, worry, stress or even hunger. A part of the photographer's job is to eliminate those causes, make the subject feel comfortable, and get at the very root of his or her individuality. The expression you capture must be a true reflection of the essence of the person before the camera.

Of course, this doesn't mean the subject must be smiling in each image. A smile must be *natural,* or it simply won't be a smile. It will more likely be a grin or a self-conscious sneer. It's up to your skill as director to solicit a smile. How you do that will differ from person to person because people are as different from each other psychologically as they are in appearance.

I generally find that the best image of a smiling face occurs *after* the peak of a smile, when it has already diminished a little.

Sadness, apprehension and scornfulness are just as valid human emotions as happiness. A people photographer must have the sensitivity to recognize the

"moment of truth"—the split second that captures the essence of the character. It's the difference between a snapshot and an artistic photograph you can "live with" for many years.

FACIAL FEATURES

Visually, the most important part of a person is the face. It is the key to character and contains the "windows to the soul," the eyes. People photography almost always implies featuring the face, either alone or with more or less of the remainder of the body. Only rarely, for specific purposes, is the face omitted from or hidden in a photo.

Everyone Is Beautiful—Every face has attractive features and, essentially, everyone is beautiful. It is your job, when wearing your *director's hat,* to convince each of your subjects of his or her own unique beauty. When you don your *photographer's hat,* you must be able to record that beauty.

Because only the most photogenic of us have features that are all equally beautiful, the art of creating beautiful images lies in accentuation and elimination. Accentuate features that appeal to you and hide or subdue those you consider less than ideal.

Here's a typical example: If I'm photographing a young man whose hairline is receding prematurely and who has a wide, chubby face, I may do two things. I may crop the image closely at the top in such a way that much of the forehead remains outside the image area. I would probably also light the subject in such a way as to cast a shadow on one side of the face to visually narrow the face.

A narrow face may look better if I broaden it graphically. I can do this by avoiding distinct side shadows. I can achieve this by lighting the face frontally or by using two main lights. Eyes that are deep-set may call for a relatively low main light to avoid unflattering shadows in the eye sockets.

If I see features or blemishes that I consider less than attractive, I can usually hide them in shadow or conceal them behind something—perhaps jewelry, a hand or an appropriate prop. To minimize the effect of skin blemishes, especially in female subjects, I may also diffuse the image slightly. Sometimes there are flaws that can't be hidden photographically. They can be subdued or removed by retouching the finished image.

But, make no mistake about it, just because I see something I don't like and therefore subdue doesn't mean that my subject is less than attractive or that I'll make an image that's less than beautiful.

Beauty Is Subjective—People photography is all the more challenging because beauty has no fixed, definable standards. Like many things in life, beauty has its fashions. There have been times when heavy, well-rounded women were regarded as the most beautiful. Today, the only ones who can generally expect to succeed as models are the very slim and trim.

Beauty is subjective. How we perceive a person depends on how we feel about him or her. Hence stems the observation that "love is blind."

What we want to record in a person need not always be beautiful in a classic sense. I consider it fortunate that we have finally entered an era in which beauty is not defined by standards of symmetry and almost clinical perfection. We now have anti-heroes who can actually aspire to being heroes! Some of the most interesting leading men and women seen on our movie and TV screens today are not the classic beauties of the early Hollywood days. Of course, there will always be a place for classic, romantic beauty, too.

We have had wonderful personalities in the entertainment world who used as their trademark features that would normally be subdued by a smart portrait photographer. No photographer in his right senses would have minimized the famous nose of that popular entertainer, Jimmy Durante, or attempted to conceal the baldness of Telly Savalas of *Kojak* fame.

The Image Must Satisfy—It seems self-evident that a successful photograph must be one that satisfies. The difficult part of the question is: *Whom* must it satisfy? The way you shoot a subject depends largely on the answer to that question.

If I take a photograph for my own purposes, I'll simply shoot it the way I like it. However, once I am shooting for someone else, be it a commercial client, an advertiser, a professional model or a private portrait client, my prime concerns must be the needs and wishes of the recipient of the images.

Shoot a Lot of Film—To satisfy the recipients and users of your photography, listen carefully to their *expressed* wishes, use your psychological skills and personal sensitivities to detect their *unexpressed* but implied wishes—and shoot a lot of film. Shoot variations on each basic theme. Film is the least expensive commodity in your photographic arsenal. When working in the field of ever-changing human expressions, use it generously.

YOU'RE THE DIRECTOR

In moviemaking there's a key person known as the *director*. On the set, he's the coach, captain, teacher, adviser and father. What he does with his cast of actors is placed in context by the set designers and stage managers, lit by the lighting team, and recorded by the camera operators.

The still photographer, in the relatively modest surroundings of his studio, is often so preoccupied with being a camera operator that he forgets one of the most important aspects of his job—that of directing.

A Good People Photographer Must Like People—I truly believe that every person is uniquely beautiful. This not only makes my life incredibly rich, it happens to make me an ideal people photographer. If you don't like people, I recommend that you would be better off photographing landscapes, buildings or still life arrangements. If you like people and relate to them easily, read on. Nothing could be more challenging and greater fun than the pursuit of recording the ever-changing

kaleidoscope of the human face.

Establish a Rapport—When I'm behind my camera, I must form a rapport with my subjects that leads to exceptional portraits. I'm in the business of producing images that are *out of the ordinary*. If my clients wanted *ordinary* photos, they would probably go to one of literally hundreds of other photographers that operate within a few miles of my studio.

An *exceptional* portrait materializes only when a photographer is able to establish an *exceptional* rapport with his subject. That rapport shows unmistakably in the images produced. It shows in the eyes. That's one reason why I like my subjects to have eye contact with the camera, and therefore the the viewer, in many of the pictures I take.

PSYCHOLOGY

People are almost as unique psychologically as they are in physical appearance. The differences affect the methods you must use to motivate subjects in front of your camera, as I explain in detail in *Secret 2: Motivate Your Subject*.

Experience has taught me that the psychological attitude of a subject also depends to a large extent on the capacity in which that subject is being photographed. For example, there's a lot of difference between photographing a professional model and a private portrait customer.

When a model is being photographed on a commercial assignment, both the photographer and the person being photographed are working as professionals. In a private portrait session, the photographer is the only professional at work.

The professional model generally has little say in the way in which pictures are shot. That's primarily up to a client, art director or editor. The private portrait customer, obviously, is very concerned about how she considers she should be photographed and has preconceived ideas on how the results should look. In the first case, the

photographer must listen to the client; in the second case, he must satisfy the subject.

When a model appears before the camera of a celebrated photographer, she may feel somewhat intimidated. She may believe that she is in competition with all the other models who have been photographed by him. A nationally famous model, on the other hand, may actually intimidate the neophyte photographer—just as a celebrity might. After all, it is now *his* work that's on trial, being compared with all the beautiful magazine cover shots other photographers have produced of the star model or celebrity.

A private customer will generally tend to feel more confident, the better-known the name of her photographer, simply because she is aware that his credibility is based on successful past performance.

I mention these few possibilities simply to point out that there can be all kinds of reasons, far beyond a concern for personal appearance in front of the camera, for the need for reassurance.

In general, you can expect a larger proportion of excellent results in a shorter time with a professional model than with a subject that is not accustomed to being photographed. But with *every* subject you should be sensitive to the unique insecurities and fears that may manifest themselves. You should have the means to deal with them effectively. Even if, in the beginning, those fears are your very own!

EXPRESSION

To capture the essence of a person's character in a fraction of a second requires much more than seeing *that moment*. You must see—and observe—your subject *continuously* and deduce what his or her unique and particularly attractive attributes are.

I casually observe my subjects from the moment of our first meeting, analyzing the way his or her face takes light and paying particular attention to facial expressions during normal conversation.

Behave in a normal, relaxed manner and make your subjects feel at ease—but be constantly aware and appreciative of the unique photographic opportunities that are before you.

I watch faces all the time—in restaurants, drug stores, at parties and in the street. A sports photographer has the knack of recording the *decisive moment* because he is intimately familiar with the *total event*. Similarly, a people photographer will produce better images of the decisive moment as he becomes more familiar with human behavior, emotion and expression. It takes practice, practice and more practice—in the studio and out of it!

A good portrait rarely results from good posing and expert photographic technique alone. The ultimate key to success is sensitivity and vision. Don't be satisfied to simply *record* a face; try to make a *statement* about the person.

A Session Is No Time for Testing—It is well known that Polaroid films are a popular and very useful tool for making photographic tests. Photographers will shoot a scene or subject on Polaroid film and evaluate the instantly available result before shooting the final picture on conventional film. The evaluation may be for exposure, composition or a variety of other things. The Polaroid test print may be shown to a client for approval.

Much as I recognize the usefulness of Polaroid film, this testing method is not for me. In people photography, nothing ever happens quite the same way twice. I want to capture the decisive moment on the film I have chosen for the purpose, not on some test exposure that may be less than ideal for reproduction.

Quite apart from a subject's expression, image resolution, shadow density and color balance will all record quite differently on conventional film, often making the test exposure misleading.

Eye Contact—As I've said earlier, I like my subjects to have eye contact with the camera—the viewer. This truly *involves* the viewer in the experience. The eyes are the portals to the

soul and nothing reveals more effectively the uniqueness of each person. The eyes can do this most effectively and appealingly by looking right at you.

There are important exceptions to the above, which I explain more fully in *Secret 8: Tailor Your Technique to the Subject.*

Expressions Must Be Compatible— When you're photographing couples or small groups, it's important to have compatibility, harmony and credibility in the expressions of all the people appearing. It would appear incongruous if one member of a couple had a happy grin on his face while the other appeared in deep thought.

Establishing this compatibility of expression is your responsibility. From camera position, you can see each of the subjects and can guide them and direct them. It isn't so much a question of *instructing* subjects to smile or look serious as to use directing skill in creating the atmosphere that *elicits* the right expressions.

SKIN TONE AND QUALITY

Skin characteristics can vary between individuals almost as much as other facial features. The tone of the skin, for example, doesn't only vary between races and nationalities but also from person to person. Skin texture varies, too, from the most lined and rugged outdoor male to the most delicate and smooth face of a young female model.

Tone of Skin—Skin that is slightly tanned or has a healthy, warm color offers the greatest flexibility to a photographer. A sallow or fair complexion needs to be handled with much more care. Skin usually looks at its best when it has a warm glow. You may have noticed that it is far more objectionable to have a photo of a person in which the colors are even just a little too bluish than one in which they are somewhat too warm.

To create the illusion of warmth in sallow skin, it's advisable to use clothing and background that have cool col-

ors. For example, a blue backdrop and a blue dress create the illusion of a warmer tone in the face than is actually there. If a neutral, colorless background is to be used it is best to keep it light. People of fair complexion lend themselves ideally to high-key photography in which most of the tonal values are at the light end of the tonal scale.

While a tan has a healthy look that can be very photogenic, an *excessive* tan can present problems. When confronted with a deeply tanned person, I generally like to use a dark background. It minimizes contrast so that the subject not only looks better to the eye but is also recorded more satisfactorily on film. To make the person stand out from the dark background, I use some rim lighting.

With women, a deep tan can present an additional problem: Normal makeup will not take well on deeply colored skin.

When photographing a black face, it is often advisable to change the basic lighting technique a little. Instead of emphasizing facial modeling with *shadows,* try doing it with *highlights.* The size of the light source, relative to its distance from the subject, will determine whether you create large, smooth highlights or small and harsher ones. The larger the source, the larger and softer the highlights.

Skin Quality—Skin color is not the only consideration a photographer must bear in mind. Skin quality also determines the techniques you should use.

If a man has a rough, lined skin texture, you may want to use cross lighting that accentuates the rugged character of the subject. However, a woman's skin that is less than smooth must be dealt with much more gently. You may want to use soft lighting, a diffuser over the camera lens, appropriate makeup and subtle retouching— or a little of several of these—to make the complexion appear as smooth as possible.

Undesirable blemishes in both men and women can be minimized by

appropriate lighting, local application of makeup, or retouching.

BODIES ARE UNIQUE, TOO

It's not only facial appearance that makes each person unique. We've all had the experience of instantly recognizing someone at a distance, long before we were close enough to see the face clearly. The giveaway clues came in the person's bodily shape, stance, walk and gesticulations. When I photograph someone half-length or full-length, I take this part of the subject's individuality into consideration, too.

There are other aspects that need also be considered. For example, some people's bodies are more flexible while others tend to be relatively stiff. Some subjects are more inhibited about their bodies and less comfortable in front of a camera than others. Some are older and some younger. I must bear all this in mind in order to get the best from a subject and to produce the most believable image.

As with faces, there are ways of accentuating the more attractive features while minimizing the less desirable characteristics of a subject's body. The photographer's most effective tools in this endeavor are the prudent use of light and shade, choosing the right camera viewpoint, the use of appropriate clothing, jewelry and props and—last but not least—getting the best pose.

Appropriate body position depends very much on the purpose of the photograph. For example, if I were to photograph a top male model in formal attire, on a beach, for a fashion spread in a magazine, I would use an elegant pose that's appropriate for the model's attire. After the formal treatment, however, I would not hesitate to ask the model to roll up his trousers, throw the jacket over his shoulder and wade through the surf. This would create an appropriate casual approach to formal wear.

I would not, however, have the model lean casually on a fence with both

elbows, one foot resting on a lower fence rail. On the other hand, if he were dressed in old blue jeans and a casual shirt with rolled-up sleeves, I would certainly consider such a pose appropriate.

Give the Subject Posing Freedom—I prefer for my subjects to pose themselves, following my basic direction, rather than place them in a position that may look right to me but feel totally alien to the subjects. Unless I'm following a very tight layout, I give my models freedom to move about within the basic constraints of the required composition.

Every time I see a pose that looks right, I'll ask the model to repeatedly move into that basic position as I shoot. During the entire shoot, I'll give verbal direction and encouragement. I avoid negative statements such as, "No, that's not right!" or "That looks stiff and unnatural!" I try to remain positive at all times. If a pose doesn't work, I simply encourage the model to continue moving and shoot at the right moments. Often, I will take the model's

place on the set or at the location in order to demonstrate the position I want.

If I see that a model is becoming stiff and awkward, I stop for a brief rest. I encourage the model to do something entirely different during this short time—walk around, sit down or even lie on the floor. Usually, he or she comes back refreshed and the shoot continues.

All Elements in a Picture Are Critical—The more you include of a person in a picture, the more other elements you usually introduce into the image. There is more background, more of the subject's clothing, more props and accessories.

It's important to remember, when adding more and more to an image, that every element should be there because it's important. If it isn't important, leave it out. If left in, make it as perfect a part of the total composition as you can. That includes the subject's pose or attitude.

Uncomfortable Poses—There are rare occasions when a pose can look

just right and quite believable although it is, in fact, quite uncomfortable for the subject. If a pose *looks* uncomfortable, avoid it. If it only *feels* uncomfortable but looks right, go ahead and shoot it that way. Of course, you should do the job as fast as possible and avoid trying poses that are clearly not within the subject's physical capabilities.

LEARN HOW CAMERA AND FILM SEE

Camera and film do not necessarily "see" what you see with your eyes. In order to convey most effectively to the viewer of your pictures what your eyes saw in the subject, you must know these differences and how to deal with them.

Camera—The camera does not see things in precisely the way you do. For example, if you come close to a subject, using a wide-angle lens, you are likely to see certain distortions in the image that are not evident in real life.

Coming close to a subject will tend to emphasize frontal features, particu-

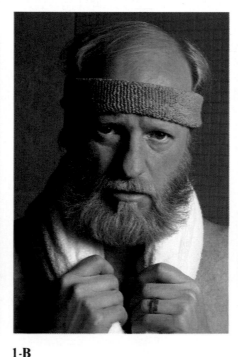

1-A

1-B

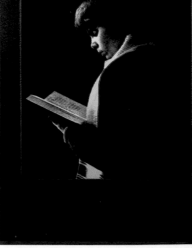

1-C

larly the nose. If you are shooting from a low angle, the chin will be accentuated. From a high viewpoint, the forehead will tend to be emphasized. The face will appear narrower, the eyes will appear wider apart and the ears will become less prominent.

In creatively interpreting the essential uniqueness of a subject, you may sometimes need to avoid such distortion and sometimes to deliberately use it.

If you are shooting a group of people, some of whom will be near the border of the image, avoid using a wide-angle or even standard lens. Use a telephoto lens and shoot from a relatively long distance. If you don't, the faces near the border are likely to appear unpleasantly distorted in the image.

Film—For several physiological reasons, the human eye adapts readily to an incredibly wide brightness range. Photographic film can record detail within only a relatively limited brightness range. This is especially true of positive color reversal film—or slide film—such as I use in most of my work.

In order to produce the image you want your viewers to experience, you must carefully translate what *you* see to what the *film* is capable of seeing. You must be familiar with the characteristics of your film. Know what the acceptable brightness range for the film is and remain within that range by carefully metering the light on the subject at its extremes of brightness. If necessary, adjust the lighting to bring the scene within an acceptable brightness range.

Sometimes, you may want to record the deepest shadows as black, without any detail. In such a case you need not include those shadows in your calculation. Meter the deepest shadows in which you want to record *some detail*.

With color-slide film, you will rarely want to record highlight areas without detail. This would result in washed-out, lifeless colors. Thus, if you are shooting in a location where you have

no control of subject contrast, it's always best to expose your slide film for the highlights and let the shadows fall where they may.

I discuss photographic control more fully in *Secret 4* and *Secret 5,* both of which deal with lighting.

THE PHOTOS
IN THIS CHAPTER

Shannon Lea (Photo 1-A) is a family friend. She had asked me to photograph her for promotional material for her acting and modeling career. I would describe her appearance as femi-

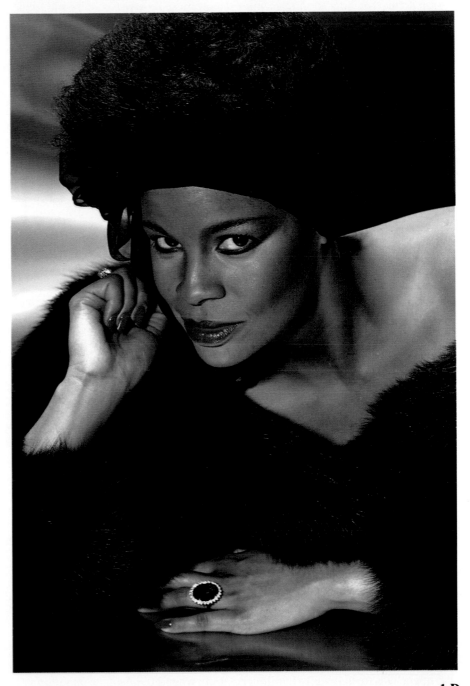

1-D

nine, romantic and soft. I wanted to convey these delightful characteristics in this image. Several techniques were called into play to achieve the desired effect.

I wrapped her in a soft fur. For added visual "softness," I selected a light-colored fur that kept the image high-key. To make the image even more ethereal, I used a weak diffuser on the camera lens. An electric fan on the studio floor blew Shannon's hair, adding a little movement to the image.

The natural pose and gentle eye contact with the viewer completed the image.

Professional model "D.J." (Photo 1-B) is always cast as the typical outdoorsman. Among many other roles, he's been featured as a lumberjack, sportsman and hunter. The strong face, reddish beard and self-assured look—directly at the camera—provided the essence for the kind of photo I wanted.

I added a couple of accentuating touches: A single, medium-sized light source, placed to the right side of the camera, provided strong contrast and appropriate modeling for the rugged face. I asked D.J. to take off his shirt and casually hold a towel around his neck. The background suggests a locker room. The result is a very "masculine" image.

In the picture of a young man at his Bar Mitzvah (Photo 1-C), I wanted to show the charming combination of the innocence of youth and the gaining self-assurance of a young man. I also intended to record the air of solemnity of the occasion.

I achieved the result in a very simple manner. One portable electronic flash head was directed at the subject at about 45° from his far side. The light yielded excellent modeling of the face and at the same time highlighted the skullcap, prayer shawl and book in a way that graphically separated the subject from the dark background.

The high-contrast enlargement was made through an etching screen to provide the characteristic texture. Finally, the image was treated with a blue toner.

Each step was a deliberate attempt to depict the young man and the solemn event in an appropriate manner.

The next image (Photo 1-D) is of a charming young woman who had aspirations for a singing career. She needed photographs for two distinct purposes: To give to family and friends and to promote her career.

The key words that came to mind when I looked at this stunning lady were "style" and "sophistication." I aimed to depict those characteristics.

I used dramatic lighting, yielding distinct shadows and emphasizing the beautifully chiselled features of the face. The black clothing and the jewelry enhanced the feeling of superior style. Fortunately, the tonal values in the face were sufficiently rich to stand the contrast against black.

The elegance of the scene was further enhanced by the suggestion of gold in the background. The gold at the same time nicely complemented the warm skin tones.

To maintain the feeling of sophistication, the pose was deliberately somewhat formal and the expression thoughtful rather than exuberant.

The four images reproduced in this chapter show four totally different faces and characters. My challenge was to do justice to the unique beauty of each. And that, basically, is the main challenge in all my photography.

CONCLUSION

Because I emphasize the importance of recognizing and appreciating the uniqueness of each individual, I am often asked, at my lectures and as a result of my magazine columns, to discuss and compare the unique qualities of some of the many celebrities I have photographed. Certainly, I have some preferences, but that's a very personal matter. The important general truth is that *everyone* is special and important to me.

When asked about my most memorable vision through my camera's view finder, I reflect back many years, to the time when I first had the opportunity to

photograph a classically beautiful model and actress. Her sensuality and grace, as well as her earlier career as a professional dancer, gave her a special quality that made her an ideal subject for the camera.

Her name is Kay Sutton York. Several of her images appear in my other two books published by HPBooks, and this volume contains several more. In the years Kay has been my wife, best friend and favorite model, her uniqueness has remained ever fresh.

MOTIVATE YOUR SUBJECT

I n the world of everyday snapshot photography, subject motivation may extend no further than a request to say "cheese." However, for the photographer who wants to *make* pictures rather than *take* them—be he professional or amateur—there are several effective approaches to subject motivation.

CONVINCE SUBJECTS OF THEIR BEAUTY

My first secret in this book was the revelation that everyone is not only unique, but uniquely beautiful. I know this to be true, but my subjects often don't. They appear before my camera with apprehension.

A man may be convinced that his nose is too prominent; a woman may be concerned about her eyes being spaced too closely together; a vibrant and attractive actress may think her chin isn't what it might be. A fault as insignificant as a small skin blemish can be blown totally out of proportion by a subject. The inhibition and negative mental attitude it creates can contribute more to the failure of a picture than the blemish itself.

Transformation by Persuasion—I'm often asked whether I truly believe that everyone is beautiful or whether I use deliberate deception in order to make a subject feel good. The answer is a little bit of each, although I think it would be more appropriate to say that I *generate awareness* rather than *deceive*.

If you were to see the appearance and bearing of some subjects when they enter my studio and then again later, when I've had a chance to talk with them for a while, you would agree that people can go through a remarkable transformation in a short time.

I truly see beauty in everyone. That doesn't mean *every* person is *totally* beautiful in every respect. Sometimes my attention may be drawn immediately to the eyes, at other times to the mouth, or to prominent cheek bones. By emphasizing the best features and minimizing those that are less than perfect, I can produce a fine image of virtually anyone.

However, in order to get the best from a subject's inherent beauty, he or she

must be *aware* of that beauty, too. A beautiful pair of eyes immediately sparkle a little more when their owner is complemented on their radiance. So, what I use may be deception in as far as it is not necessarily true at the *moment* my subject and I meet. But, because my comment actually changes the appearance of the subject, it is much more than deception—it is a *transformation* through *generating awareness* in the subject.

Character and Personality Are Also Beautiful—Even people who don't immediately appear beautiful or handsome in the fashionable sense almost always have personal characteristics, such as wisdom, courage or humor, that can be brought out by a skilled photographer to yield a truly "beautiful" image. In such a case, too, a complementary observation from the photographer can visually enhance the existing characteristic.

Praise Works Wonders—We all thrive on praise. If we do a particularly good job, or give someone an especially pleasing gift, we like to be praised for it. It makes us confident, makes us smile—in short, makes us feel better and look better. If we do something negative and get criticized or reprimanded, our expression instantly "sinks" and we look glum. It's very important to remember this basic human trait in the photo studio.

Age Has Its Own Beauty—You may ask me whether I really believe that the average seventy-year old grandmother is as beautiful as Farrah Fawcett or Victoria Principal. My answer is, no, she isn't *as* beautiful, simply because beauty is not *comparative*, it's *absolute*. Grandma is as beautiful as only a seventy-year old grandmother can be. Don't misdirect your efforts by making someone appear younger when you should be directing your attention at making the person look good for his or her age.

CONVINCE THE SUBJECT OF YOUR CAPABILITIES

When I'm behind my camera, I'm a professional in two ways: I'm an accomplished and informed photo technician and a skillful and sensitive director of people. If my photo sessions are to be successful, each subject must be convinced beyond a doubt that I'm totally in control in both of these very different areas.

Photo Technique—I do not attempt to win my subjects' confidence in this area by using long and obscure technical terms. Neither do I flaunt my wonderful equipment. I assume that my client is not necessarily interested in photography but only in my achieving good results.

I inspire confidence in my subjects regarding my technical prowess by taking it for granted and showing that it has long ago become second nature to me. When Yehudi Menuhin plays the violin, the pleasure the audience derives is from the music, not the specific violin he happens to be playing or his playing technique. When instrument and artist become as one, execution of technique becomes barely noticeable and the music is at its best.

It is the same in photography. My technique need be nobody's business but mine. My subjects shouldn't even be aware that technique is involved. It should appear that natural and easy. The camera should be a natural extension of me, so that it truly appears as if I am taking the picture rather than my camera.

If I can perform the magic act of placing my lights, metering and determining exposure, setting the camera controls and posing the subject without the subject even noticing these activities, I have a good chance of establishing an unencumbered rapport that will lead to fine photographic images.

Directing—The human aspect of my activities can be placed under the general heading of *directing*. It involves establishing and maintaining a good rapport with a subject and giving encouragement, advice and posing instructions throughout a shooting session. To get the best from a subject, I must be decisive and in control.

Being *in control* does not mean being *inflexible*. Part of the quality of an expert or a professional is flexibility. I must be able to change course as the client, the subject, the circumstance or my own judgment demand it. And I must be able to do this smoothly and without concern or panic.

I discuss the art and craft of direction a little later in this chapter.

BE SENSITIVE TO YOUR SUBJECTS' NEEDS

The first "need" each subject has, whether he or she is fully aware of it or not, is to be totally comfortable and self-confident in my presence and before my camera. This is a particular challenge for a photographer because, traditionally, the photographic experience has become almost as distasteful as a visit to the dentist's office.

Dispel the Stereotype of Traditional Portraiture—People are accustomed to being led into a musty camera room, placed in a Louis XIV chair, directed to hold their hands in a certain way and instructed to smile. Half a dozen exposures later, the experience is over. The customer makes his selection from that stereotypic half dozen images, hoping that there *might* just be something he likes. No wonder studio photography has become a painful experience.

I very quickly assure my subjects that, *in my studio,* it's quite different. There will be no stiff poses, no antique furniture unless the situation specifically calls for it, no cold, impersonal encounter, no skimping on time and especially on film.

In my studio, photography is fun—for me and for everyone involved. I try to generate an atmosphere that would be fulfilling just for its own sake, even if not a single exposure were made. But exposures *are* made—*lots* of them. And the result is usually indicative of the atmosphere during the shoot: Eyes are bright, smiles are natural and warm, and poses are dynamic.

Each Subject Is Different—The uniqueness of my subjects has been a major theme in this book so far. Some individual characteristics determine not so much *what* kinds of photos I'll

take but *how* I work with the subject.

Some people are more photogenic than others. This doesn't necessarily mean they are more beautiful. It simply means they have features that are relatively easy to light in different ways and shoot from varied angles. The less photogenic subjects need to be directed, lit and shot with greater care to ensure a high percentage of successful images.

Some people are more versatile physically than others. With them, you are likely to have more posing possibilities than with the less agile.

Others have a high level of imagination and acting potential. You can exploit this by giving them relatively free rein, allowing them to pose themselves in many of the shots.

Age is another obvious difference between subjects. It can determine appropriate pose, wardrobe and setting.

Some subjects feel so insecure that they are uncomfortable in front of a camera in the middle of a large studio. There's no reason why they shouldn't be photographed leaning against a wall, resting on a comfortable prop, or even sitting on the floor. I photograph many of my subjects sitting on the floor—although in most instances you wouldn't detect it in the image.

THE PURPOSE OF THE SESSION

Before you can motivate anyone, it is clearly essential to know what you are motivating them toward. The purpose of a session must be clearly spelled out. This subject is dealt with more fully in *Secret 7: Define the Purpose of the Session.* A few words will suffice here.

I must take into consideration not only the subject, but also the client. He may be an art director, an editor or some other commercial client. The subject in such instances will generally be a professional model, who has no direct say in the shooting session. In a private portrait session, the client and the subject before my camera will generally be the same person.

The purpose for a session originates from the purchaser of my pictures, be it client or actual subject. This is the person or organization I advise and shoot for.

Regardless of who the client is, a photo may be for an advertisement, an editorial story in a magazine, for hanging on an office wall, for presentation to a mother, for the intimate environment of a bedroom, for a model's portfolio, or for one of many other purposes. It doesn't take much imagination to realize that the manner of execution depends to a very large extent on the ultimate purpose of the photographs.

Basically, *my* purpose is to satisfy *my client's* purpose most effectively. Sometimes the directions I am given are very specific, including a tight, preconceived layout. At other times, I'm given more freedom to express myself. In any event, if I have any misgivings about the client's directions or feel uncertain about his decisiveness, I like to shoot it my way, too.

Of course, time is always at a premium and I must accomplish the task at hand in a limited time period. Fortunately, I shoot very decisively and fast. This usually enables me to shoot things the client's way and my way. When the processed images are delivered, it is not unusual for a client to prefer the shooting approach I had initiated.

If you are photographing people as an amateur photographer, what and how you shoot depends entirely on what is agreed between you and your subject. Even in this situation, however, it's important to establish in advance precisely what the purpose of the photography is.

DIRECT DECISIVELY

As director, I'm the catalyst that causes things to happen. No matter how beautiful and talented my subject may be, he or she cannot provide the impetus that yields good photographs. It's my job to translate the beauty I see in front of me into an image on film.

Directing is not enough—I must direct *decisively.* This means that I must know exactly *what* I want to achieve and *how* to achieve it. My main goal is to make subject, client and viewer more thrilled with my images than they have been with any other photographs. When they want photographs in future, I want them to think of me first—not just because they believe I produce the best photos most consistently, but also because, in front of my camera, it's fun.

Before I can direct my subjects effectively, I must be sure they are comfortable in the environment I provide. I discuss this more fully in the next section.

Following are some additional basic requirements that, as experience has taught me, lead to effective direction.

Work as a Team—Although you must take the ultimate responsibility for what you do and for the end result, I advise you to include your subjects and clients in the decision making. You have nothing to lose by asking others for their input. It may prove creatively useful and, at the very least, it will make those you are working with feel a true part of a team effort.

Although I encourage teamwork, I discourage clients or others in my studio from talking with the subjects in front of my camera during a shoot. I am experienced in communicating and directing during photography and I don't like the rapport between me and my subject to be broken by a third party. I ask those involved in the shoot to direct their suggestions or comments to me only.

Assistants Need Directing, Too—I use one, two or more assistants, the number depending on the complexity of the job. It's important to motivate them, too. I tell them in advance what the session is all about, what my aims are, what possible difficulties may be encountered and any special characteristics of the people involved that may need to be taken into account.

I instruct my assistants to never talk with a model, subject or client during a session or to intrude into a conversation I may be having with them. If an assistant wants to discuss something pertaining the shoot with me, he must take me aside so we can discuss it privately.

The reason for this is not pride or a desire to keep my assistants "in their place." As my assistants know, it's much more pragmatic than that. My assistants are not present when an assignment is booked, at planning discussions with art directors, or when models are selected. They do not know the needs or sensitivities of the subject I'm photographing. Because my assistants are not privy to such facts, any intrusion on their part could be potentially embarrassing.

I think the same basic philosophy is sound in all people photography—professional or amateur. The shoot should be the result of interaction between subject or client and photographer only.

Don't Talk Incessantly—I talk naturally with my subjects during a shoot. I'm aware that some portraitists feel obliged to talk constantly. They believe that a break in verbal communication will lead to an immediate break in rapport. From my own experience, I'm convinced that what matters is the quality of the communication—the rapport—and not its continuity.

A subject will be at his or her best in a relaxed environment. And I feel most relaxed when I am being my true self—talking when I feel the need for it and remaining silent when there's nothing significant to say.

PROVIDE A
PLEASANT ENVIRONMENT

People look their best when they are relaxed and enjoying themselves. The one time when you really want people to look vibrant and attractive is when you're about to record their image for posterity. It is, therefore, extremely important to provide, in your studio, an environment that is pleasant.

Studio Space—Over the years, people have formed very negative mental associations with the typical, conventional portrait studio. It is, after all, the place where so many have endured boring sessions, in oppressive surroundings, sitting in uncomfortable chairs. The reward for their suffering

has all to frequently been a selection of a half dozen mediocre images.

I would emphasize that the above does not describe all studios. I know there are some excellent, creative and sympathetic portraitists. However, the stereotype is sufficiently widespread to have affected society's feeling about "having one's picture taken."

The kind of studio people associate with more happily, and in which they even see some glamour, is the large commercial studio. It resembles a Hollywood sound stage or, at the very least, one of those places where national ads and fashion shots are made. I work in exactly such a kind of location.

My studio is large, unpretentious and very practical. My friends have heard me say this many times: "I sell steak, not sizzle!" It describes very graphically my attitude toward my work place and my tools. My studio must provide an environment that gives me the best chance of producing good photographs—technically and esthetically. A typical example that reflects my attitude of "steak, not sizzle" is the fact that one of my studio walls is covered with tear sheets and photos that are simply stapled or pinned to the wall. There are no fancy frames or mounts. What counts is the image, and the image alone.

Most amateurs will not be able to afford a large studio space, such as I have described. However, I think it is important to keep away from the stereotype of the photo studio that inhibits all joy and creativity.

Refreshments—To make your studio a more welcoming and comfortable place, it's important to always have refreshments on hand. Stock your refrigerator with appropriate beverages and snacks and offer them at your shooting sessions.

Music—Music forms an important part of my shooting environment. If the subjects don't specifically request it, I will play music anyway—for my own benefit.

Music should be appropriate. For example, I'm not likely to photograph

a rock group with a background of Mozart, nor will I shoot a Shakespearean actor to an accompaniment of hard rock. During an energetic and dynamic fashion shoot, I'll often play lively and stimulating music—and play it loud. Sometimes it's so loud that I have to shout out my directions. But, as long as the music helps the shoot along, that's OK. Generally, however, I opt for subtle, low background music.

Some of the celebrities I have photographed, including Elizabeth Taylor and Joan Collins, have specifically requested that I provide some of their favorite music. Others, including Victoria Principal, have brought their own tapes to the studio.

Posing Locations—I keep in my studio a large selection of cushions of varying sizes and shapes. I also have posing stools of different heights and sizes. A variety of blankets and rugs can be used to cover these supports.

Possibly my favorite posing place of all is my studio floor. I take many of my photographs with the subject comfortably on the floor, although most of my pictures do not betray this fact. Nervous, insecure subjects tend to feel most comfortable on the floor. And, you would be surprised how many different posing possibilities the floor offers.

Electric Fan—In some of my photos I use an electric fan for the obvious purpose of blowing hair or clothing, to bring additional life to an image. In other cases I use a fan for another, less obvious purpose: The gentle blow of air on a subject's face often helps him or her to relax.

THE PHOTOS
IN THIS CHAPTER

I photographed top models Matt Collins and Dayle Haddon (Photo 2-A) for a Max Factor ad for lip gloss. Models with such wonderful talent need little motivation from a photographer. With models of lesser experience, and especially with a couple who are not naturally compatible, a lot of direction may be called for. A truly professional

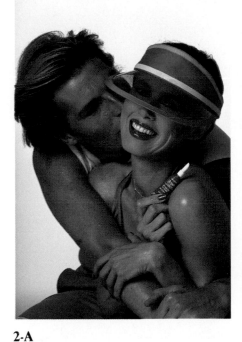

2-A

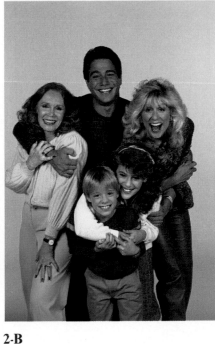

2-B

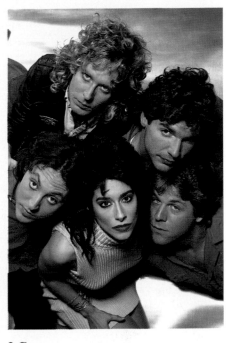

2-C

photographer should be able to produce images such as the one reproduced here with models of relatively little experience.

It involves more than directing the shooting of a few photographs. It requires skillful direction of a mini-drama or mini-comedy. You must have the talent for explaining to your subjects the roles they are to play and for eliciting the right moods from them.

It's worthwhile to point out some other interesting points in this picture. The key component is the product—the lip gloss. It is held at a point of dynamic impact in the image area, about one third of the way in from the side and one third of the way up from the bottom.

Because of the nature of the product, the female model's mouth is of prime importance. I had to select a model with an unusually attractive mouth and had to elicit a radiant, natural smile from her.

I wanted Dayle to make eye contact with the camera. However, I didn't want the eyes to steal attention from the tube of lip gloss. To subdue the eyes, I

had Dayle look through the tinted visor of the sunshade.

Because Matt Collins' role in the picture was secondary, I asked him not to make eye contact with the camera. This gives graphic prominence to the female model and, by association, to the product being advertised.

Many celebrities do not enjoy still photo sessions although they are aware that such photos are needed for advertising and publicity. I understand their reluctance. After all, dynamic performers like Tony Danza and his cast in the TV series, *Who's The Boss* (Photo 2-B), are popular largely for the vitality of their acting talent. A still picture "freezes" all that. In a case like that, motivation and direction from the photographer is often called for.

Danza and his supporting cast knew what was needed and required little prodding from me. However, because my five subjects could not see each other, it was necessary for me to direct from camera position. I had to ensure that the five poses interrelated to form a pleasing and vital composition. I also had to provide some direction to get a

good, believable combination of expressions. Then, I had to be watchful that each expression was right at the moment I made each exposure.

As usual, I shot a lot of film. I think that the image reproduced here depicts the group's vitality and camaraderie as faithfully as a still photo can.

I photographed the rock group, *Idle Tears* (Photo 2-C), for the record cover of their first recording.

Having more than one person in a photo has its advantages and disadvantages for a photographer. The members of a group tend to get energy from each other, which helps to make dynamic images. Also, each member will do his or her best to not let the team down and this leads to excellent cooperation.

A difficulty in shooting groups like this, or the one in the previous picture, is the coordination of expressions and poses.

The photo reproduced here was made under somewhat difficult conditions. The subjects were seated on the floor and I was high up on a ladder. Each of the faces had to have equal

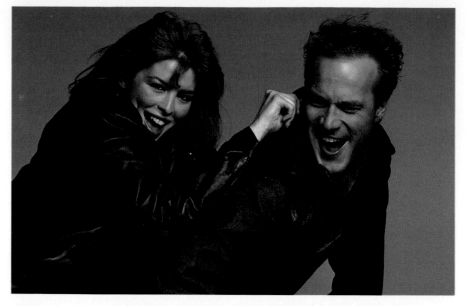

2-D

graphic impact and the image had to crop to a square to make the album cover.

I asked each member of the group to look directly at the camera. I asked for an intense expression in each face. I then told the group that, because I couldn't satisfactorily monitor five faces, each member had to be responsible for his or her expression.

I shoot even more film than usual when photographing groups. This not only ensures that I get a wide selection of expressions but also virtually eliminates the possibility of any of five pairs of eyes blinking at the time of exposure in all shots. A little added motivation on my part was called for because the pose for the group was far from comfortable.

To demonstrate my shooting technique at a lecture in Washington, D.C., I hired this charming and talented pair of professional models (Photo 2-D). During the shooting session we tried a lot of situations, from sensuous to humorous, and had a lot of fun.

To get the most from the session, I had to use my inventiveness in generating different situations. I then had to motivate—or direct—the models. For the photo reproduced here, I had asked the woman to pull the man's ear, naturally and spontaneously. I directed him to respond without thought, in an intuitive manner. As you can see, they both performed well and convincingly.

As professional models, these two were totally at ease in front of my group of students. Nonetheless, I like to believe that I could have achieved much the same result by simply selecting a couple from the group and photographing—and directing—them.

CONCLUSION

Sometimes, motivation is called for with the most unexpected subjects. I had great difficulty putting at ease before my camera one of the giants among Hollywood actors and a good friend, Rock Hudson. As so many actors, he simply didn't feel comfortable before a still camera.

To avoid stiff, uncomfortable looking poses, I had asked Rock to look away from the camera between shots and then come back with a new pose each time. It didn't help much.

During our conversation, as I was shooting, Rock told me that he was on one occasion photographed by Roddy McDowall who, in addition to being a fine actor, is also an accomplished photographer. As my celebrated subject told me, Roddy had found a way to put him at ease. The trick was to sing to him!

Without hesitation, I began singing my best rendition of *Melancholy Baby* and was rewarded with some excellent photographs of Rock! One of the images, selected personally by Rock, appears on the cover of his autobiography.

BE PREPARED

A chain is only as strong as its weakest link. In photography, that weak link is often a lack of adequate preparedness. Being fully prepared for a shoot involves having the right equipment at hand—and a lot more.

In this chapter I discuss the various aspects of preparedness that I've found crucial in my work. By following my advice, you'll be able to shoot with greater ease and confidence, be able to concentrate on the subject before your camera—and have the best chance of getting a high proportion of fine images.

CHECK LIST

In order to be totally ready for a shoot, there are many things I need to prepare in advance. I need to discuss the project with my client, art director or subject. In the case of a fashion or editorial assignment, I may have to select one or several models. Suitable props must be obtained and a variety of appropriate backgrounds chosen. However, none of the above are of any use if my equipment isn't exactly right and ready.

There are many items to remember. They include more than cameras, lenses, lights and, of course, film. I need extension cables, reflectors, diffusers, umbrellas, light meters, filters and numerous other items. To help me remember all the things I require for a shooting session, I prepared a special check list many years ago and I use it regularly.

The list contains pretty well all the items I normally use. I may not need every item for each of my shoots. I check off the things I may need on any specific day, so I can be sure not to forget anything.

The check list is particularly useful when I'm shooting on location. If I should have forgotten something when shooting at my studio, the error is generally corrected easily. I simply grab the forgotten item. However, when I go on location, I must be sure to take with me everything I may need.

At an outdoor location, away from the studio power supply, I use the available light, controlling and modifying it as necessary. However, preparedness dictates planning for the possible loss of usable light. I do this by taking along portable electronic flash units, complete with charged batteries and spares for replacing discharged ones.

Some location assignments require more extensive artificial lighting. In such a

case, I'll rent a location van with a power generator, enabling me to use my studio lighting equipment.

You may find it helpful to add other items to your check list besides photo equipment, such as special refreshments, music tapes and wardrobe.

My list has an added usefulness. It helps me to communicate to my assistants with ease and clarity exactly what they need to prepare.

KNOW YOUR EQUIPMENT AND FILM

To be an effective photographer, your equipment should be like a natural extension of yourself, and your technique should be second nature.

Don't Switch Needlessly—Know your cameras and their controls. Be familiar with your lights and reflectors and the effects they produce. Know your films and their characteristics. Then, stay with the equipment and materials you know unless there's a good reason to change.

Cameras—It's advisable to have more than one camera body. Not only is it a safeguard in the event one breaks down, it is also useful for a rapid change of film type or lens. If you plan to own two, three or four SLRs, I would strongly recommend they all be similar models. When you're familiar with one, you'll be familiar with all. Each time you switch cameras, you won't have to concentrate on different operating characteristics. This is much more desirable than having, for example, one Nikon, one Canon and one Minolta.

Keep your equipment as simple as you can. Not only does this make your operation a lot less costly, it also tends to make your work a lot more streamlined. I don't mean to advise you to buy a cheap camera, or to stay with just one lens. I simply want to discourage you from making *equipment* more important than *photography!*

It's amazing what you can achieve with a couple of SLRs and three lenses. I do most of my work with an 85mm, 105mm and 180mm lens. Frequently, I use very simple lighting setups. If my equipment were temporarily misplaced by an airline tomorrow, I could rent one SLR, an 85mm lens, one light and a couple of reflectors and go ahead and shoot many kinds of assignments. From my pictures, the client would be totally unaware of the handicap under which I was shooting.

The less encumbered you are with needless equipment, the better you'll be prepared to do fine photography. By all means get cameras of the highest quality you can afford, but don't be tempted to buy more than you need and don't constantly switch equipment unless it's for a good reason.

Keep Cameras in Good Condition— Being prepared involves more than having cameras you are familiar with. You need cameras that you know to be in good working condition. This means you should take good care of your equipment. Keep cameras and lenses clean, don't leave them lying in direct sunlight or any other hot place, and avoid dropping or jarring them.

If you know that a camera has been damaged, if any part doesn't function properly, or if dust, dirt or salt spray from the ocean have penetrated a camera or lens, have it attended to by an authorized repair shop. You can't work confidently with equipment you suspect to be faulty.

Film—The better you know your films, too, the better you will be prepared to produce fine photographs consistently. Select films that suit your particular needs. Conduct experiments and tests, to determine your favorite films—but don't do such tests during a shooting session for a client.

Stick with your chosen film or films unless there's a good reason to change. I use a slow 35mm slide film—speed ISO 25—for much of my work. I like its sharpness, vibrant colors and warm rendition of skin tones, and its excellent color stability during many years of storage.

However, when I plan to shoot in dim light, for example, or to deliberately achieve a noticeable grain structure in the image, I'll select a film with higher speed.

Each color film has its own subtle color characteristics. Try as many as you want, carefully evaluate the results, and then select the film you'll use for most of your work. Deviate from it, when the circumstances call for an emulsion with different characteristics.

Over the past 10 to 15 years, I've shot almost exclusively on color film. When a black and white image is required, I'll either change to a black and white film or shoot color and later convert the image to black and white.

Recently, the special quality of black and white photography has become increasingly appealing to many of my clients. Such artistic fashion, like all fashion, tends to run in cycles.

I'll only rarely use a soft-focus device or diffuser on the camera lens. If I want a soft-focus image, I can make a copy slide or print and introduce the effect at that stage. I shoot for maximum information. I can produce a soft-focus image from one that's pin-sharp, but not the reverse.

Film Testing—Like most photographers, you have probably been advised in the past to test each new emulsion batch of film that you purchase. The tests are intended to indicate color balance and filtration needs as well as film speed. The advice usually includes the recommendation that you buy film of a specific batch in the largest quantity practicable, to obviate frequent re-testing.

From practical experience, I've found the 35mm slide film I normally use to have very consistent film speed through all production batches. As far as color is concerned, I'm convinced that the color changes caused by interchangeable lenses having different light-transmitting characteristics are greater than film-batch variations— even though variations in today's lenses are truly minute. For these reasons, I don't make tests from batch to batch of my 35mm film.

When using 4x5 sheet film, I generally do buy an adequate amount of film

in one specific batch and have my lab process a batch test.

BE SURE OF YOUR TECHNIQUE

Obviously, the better your knowledge of photographic *theory,* the better equipped you will be for taking good photographs consistently. However, the *practical application* of your knowledge is just as important. Effective practical photography is dependent on thorough familiarity with your equipment, knowledge of theory, and practical experience.

The Right Time To Make Tests—As I said earlier, the time for testing and experimentation is not during a shoot for a client or customer. Before you use a new camera, lens, film or lighting setup for pictures that are going to be important either to you or a client—make tests. Only in this way can you be sure of your technique in the context of practical application.

Before you use a specific camera you haven't used before, even if you are familiar with that particular model, run a film through it and look at the results. This is especially important if the camera was purchased used, or if it is borrowed equipment. You don't want unpleasant surprises on its performance during an important shoot.

Shoot It Several Ways—I don't want to discourage you totally from experimenting during a professional or otherwise important shoot. However, I recommend that you only try things that you are fairly confident will succeed. Also, I suggest that you shoot the photos in several other ways, too.

Bad Weather—If you're shooting on location, don't be discouraged or intimidated by bad weather. Sometimes dim light, very soft light, fog and mist, dramatic cloud formations and a wet, shiny foreground surface can all add special atmosphere to a photo.

Be prepared for all kinds of weather by taking slow and fast films with you. Be sure to also have flash and some reflectors. Take filters for correcting or deliberately accentuation color. Final-ly, take a large umbrella to protect you and your camera from rain—and have an assistant or friend with you to hold the umbrella.

In inclement weather, lighting conditions can be unique and very changeable. Use your technique as best you can, but don't be inhibited because you may not be getting the results originally intended, based on the availability of good weather. Shoot as varied a set of pictures as you can, using a wide range of exposures and viewpoints.

SET UP STUDIO LIGHTS BEFORE A SHOOT

When I'm going to photograph a celebrity, I know in advance the general appearance of the person who will be before my camera. This enables me to determine my basic lighting setup in advance. If I'm commissioned to shoot an advertising or editorial assignment, I'll also know before the shoot approximately what is required. When I have such advance information, I find it expedient to set up my basic lighting in advance.

Lighting equipment should, at the very least, be assembled and ready for use at the start of a session, so that the session can get under way without needless delay.

Shoot with the lighting you had originally planned to use and then, as appropriate, vary it to achieve specifically what the subject's features and coloration, and your esthetic desires, demand.

I use one of my assistants, or anyone else who happens to be available at the time, to stand in for the actual subject. It's quite OK for a male assistant to take the place of a beautiful female movie star for this purpose. After all, the light placement is only approximate and must be "fine tuned" for the actual subject.

Lighting and background are generally closely interrelated. Therefore, when I set up my lights I will, at the same time, also select and set up my background for the shoot.

At the time I set up the lights, I also make exposure-meter readings to determine the intensity and placement of each light, as well as appropriate background illumination.

BE PREPARED PSYCHOLOGICALLY, TOO

Being a professional photographer is a little like being an actor or performer. When I'm behind my camera, and my subjects are in front of it, I'm *on.* I must perform, and must do it well, each time.

The Show Must Go On—If you work in an office from nine to five each day, you can afford yourself the luxury of taking time out. If you don't feel on top of your form, you simply produce less effectively than usual on that day. Nobody will notice. If you feel sick, you take the day off.

As photographer, once you've made a commitment to do an assignment, you must appear—unless circumstances really prevent you from performing—and you must do well. I've shot important assignments with celebrities or nationally known clients while I had a toothache, a cold, a personal problem on my mind or just "wasn't in the mood." However, once a session starts, I'm always able to "lose myself" in my photography, forgetting everything except the subject before me and my photographic objectives. It's a matter of dedication and mental discipline.

Those who hire me do so because they are familiar with my work and like it. I must provide the quality they expect—every time! I must be capable of putting my worries and pains on a metaphoric shelf for the duration of the shoot. I have learned to do this quite readily, knowing very well that my problems will be eagerly waiting for me when the session is over!

Expect the Unexpected—As I've said earlier, being prepared means being flexible. Don't just expect the things you *know* are going to happen. If a subject or client changes the direction of the shoot, even drastically, during a session, be prepared to satisfy his

needs, so long as the changes are esthetically acceptable to you.

If the circumstances alter—such as a sudden change in weather during an outdoor shoot—be prepared to adapt your technique.

If something you had expected to work just fine doesn't work at all in practice, don't make a futile attempt at doing it anyway. Change your approach, no matter whether it involves an impossible pose, an unsuitable background or lighting arrangement, or a model that proves totally unsuitable for the purpose of the assignment.

Don't expect the client or subject to be totally satisfied with the approach he or she had specifically asked for. Just in case, shoot it different ways.

Personal Rapport—I've already emphasized the importance of establishing a good rapport. To be a successful photographer, you must communicate well with your subjects, clients, art directors, assistants, and anyone else associated with a shooting session. Get to know your subjects and their desires and needs. Understand what your clients require.

In the nature of things, some people will always be more experienced and decisive than others. I have found that, in general, the more experienced an art director, the more decisive will be his orders to me. It's the less experienced ones who tend to ask me to "shoot it several ways." I must satisfy that need, too.

BE PREPARED VISUALLY

To satisfy your clients and subjects, you must be decisive visually. You must make vital visual decisions twice—first at the time of shooting and then again when you select the best from the processed photos.

Shoot Decisively—Only rarely do I use the motor drive on my camera for shooting rapid sequences automatically. I do so when the action is so fast that I can't possibly shoot selectively. Normally, I use the motor drive simply as an automatic film winder. It enables me to expose frame after frame fast but selectively. I'll press the shutter button when I see the image I want.

A Tripod Can Help—Whenever the circumstances permit it, I prefer to shoot with my camera on a tripod. This prevents me from having to be preoccupied with framing and focusing and enables me to give my full attention to the subject's expression and body position. When the assignment calls for a very specific layout, with a precise crop, a tripod is virtually essential.

However, you should never sacrifice spontaneity and flexibility due to the inherent limitations a tripod imposes. You must use your judgment when it's best to shoot handheld and when to anchor the camera securely on a tripod.

Select Wisely—I always shoot a lot of film when photographing people. I want to capture as many fleeting expressions and attitudes as possible. After the session is complete, I'll advise the client as to which images I consider best express his specific needs.

An important aspect of being a professional is to know how to select the best images from the many that were shot. When you examine carefully a contact sheet of 36 exposures, you'll notice that, at a glance, many images may appear very similar. However, at closer inspection you notice the difference between a radiant smile and a slight smirk or grin. This minimal difference in expression makes the difference between an appealing image and a mediocre or totally unusable one.

The same applies to body pose. At a glance, two positions or attitudes may appear very similar. On closer inspection, one will be *just* right and another *just* not right. The difference may be very subtle, but it can be the difference between a good shot and an "outtake."

KNOW YOUR PROCESSING LAB OR TECHNIQUE

I've told you how to be prepared for producing good photography in a variety of ways. However, all your technique, creativity and psychology will be in vain if your films are not processed correctly. This, too, can be the weak link that causes the chain to break.

Many color reversal films and all color negative films can be processed in your own darkroom. Enlarging and printing from color negatives can also be done without the use of a commercial lab. However, doing any kind of color processing reliably requires special equipment and carefully following the film or paper manufacturer's instructions.

If you choose to do your own processing, prepare yourself fully by reading all the relevant directions. Know also how you can vary processing to alter film speed, color balance, grain structure, and so on. And, be prepared to spend considerable amounts of time in your darkroom!

Finding a Good Lab—Like most professional photographers, I choose to use a commercial lab to do all my processing. In a large city like Los Angeles, where I'm located, there is a good selection of labs to choose from. If you live in a relatively small community, you may need to mail your material out for processing.

Whichever method you use, I recommend that you take the following steps to find the right lab. First, ask among your photographer friends regarding tried and trusted labs in your area. Then, use one of them. If, after a few tries, you feel satisfied with the quality, consistency and service you're getting, stay with that lab. If you're not totally satisfied, try elsewhere.

Be Sure You Can Get Everything You Need—A processing lab should be able to do more for you than straightforward processing. You should be able to request that film be *push processed* for added film speed or that *snip tests* be made by cutting a frame or two from a roll of exposed film. You should be able to ask for duplicate slides to be made. In doing this, the lab should be able to change the color balance of the image, if you request it. The lab should also be able

to provide you with contact proof sheets and enlargements of any size you may need.

One difficulty I have experienced in the past is getting satisfactory prints made from color images that had a lighting ratio higher than about 3:1. Another complaint I've had on numerous occasions concerns skin tones that were much too rich and colorful in enlargements. I now work with a lab that understands my basic requirements and gives me excellent service, consistently.

Before you select a lab, be sure it has the *equipment, technical talent* and *esthetic understanding* that can satisfy your needs.

When You've Chosen a Lab, Stick With It—Once you've chosen a lab, try not to leave it. Work with the staff; get to know them; let them get to know you. As the staff becomes more familiar with you, your work and your requirements, you'll get ever better service. Like any good relationship, it improves with time. Don't expect a perfect understanding of your specific preferences from day one.

Don't be concerned only with what the lab can do for you. Consider also what you can do for them, to make their work easier. For example, I've found it useful, when having enlargements made, to leave sample prints that indicate the kind of skin tones I expect to see. Another way in which you can help the lab is to carefully study the results produced by specific requests such as, for example, *push processing*

Ektachrome by 1-1/2 stops. Before requesting the same thing again, be sure the result is satisfactory, in effective exposure, color balance, grain structure, and so on.

CONCLUSION

The following story serves to teach a useful lesson. Luckily, it ended on a happy note rather than in disaster. It clearly shows the need for preparedness.

I had flown From New York to Nassau, in the Bahamas, to shoot fashion photographs for an 80-page booklet. It was an expensive shoot. I had with me an assistant, production staff and three professional models for about a week.

This was many years ago, at a time when I could not afford more than basic equipment. I had taken only one 35mm SLR, together with three lenses of different focal lengths.

My short telephoto lens proved to be the most useful, so I used it almost exclusively throughout the week's photography. Unfortunately, the automatic aperture stop-down on the lens was malfunctioning—an undetectable fault during normal camera operation. However, use of the depth-of-field preview button began to indicate the failure after I had already shot for five days.

I was shooting nearly all the outdoor fashion photos at about *f*-5.6. With the short telephoto, this gave me just enough depth of field while yielding a sufficiently blurred background to retain viewer attention on the subjects.

When I returned to New York and had the camera and lens examined, it turned out that the lens aperture was jamming at *f*-5.6. All my pictures turned out fine. But it was purely luck.

I learned an important lesson from this near disaster: Since that time, I've always checked out my equipment carefully before a shoot. And, I now always take at least two or more of each required item.

You're the Captain of Your Ship—Just like the captain of a ship, I must take full responsibility for everything that may go wrong during a shooting session—whether I'm personally at fault or not. I must make many careful decisions and selections.

Technically, I must have the right equipment and use it appropriately. Esthetically, I must produce pictures of a quality which attracted my client to my work in the first place. I must be sure that everything is available—from wardrobe, props and backgrounds to music and refreshments.

I must choose assistants that are bright and motivated and will work well to my direction. And, I must be prepared to work harmoniously with many people I don't personally select—such as clients, art directors, editors, stylists and, of course, subjects.

I must be fully prepared all along the way, so that there isn't a single weak link at which the chain might break— or an unexpected wave that might sink the ship! As a photographer of people, you face the same challenge!

MODEST LIGHTING EQUIPMENT IS ENOUGH

It has been said that you can never have too much of a good thing. In some respects, that may well be true. However, good photographic lighting is much more a matter of quality than quantity. You really don't need a vast array of shiny, impressive and expensive lighting equipment.

A look at many of my pictures and how they were made will easily convince you. The real secret is this: You can achieve an incredible variety of excellent people photographs with very modest lighting.

Light is a very democratic entity. It obeys basic physical laws, no matter if the light comes from a floodlight or a desk lamp. All light travels in straight lines unless deflected by reflection, refraction or diffraction. When light is redirected from a surface by reflection, the angle of reflection equals the angle of incidence.

Another law states that the brightness of light from a small source decreases as the square of the distance from the source, so that a subject twice as far from the light will receive one fourth the amount of light.

Refraction is the characteristic that enables a lens to focus the image of a subject on film. That characteristic, and diffraction, need not concern us here. However, the basic laws of refraction and diffraction also apply to all light, no matter how dim or bright.

Taking a portrait with two portable electronic flash units and a couple of reflectors is no different than using two professional flash heads connected to high-output power packs. The only significant difference is the light output you'll get. I discuss this more fully later in this chapter.

BASIC CHARACTERISTICS OF LIGHT

To make fine photographs with limited lighting equipment, it helps to be

familiar with the basic characteristics of light and to know how to control them.

To show how differently light can affect a subject, let us take two extremes. When no light is present, there is total darkness and a subject will not be visible. When a subject is bathed in uniform, soft light from all directions, you will see a lot of detail. However, there will be no shadows and, therefore, no *modeling*. In other words, the subject will appear flat rather than three-dimensional.

A subject lit from the side by a spotlight comes somewhere between these extremes. There is good modeling and deep shadows. Some parts reveal a lot of detail while others are hidden in shadow.

Let us look at the major characteristics of light and their effects.

Direction—When a light source is near the camera position, shadows caused by protruding parts, such as chin, nose and lips, are short. At first glance, the lighting may appear to be flat because much of the facial surface area is bathed in light. In reality, the small shadows are often quite deep and dark, giving the image good contrast.

If you want to avoid frontal lighting with on-camera electronic flash, you can use a special flash bracket that removes the light source from close to the lens. Or, you can use a long sync cord and hold the flash out at arm's length or place it on a light stand. Side light yields more prominent modeling. The distinct highlight and shadow areas produced give a subject an apparent three-dimensional form.

Light that comes from behind the subject, or nearly behind, creates a rim light on the subject. As you'll see a little later, this form of lighting is also very useful in people photography.

Outdoors, in natural light, we're used to seeing people lit from above— by the sun or diffused daylight. That's why the most natural studio portrait lighting also comes from above— generally at an angle of about 45°. Placing a light lower than a subject's

head usually creates an eerie effect that is less than flattering.

Brightness—The brightness of light on a subject has little effect on the image of the subject except that it affects the camera exposure needed.

The effective brightness of studio lights used by professionals can be controlled in several ways. The power setting can be changed; the lamp distance from the subject can be altered— although this also affects lighting contrast on the subject; the size and type of lamp reflector can be changed, although this, too, has an effect on contrast; and neutral-density gels or diffusers can be added to or removed from in front of the light source.

With portable flash equipment, you'll generally need all the light you can get, so buy a unit with as high an output as possible. As I've indicated, it's easy to reduce light output, but impossible to create additional power that isn't designed into the unit.

On rare occasions, it may be necessary to further increase the effectiveness of the light to get adequate exposure. If the esthetics of the shoot don't call for a specific film, use a faster one. If depth of field is of no consequence, opt for a larger lens aperture. If you're using tungsten lights, you can use a slower shutter.

Size of Source—The size of a source, relative to its distance from the subject, determines the basic contrast of the light. I'm saying *relative to its distance from the subject* because it's the *apparent* size of the source, as seen by the subject, that matters. For example, we regard the sun as a small source, even though it is, in effect, huge. What matters, from a lighting-effect point of view, is that the sun *appears* small from where we see it.

The relative size of a light source affects contrast in two ways. First, a small source creates a more distinct demarcation between shadows and highlight areas. Shadows have a relatively hard edge.

Second, a small source cannot *wrap around* a subject in the way a large

source can. For example, a large light bank near camera position can light the sides of a face almost as brightly as the front. A small source near camera position, on the other hand, will light the front of the face more brightly than the sides, leaving distinct side shadows and creating higher contrast.

The size of a light source can be changed by placing it in a smaller or larger reflector. A flash in an umbrella makes a large source for portraiture. At the other extreme, an on-camera flash without any additional reflector constitutes a very small—and therefore contrasty—source.

For much of my work, I use small to medium-sized light sources. I like the distinct shadow outlines and contrast they produce.

Distance of Source from Subject—The closer a light source is to a subject, the more distinct will be light falloff from nearer to farther parts of the subject. This characteristic enables you to control contrast on a single face, between two or more faces, or between subject and background.

Color—Every light source has its own color characteristics. Average daylight has a balance of all the colors of the spectrum that is equivalent to a color temperature of about 5500 degrees Kelvin. Daylight-balanced color slide film is designed for illumination with these color characteristics.

Electronic flash has similar color characteristics, making it ideal for use with daylight-balanced film. Tungsten light contains relatively more yellow, orange and red. Photos taken in this light on daylight film would appear excessively reddish. Special tungsten-balanced slide film is provided for this illumination.

Most fluorescent lamps have a non-continuous spectrum that contains very irregular and unequal amounts of the colors of the spectrum. With such lights, it is very difficult to get really good color images, no matter what filtration is used. However, there are daylight fluorescents that come close to giving acceptable results.

If the color of the illumination does not exactly conform to the specifications of the film, the colors can be balanced with suitable filters, such as Color Compensating (CC) or Light Balancing filters.

Softness and Hardness—In addition to the ways already described, the softness or hardness of a light source can be controlled in other ways. For example, you can place a diffuser over a hard light source to soften the light. Softening gives a more gentle demarcation between shadow and highlight areas and reduces overall contrast between light and dark areas.

Another way to soften light is to reflect the source from a white wall or reflector card or from a specially designed matte or silvered umbrella.

LIGHTING PEOPLE

There are four basic lights for people photography in the studio—the main light, fill light, rim or hair light, and background light. Not every photograph necessarily requires each of these lights. Also, there are times when one light can serve the purpose of two. For example, frequently the main light and background light can come from the same source.

To get the four lights mentioned, you don't necessarily need four light sources. Your lighting arsenal can be augmented very effectively by the use of a variety of reflectors, as I'll discuss a little later. In addition, the lighting can be controlled by gobos, barn doors and other devices, as I'll show later. First, however, I'll define the four basic lights for people photography.

Main Light—This is the light that determines the modeling on the face. Depending on its size, direction and distance from the subject, this light can be relatively soft and gentle, to yield an ethereal image of a woman, or robust and harsh, to produce a rugged character study of a man.

Fill Light—The purpose of the fill light, as the name implies, is to "fill," or lighten, shadows. Essentially, it lowers contrast to bring the subject within a brightness range that's acceptable to the film. The fill light should only lighten shadows, not destroy them. Also, it should not produce shadows of its own. To satisfy these needs, the fill light should generally be soft and must be of lower intensity on the subject than the main light.

The fill light can be a second light source, or it can be a reflector that redirects the light from the main source or another source. Reflector cards make an excellent fill light because they satisfy the two needs just expressed: They give soft illumination and cannot give a brighter light on the subject than the source they reflect.

An added advantage of the fill light is that it can add a second catchlight to a subject's eyes, giving an image extra sparkle.

Rim Light—This light is aimed at the subject from above and behind, producing a rim of light on hair, shoulders, or other areas of the subject. The purpose of this light can be simply to add accent to the image, to separate a dark subject from a background that's also dark, or to give additional highlighting to the hair or other areas of importance. A well-placed rim light can add a convincing three-dimensional effect to an image.

The rim light is usually in the form of a contrasty, directional source. A directional light is needed because it is generally important to limit the light to the desired area and prevent it from spilling onto other subject parts, or entering the camera lens.

Background Light—Backgrounds can be created in several ways. You can use a setting such as a wall, doorway or textured screen. Or, you can use seamless paper, available in rolls of various widths, and in many different shades and colors.

Unless you want a detailless, black background, the background must always receive light.

The easiest way to get background versatility—a way that I use a lot—is to use a white background surface and vary the light intensity on it or on my subject. For example, if the amount of light reaching the background remains constant as I increase the amount of light falling on the subject, the background will be recorded darker because the lens opening must be reduced to expose the subject properly.

In this way I can create anything from a white to a near-black background. I can even add color by using colored gels over the background light.

Instead of a white paper background, I often use the specially constructed white cove in my studio.

The nature of the background light source must depend on the effect you want to achieve. If you want a uniform background, use a large, soft source. For full-length shots, where you must cover a larger background area, you may need two or more background lights.

It's often possible to use the main light as background light as well. By varying the distances between camera, subject and background, you can achieve a wide variety of background tones, together with a properly exposed subject—all with the one light source.

HOW LITTLE IS ENOUGH?

You can establish the four-light portrait setup described above with two lights—electronic flash or tungsten—and sometimes even only one, plus a couple of reflectors.

Two Light Setup—A typical example of full portrait lighting with no more than two light sources can be achieved in the following way. Use a main light and rim light in the normal way. Light the background with the main light. Introduce fill light by using a reflector, redirecting light from either the main light or rim light.

You could also replace the main light source with a reflector. Use one of your two lights to illuminate the background and the other as rim light. For main light, use a silvered reflector redirecting light from the rim light. For fill light, if needed, you can use a white, matte reflector.

One Light Setup—You don't always

need the rim light. In such cases, you can get excellent, professional-looking results with just one light—the main light—and a reflector or two. I often shoot with such a simple setup and get very striking results.

Natural Reflectors—You'll often find surfaces in the studio or shooting environment that make excellent reflecting surfaces. You can place a subject close to a light wall or door. Or, you can seat the subject on a light floor or a sheet of white seamless paper.

One thing is important: When shooting color film, use only white or silvered surfaces as reflectors. Colored surfaces would introduce a color bias into the image that could be objectionable.

In certain circumstances, mirrors can also be excellent photo reflectors. However, because they are very efficient, throwing back most of the light that reaches them, they must be used with care.

Reflector Types—If you want to use a reflector as main light or as an efficient fill light, use a silvered reflector. It throws back a higher percentage of the light reaching it than does a matte, white reflector. To lighten shadows subtly, use a matte, white reflector.

Especially when using the efficient reflectance of a silvered reflector for filling shadows, remember that the intensity of the reflection can be varied by its angle to the subject. Consequently, by "fanning" a silver reflector slightly away from the subject, the amount of light reflected onto the subject is reduced.

Many people make their own silvered reflectors by crumpling aluminum foil and then straightening it again, finally mounting it to a firm base. I don't recommend that you do this. No matter how finely you crumple the foil, it will always give you some small specular reflections that mar the uniform reflection you should get. It's much better to buy commercially available silvered reflectors. The material is available in a wide range of sizes.

In *Secret 5*, I'll mention the gold foil

reflector. It behaves essentially like the silvered reflector except that it yields a warmer light. It is mainly useful outdoors, under a blue sky, when you need to fill shadows that are somewhat blue. The reflector adds a nice warm light to the shadows as well as the skin tones.

Generally speaking, you can use almost any bright surface as a reflector—as long as you don't use a colored surface with color film.

FILM SPEED

There is no absolute answer to the question, "How Little Light is Enough?" You can maximize the light output at your disposal by moving the lights as close as possible—and comfortable—to the subject. However, because this method also affects image contrast, the easiest resort to getting well-exposed images with less light is to use a fast film.

For example, if you use a 200-speed color film instead of a 64-speed film, you can increase the light-to-subject distance by about 60% or you can use light with well under half the output.

Generally, you should use fast film only when it is necessary because with it comes increased graininess and lower image resolution. Sometimes, however, you may actually welcome the more evident grain structure. With some images, it's a very effective esthetic addition.

There's another good reason for using fast film. Although a slower film may give sufficient exposure, it may do so at the cost of having to use a wide lens aperture. Limited depth of field may sometimes be a problem. By going from a 64-speed to a 200-speed film, you can close the aperture by about 1-1/2 stops—an appreciable amount.

When you're using electronic flash, you can't achieve any noticeable extra exposure in a studio by using a slower shutter speed. With tungsten light, on the other hand, you can do so. However, when using a standard or short telephoto lens at shutter speeds of 1/60 second or slower, it's advisable to have

your camera mounted on a tripod. You should also be sure your subject is in a position that makes remaining relatively still possible.

ELECTRONIC FLASH

Electronic flash has many advantages over tungsten illumination. It gives light of a color balanced for daylight film; the lights do not get hot; it is cheap to operate, portable and can operate from battery power. The duration of a flash is short enough to prevent blurred images due to subject or camera movement. The light output from a flash unit is remarkably constant during its life.

Although electronic flash is definitely the light I prefer for people photography, it does have some disadvantages over tungsten lights. Unless you use professional studio flash, you'll have no modeling lights. This means you cannot build up and analyze your lighting visually. You have to more or less guess where to place your lights to achieve the desired effect.

Remembering the optical law that the angle of reflection is equal to the angle of incidence helps. It enables you to rationally determine light positions. You can also develop the capability to "see" the subject well enough during the tiny fraction of a second of a flash to determine shadow positions, highlights and catchlights in the eyes.

If you're handy at making things, you can make some modeling lights for your portable electronic flash heads. You need simply mount small tungsten lights in front of the flash in such a way that the light comes basically from the flash position but does not cause a major obstruction to the flash itself.

TUNGSTEN LIGHTS

For the beginner in photography, tungsten lights are wonderful because, basically, "what you see is what you get." You place your lights to get the effect you like and then shoot.

However, you must remember that what you see is *not quite* what you get! You'll see the *modeling* the film will

see but not the same *contrast*. The eye can adapt to greater brightness ranges than film. Although you may see plenty of detail in the shadows on your subject, the film will not necessarily record that detail. With color film, you should generally keep the highlight-to-shadow ratio no higher than 3:1 if shadow detail is important. This applies of course, to electronic flash as well as tungsten light.

This means that, if you're using two light sources of equal intensity, the fill light should be no more than 1.7 times the main light distance from the subject. Remember, these are only guidelines. It is for you to determine the precise lighting that best suits your taste and the prevailing conditions.

Disadvantages of tungsten lighting, balanced for tungsten film, include the fact that, unlike with electronic flash, you must change films when going from outdoor shoots to indoor ones. You could use daylight film with appropriate conversion filtration, but with a considerable loss in film speed.

An additional drawback of tungsten lights is the heat they generate. It can create discomfort, especially if they are left on for long periods.

Tungsten lights—with the exception of quartz-halogen lamps—change in intensity and color toward the end of their burning life. You don't get the consistent light output and quality that you get with electronic flash.

Using fast film, you can shoot with low-wattage lamps such as a 100-watt desk lamp instead of using photo lamps such as photofloods. However, the light will be so reddish that you'll need corrective filtration, even with tungsten-balanced film, for accurate color rendition.

LIGHT MODIFIERS

There are several kinds of light modifiers, in addition to the reflectors I've already discussed. The modifiers serve two basic purposes: They can help to give you more light on the subject with less lighting equipment. They can also change the quality of the light. Following are some typical light modifiers.

Pan Reflector—Through the years, one of my favorite light modifiers has been the pan light or pan reflector. The reflector is round, usually having a diameter of between 12 and 18 inches. Generally, the flash tube and modeling light are covered by a small conical reflector that shields the subject from direct light from the source and, at the same time, bounces the light back into the larger pan, from which it is redirected toward the subject.

The resulting light, at my normal main light-to-subject distance of four to six feet, renders hard to medium-contrast subject illumination.

Umbrella—This is perhaps the most popular of all light modifiers to the people photographer. In essence, it's simply a circular, collapsible reflector in the shape of an umbrella, to which a flash can be attached. By reflecting the light from the umbrella you are, in effect, creating a new light source that is larger and, therefore, softer than the original source.

Some umbrellas are somewhat translucent, so you can light the subject by either reflecting the light from the umbrella or by transmitting it through the umbrella. Altering the distance of the flash from the umbrella changes the characteristics of the light.

For example, when a light transmitted through an umbrella is relatively far from the umbrella surface, you'll get a fairly uniform soft light. If you bring the light close to the umbrella, you'll get a general soft-light effect together with a somewhat directional light. It is similar to the light you get from a lightly overcast sky, where the sun itself is still discernible.

Normally, I like to use opaque umbrellas. It avoids the discomfort and distraction caused by the view at camera position of a transilluminated umbrella. It also eliminates the possibility of lens flare when the light source is in front of the camera.

Other disadvantages of a translucent umbrella are light loss through transmission, when the umbrella is used for reflecting light, and a certain loss of lighting control when transmitted light is reflected back from nearby surfaces such as walls.

Grid Spot—This light source has a specially designed grid in front of it to direct the light in a relatively narrow beam. It is ideal for rim and hair lighting, and for situations where a small area must be lit selectively.

Most grid spots come in kits with four to six different grids, providing various angles of coverage. The same effect can be achieved by focusing spotlights that enable you to vary the width of the beam.

You can also get simple snoots that attach in front of a light source to limit its spread.

Barn Doors—Most light reflectors can be fitted with barn doors to provide light-spread control. Barn doors can come in diametrically opposed pairs or in fours. By adjusting the position of the doors, you can control light spread selectively in different directions. With a grid spot you're pretty well limited to a spread control that's equal in all directions from a fixed light position.

Light Bank—This is simply a large box with white interior surfaces and a translucent front face. These banks are available—or can easily be made—in a wide range of sizes. By uniformly spacing several light sources inside the box, you can create a very uniform, soft light that can be very flattering to certain subjects.

The light bank is particularly useful for simulating window light in a studio.

Gobo—The word gobo is probably a condensation of the words "go-between." It is essentially a blocker or eliminator of light. If, for example, a rim light is shining directly at my camera lens, creating the probability of flare, I'll place a gobo card between the source and the lens. In doing so, I do not prevent the light from serving its intended purpose of highlighting the subject's hair.

Gobos can be very useful outdoors, too, as I explain in *Secret 5*.

Black Reflector—A black reflector, unlike a gobo, is intended to have a direct effect on the lighting of a subject. It is a black card which, when placed near the subject, eliminates reflection and increases shadow depth. Typically, black reflectors can add a shaded rim to a face or garment, creating a three-dimensional effect and setting off a light subject against a light background.

While a white reflector adds light, a black reflector removes light.

YOU CAN SATISFY MOST LIGHTING NEEDS

With the simple and modest lighting equipment I've discussed, you can satisfy most of the basic needs of indoor people photography. A couple of light sources, a light modifier such as an umbrella, a reflector or two, and you're in business. Here are some of the lighting effects you can achieve:

High Key and Low Key—For high key photography, use a uniformly lit, bright background. Set the lights so the exposure for the background and the subject are the same, producing a clean, white background. If you have more light on the subject than on the background, the white background will record as gray when the subject is exposed properly.

Ideal high key photography requires that the subject be wearing a light outfit, too. The areas of deepest tonality will generally be the subject's hair, eyes and lips. The skin tones will also be darker than the background.

While a high key photograph has most tones at the highlight end of the tonal scale, the reverse is true of low key photographs. When you aim to shoot low-key pictures, select a subject with dark hair and dark clothing. Use a dark background. The lighting should provide plenty of shadow areas. Use rim lighting to graphically separate the subject from the background.

Short Lighting and Split Lighting—If a subject has a wide or round face, you may want to use a lighting technique called *short lighting*. It helps to graphically narrow the face. Aim the main light at the subject from the side of the face that's less visible from camera position. This creates a shadow on the broad side of the face—the side that occupies more image area—and thus effectively narrows it.

For a more pronounced effect, try *split lighting*. The main light is positioned to illuminate only half the face. Split lighting can achieve very dramatic effects with men's faces. I've found, however, that it's important to bring the light far enough forward to produce a catchlight in both eyes.

Broad Lighting—If a subject has a thin face, you can effectively widen it by using *broad lighting*. Aim the main light at the subject from the side of the face that is most visible from the camera. This uniform lighting will create the illusion of a wider face.

Lines and Wrinkles—I don't believe that diffusers and diffused lighting are the answer to minimizing lines and wrinkles. With men, I rarely try to reduce the prominence of wrinkles, much less to eliminate them.

With women, it's a little different—I want them to look beautiful and ethereal, yet real. A light source of medium to high contrast portrays the angles and planes of a face in a way that captures the unique appeal of a woman. Depending on the angle at which the light is used, such lighting can reveal lines and wrinkles. However, a soft, diffused light, used at an oblique angle, will reveal far more lines and wrinkles than will a frontal light that's contrasty.

I like to use a crisp, undiffused light and, when necessary, have an image retouched. The alternative—a soft light—may be more economical in this respect by eliminating the need for retouching, but it will give results that are less appealing.

Viewers of photographs are sufficiently sophisticated today to wonder why soft lighting is being used: Is it trying to hide something? The answer is a light of medium contrast, used from a frontal position. It produces a crisp, bright image, without undue evidence of lines and wrinkles.

BACKGROUNDS

There's a very close relationship between lighting and background. Lighting and exposure for background and subject must be interrelated. In most cases, the subject should stand out from the background. This can be achieved by either having the two of very different tones or colors, or by rim lighting, or by a little of each.

Background Exposure—Exposure for the background is important. For example, as I indicated earlier, you can achieve virtually all background tones by using a white background surface and adjusting the lighting relationship between subject and background.

Decisive Shadows or None—I like my backgrounds to be decisive and compositionally strong. I like a background to either have uniform tonality or decisive and dynamic shadows or patterns. That's one of the reasons I shy away from seamless paper—which tends to appear mottled or rippled—whenever possible and use the white cove in my studio instead.

Texture—For many of my people pictures, I find distinctly textured backgrounds such as fabric, wood or stucco appropriate. By contrasty cross lighting, I can accentuate the texture.

THE PHOTOS IN THIS CHAPTER

To feature prominently the shirt in this fashion shot (Photo 4-A), I used nothing more than one light. I didn't even use a reflector.

I used a small light source to create distinct shadows on subject and background. The shadows form a distinct part of the graphic composition.

I broke a basic lighting rule: I lit the subject from *below*. Low lighting must be controlled carefully, otherwise it can create an eerie, unflattering effect. Here, the low light gave the texture and modeling I needed in the shirt, as well as providing the shadows where I wanted them.

I had the model face in a direction

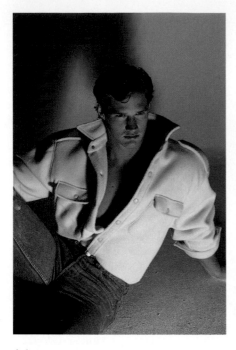

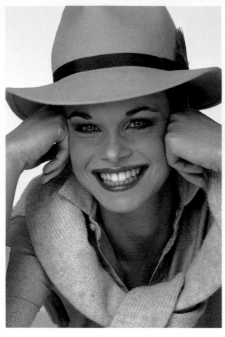

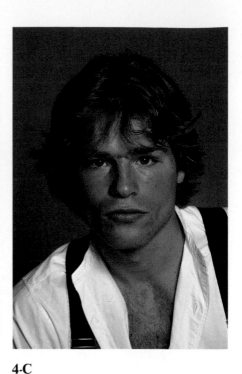

4-A 4-B 4-C

that provided brightness to the eyes and gave good modeling to the face.

The subject-to-background distance was determined carefully so that the single light source would give good subject exposure and, at the same time, provide a mid-gray background.

The image of model Gina Gibbs (Photo 4-B) was made for a Max Factor cosmetics ad. Because the ad was designed to sell junior cosmetics, I opted for a soft and light rendition of the subject. Harsh shadows and high contrast would have defeated my purpose.

One medium-sized source was all it took. I aimed the light down at about 30°. I didn't raise the light higher because I wanted to light the eyes below the hat brim.

As in so many of my photos, the model was seated on a white floor. The floor acted as a reflector, brightening shadows on Gina's forehead and under her chin. I used a single light on the background, balancing the exposure to give a white background in the image.

I photographed pro model Frank Durlenko (Photo 4-C) as part of a series on great faces of men. I lit Frank fron-

tally with a single light in a pan reflector. The background consisted of a brownish paper, which was in keeping with the rural appearance of Frank's clothing and his casual hair style.

My main purpose in this photo, as in the entire series, was to capture the character of the man. Therefore, I avoided all possible graphic distractions. I also didn't request any specific expressions but rather encouraged my subject to simply be himself.

CONCLUSION

In London, England, some years ago, I had an assignment that required elaborate lighting. The shot involved four people—two men standing together and two women, also together but removed from the men by about 10 feet.

I had inadvertently used incorrect voltage converters with my lights and they had failed. I was down to one source, yet the shot had to be produced!

To compensate for my limitation to a single light, I shot in a room that was amply mirrored. By positioning my models, light source and camera

appropriately, I was able to simulate rim, fill and background lighting using reflections from the mirrors, walls and ceiling of that room. One light can do a lot if you use it creatively!

USE THE VERSATILITY OF DAYLIGHT

Instead of the above, another apt title for this Secret might be, "Recognize the Serendipity of Daylight." I must admit, honestly, that I prefer the controlled conditions I have in my studio to the unpredictable lighting typical of the outdoor scene. However, there's wonderful excitement in shooting in an environment that is constantly changing, constantly new.

The art of shooting outdoors is to be aware of the infinite variety of lighting conditions that offer themselves, to know how to "harness" them to your specific needs, and to act fast—for the brightness, contrast and color of the light can change before your very eyes.

The versatility of studio lighting is dependent on your imagination and skill. You can add or remove lights, change their power and direction, add reflectors and diffusers—until you see the effect you want in your images. The creative use of daylight, too, is dependent on imagination and skill. However, outdoors you must learn to work with and modify what's there, because your lighting equipment is provided by the whims of nature. You can accept it, modify it, or wait until conditions are right for your purposes.

Of course, many photographers "stabilize" the situation by choosing a suitable location. Top fashion, advertising and editorial photographers will fly to Arizona or California to shoot a week-long assignment, if the session requires constant sunlight.

Photographers in northern cities, such as New York, Boston and Chicago, often fly to Florida or the Caribbean islands to shoot swimsuit and other light-weight fashion assignments in winter, when their home locations are deep in snow.

However, wherever you happen to be, and however you may sometimes be exasperated by the capriciousness of daylight, one of the important secrets to

success in people photography is to be aware of the wonderful versatility offered by daylight. One type of "available" light—window light—is so popular with people photographers, that they often simulate it in the studio, using large light banks. I'll say a little more about this later in this chapter.

THE SUN: THE PRIME LIGHT SOURCE

The sun is our only natural light source. The infinite variety of daylight conditions that we are familiar with are all generated by sunlight—more or less diffused; more or less reflected from other surfaces.

Daylight came first; studio light followed. That's why successful studio light nearly always simulates one of the basic conditions of daylight: The main light source illuminates the subject from above. When a subject is lit from below, the effect is usually an eerie, unflattering one. We're not accustomed to seeing faces in such light.

Nature, outdoors, can provide a small, contrasty light source in the form of direct sunlight. It can provide a diffused source in the form of sunlight through an overcast. Later in this chapter, I'll tell you how you can generate the classic studio lighting set up of main, fill and rim light, outdoors.

THE PROS AND CONS OF DAYLIGHT

As almost everything else in life, daylight photography has its advantages and disadvantages. I've already indicated my preference for studio lighting because of the control it offers me. To offset that, however, there is the delightful serendipity daylight offers to the observant, creative—and patient—photographer.

There are a couple of other, obvious advantages to daylight: It requires no, or very little, additional equipment. And, in contrast to electronic flash, it is a continuous light source, enabling you to see what you're going to get on film.

THE CONTROL OF DAYLIGHT

You can control the quality and effect of daylight in three basic ways: First, you can determine the angle of the light on the subject by appropriate positioning of the subject. Second, you can control the hardness or softness of the light, either by awaiting the right conditions of direct sunlight or overcast, or by the use of a scrim or diffuser between sun and subject. Third, you can generate fill and rim lighting by using either reflector cards or electronic flash. Let's look at each of these basic controls.

Angle of Light—Try to shoot people pictures when the sun is no more than about 45° above the horizon. Noon sunlight in midsummer causes dark, unflattering shadows in the eye sockets and under the chin. If you must shoot with a high sun, angle your subject in such a way that the lighting is not high in relationship to the face.

I like to shoot when the light is low in the sky. Sunlight just after sunrise and just before sunset tends to be reddish and may need corrective filtration. I find the morning light generally less reddish than evening light, and prefer shooting in the morning for that reason.

It's important to realize that almost all natural light has some direction. Even when the sun is behind a uniform overcast, the dominant direction of the light will be from the approximate location of the sun in the sky. When there's a break in a heavy overcast, the direction of the light will be from that break.

Hardness or Softness of Light—In its natural, unaltered state, daylight offers you three basic conditions. First, there's the harsh illumination of direct sunlight. Second, there's the soft but distinctly directional light of a light overcast. The sun is behind clouds, but the overcast is not dense enough to hide the sun. You can clearly see the circle of the sun. The illumination causes distinct, although soft, shadows. Third, there's the heavy overcast. You cannot determine the exact location of the sun in the sky. The lighting is very soft, and shadows are very indistinct, with no clear outlines.

If you want to soften direct sunlight, simply place a scrim, or diffusing material, between the sun and your subject. You can control the amount of diffusion, and therefore the softness of the light, by the thickness of the diffusing material or the number of layers of material you use.

Fill Light—When you're shooting outdoors, especially in direct sunlight, you will generally be able to improve your images by the use of fill light. When properly balanced, fill light will lighten the shadows, so your film can record the entire tonal range of the scene with some detail.

You can use portable electronic flash, at or near the camera position, as your fill-light source. The flash exposure should be balanced with the main-light exposure in such a way that shadows are lightened but not totally destroyed. If you allow the flash to dominate over the main source, your subjects will appear flat, almost like cut-out figures that have been placed in an outdoor setting.

Reflectors are also excellent for producing fill light. In fact, I prefer them over flash for several reasons: They can never throw back more light than is produced by the main light; they enable me to work fast because I need not wait for the recycling of a flash; they enable me to use longer lenses and, therefore, get farther away from my subject or create a more interesting pictorial perspective. Reflectors also enable me to see, and visually control, the fill effect I'm getting.

Another important advantage of reflectors over electronic flash is that they give more flexibility in exposure. You simply set your camera for the exposure you want and place the reflector where it achieves the desired fill effect. With flash, you must juggle guide numbers, flash-compatible shutter speeds and aperture settings that satisfy both the flash and ambient-light condition.

In addition to reflectors you can carry with you, nature offers many natural reflectors. They include white walls, light-gray pavement, large clouds, and snow and beach scenes.

Rim Light—The most effective way to get rim lighting outdoors is to backlight the subject by the sun. Then, use a silvered reflector from the subject's front to provide a reflected main light. The sun, in effect, becomes both the main light and the rim light. You may need a second, matte reflector to fill shadows caused by the main light from the silvered reflector.

Incidentally, having the sun behind your subject and using a reflector—silvered or matte—at the subject's front to provide the main light, is good practice, whether you want rim lighting or not. This technique enables you to work with a high sun, redirecting it from an acceptably low angle. It also provides a larger light source—the reflector being effectively larger at subject position than the sun—and, therefore, a softer light than direct sunlight would yield.

Gold Reflector—In addition to silvered reflectors, you can buy gold reflectors. You can even get reflectors that are silvered on one side hand have a golden surface on the other.

Gold reflectors are particularly useful when you're shooting in open shade, where most of the illumination is coming from blue skylight. A gold reflector will add a pleasing warm glow to shadows while, at the same time, warming the general skin tones also.

GOBOS AND
BLACK REFLECTORS

Gobos and black reflectors serve the same basic purposes outdoors as they do in a studio.

Gobo—You can use a gobo to shield the camera lens from direct sunlight or from unwanted specular reflections that might cause lens flare.

Incidentally, it's prudent to always use a lens shade on your camera when you're shooting outdoors. A most effective shade is one that prevents light from reaching the lens from anywhere beyond the actual subject area being shot. So, the longer the shade, the better—as long as it does not vignette part of the image area. Adjustable bellows lens shades are a good

idea, because they enable you to tailor the shade to each specific lens.

In addition to shielding the lens from unwanted light, a gobo can also be useful in providing less light to one part of your subject than another. For example, if you're photographing two people, one wearing dark clothing and the other white, you may want to "gobo" the light on the white clothing in order to reduce the overall contrast of the scene.

Black Reflector—A pair of black reflectors, placed close to both sides of a subject's face, can cause the sides of the face to go darker. This helps to provide roundness, or modeling, to the face. It can also be useful in graphically separating the subject's face from a bright background.

Outdoors, you may sometimes need a very large black reflector. For example, you may be shooting someone full-length on a beach, where there are bright surfaces on all sides. If you want to create a shadow effect on one side, place a large black reflector—maybe six feet tall—on the appropriate side of the subject, and as close to the subject as you can without actually including it in the picture area.

THE WONDERFUL QUALITY
OF WINDOW LIGHT

I love window light—daylight entering a room through a window—for people photography. It is a soft, yet directional, light that can be most flattering to men and women alike. To simulate its effect in the studio, I have a large light bank, capable of containing as many as six flash heads.

The advantage of simulated window light over its natural counterpart is that electronic flash, used in a light bank, produces far more light, making possible greater depth of field with slow-speed films. Flash also has the great advantage of producing light of constant output and color.

The best "real" window light, in the northern hemisphere where we happen to live, comes through windows facing north. That's because you don't want direct sunlight coming through the

window. The light entering the room should be soft and uniform.

You can control the softness of window light by the size of window you select and by how far from the window you place your subject. The rule mentioned earlier applies: The larger the light source—in this case the window—in relationship to the subject, the softer the illumination. Remember, however, that the light will fall off noticeably as you bring the subject farther from the window. This has to be a major consideration where exposure times are concerned.

Because window light is skylight without direct sun, it tends to be bluish. You may need to use a warming filter—perhaps one in the 81-series of amber light balancing filters.

Generally, you'll also need fill lighting. The most suitable way of providing it is either by using white reflectors or using a white wall or door that may happen to be close to the subject.

THERE'S NO SUCH THING
AS "BAD" WEATHER

In photography, there's no such thing as truly "bad" weather. Unless you're shooting an assignment that specifically calls for bright sunlight, distinct shadows, and so on, you can get very exciting images in all kinds of weather conditions.

Shoot in mist and fog, to get a clear image of a nearby subject against a misty, soft, light-gray background. Use a lens of relatively short focal length and get close to your main subject to ensure a crisp image of sufficient contrast, against a hazy background.

Shoot just after a heavy rain, when the sun has come out again but the ground and the roofs of buildings are still wet and shiny. This condition, too, is so popular that it is often simulated by hosing down the foreground of a scene or set. The reflections caused can be a great compositional aid.

Shooting in most "bad" weather conditions has one added advantage. It usually narrows the brightness range of the subject or scene, thereby giving more exposure latitude and a greater

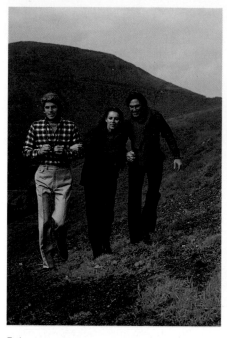

5-A

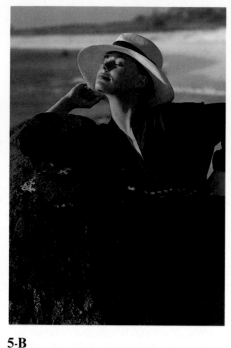

5-B

5-C

tolerance for exposure error.

FILTERS OUTDOORS

I rarely use filters, even outdoors. The main purpose for filters in people photography is to ensure adequate warmth in skin tones. You want to avoid bluish skin. Skin tones that reproduce a little on the reddish side are far more acceptable. The color slide film I use for most of my work has an inherent warm quality, making filtration all but unnecessary.

The only filter I use with any regularity is a Wratten 1A skylight filter. It is pale pink, absorbs ultraviolet from open shade under a blue sky or from a cloud overcast, and warms up an image noticeably. A face that would otherwise appear lifeless and bluish takes on a healthy glow.

Other filters you may want to use to warm an image include weak yellow or red color compensating (CC) filters and filters in the amber 81-series of light balancing filters.

If you want to create a misty or foggy scene where those conditions do not exist at the time of shooting, you may want to use a diffusion filter or a fog

filter. At the other extreme, if you want to increase color saturation in a scene, try a polarizing filter. As I've said, my personal preference is to use no filters except the warming A1 skylight filter.

THE PHOTOS
IN THIS CHAPTER

The observant photographer can usually find locations suitable for many different purposes not far from his home. The photo of the trio walking in the hills (Photo 5-A) was made just to the north of San Francisco's Golden Gate bridge. However, the scene might just as convincingly be in Ireland or Scotland. The location is appropriate for the clothing featured in this fashion shot.

Although the sky was overcast, the sun's disc was clearly visible. The result was soft but directional light— often the best of all outdoor conditions. You can see distinct, yet soft, shadows. The lighting, and its direction, flatter the models and the garments. I used my 1A skylight filter to warm the inherently bluish scene slightly.

Exposure under low-contrast conditions, such as existed here, is no

problem. The exposure latitude is wide, so there's ample room for miscalculations in exposure. An in-camera-meter reading is adequate. However, to be sure of getting the best possible image, it's always wise to shoot a little extra film and bracket exposures.

Incidentally, although the three models in this photo are walking on sloping ground, I took care to ensure that their relative heights did not compensate in such a way that all heads ended up level with each other. It's always better, compositionally, to have heads at different levels.

The dramatic shot of Margaux Hemingway (Photo 5-B) was made about noon in Aruba, Netherlands Antilles. I successfully broke the basic rule to not shoot people pictures in mid-day sunlight by having the subject turn her head toward the sun. As you can see, the facial modeling is very appealing.

The light was hard and directional, but the reflective surfaces of beach and water lightened the shadows. The brim of the hat also served as a reflector.

The small-source illumination from

34

5-D

direct sunlight created a dramatic effect somewhat similar to that found in stage spotlighting.

For obvious reasons, Margaux and I agreed that she should close her eyes. Hardly a "normal" situation in people photography, but it was highly appropriate for this shot. The closed eyes emphasize the sensuous and comforting feeling of being bathed in warm sunlight.

In the shot of the boy with the skateboard (Photo 5-C), I used the sun as hair light and rim light. The sun was high in the sky and behind the boy. The frontal main light consisted of sunlight reflected from a silvered reflector. It constituted very simple and effective lighting, highly suitable for making attractive people pictures at midday, when the sun is high in the sky.

Incidentally, to find the right young model for this Munsingwear children's clothing ad, we looked at about 200 kids. The boy we finally selected had a real Huckleberry Finn look, as you can see. He seemed very relaxed in the jungle gym setting, leaning on the skateboard.

Although the purpose of this shot was an ad, any parents would be proud to possess such a portrait of their son for their home.

The photo of the young man with the little boy (Photo 5-D) was made indoors, by multiple window lighting. The shot was made early in the morning, under a hazy sky, in Sausalito, California. The purpose of the shot was an ad for Gant shirts.

A large window to the left of the camera position provided the main light. The window visible behind the subjects, in front of the stairs, provided rim lighting on hair and shoulders. A third window, behind the camera, gave fill lighting to lighten shadows. To get additional, needed fill lighting, I placed a large white reflector to the right side of the camera position.

As is typical of most "natural light" situations, I couldn't move the light sources, so had to place my models in the most desirable positions.

CONCLUSION

Daylight can be elusive indeed. Constantly changing in character, color, intensity and mood. Sometimes it is totally ideal for shooting, at other times quite useless. It's a continuous and stimulating challenge.

When I had first moved to California from the East Coast, I loved my new environment and its beautiful climate. Soon after my arrival, a New York client called, booking me for a two-week shoot in the Virgin Islands for Virgin Islands Rum. I suggested, instead, that the client change the shooting location to Los Angeles, stressing that we "had it all" right here, in sunny Southern California.

I found an ideal location in Pacific Palisades and awaited the arrival of my client from New York. The selected location was on the beach but required climbing down a steep cliff to get there.

On our arrival, the light was perfect, but before I could begin to shoot a fog suddenly rolled in. I tried to shoot with flash, but with what I sensed would be less than spectacular results.

With the daylight waning, we packed our belongings and struggled back up the cliff. Jumping in our cars, we drove south. After a drive of a few miles, the sun reappeared. We ran from our cars, onto the beach. The sun was shining beautifully—but it was getting late. There wouldn't be much shooting time left that day.

We worked fast. The entire shoot took less than five minutes—and I got beautiful images!

Such is the unpredictability of daylight photography. However, with a sound knowledge of photo technique, plenty of dedication, patience, and a little help from Mother Nature, daylight can often yield successful and unique images.

KEEP
IT
SIMPLE

C lean graphic design dictates the elimination of the superfluous. Keep out what's not needed or what distracts. Keep to the point. Of course, here, as elsewhere in creative endeavors, there are exceptions to the rule. However, the basic tenet that "less is more" applies.

Early in my career, I experimented with excessive styling and special effects. However, I always returned to a clean, simple and straightforward form of photography. Being a photographer of people, my main concern, and the essence of my work, is generally to have my subjects create a strong impact on the viewers of my images. Anything that interferes with that impact, or weakens it, is superfluous and remains out of my photographs.

AVOID CLUTTER

Those who are familiar with the art and science of sound recording know the term *signal-to-noise ratio*. It relates the useful sound signal with the background interference, or unwanted noise, which reduces the clarity and quality of the useful sound. The higher the ratio, the better the sound quality.

In the visual arts, including photography, you must watch out for *visual* signal-to-noise ratio. I don't mean the kind of interference with the clarity of a photographic image that's caused by physical phenomena such as film grain, lens flare or poor lens quality. In the context under discussion, I mean the useful-image/visual-clutter ratio. Clutter must never be permitted to weaken the main content of an image.

Subject Determines Image Impact—As a general rule, I aim for a clean, uncluttered image in which the main subject—the person or persons featured— are dominant. The more appealing and exciting the subject, the easier it is to achieve this goal. A "strong" subject, when photographed with proper technique and sensitivity, will automatically grip the viewer's attention. The background can be very simple or, for that matter, quite complex.

The less appealing your subject, by popular "commercial" standards or mass acceptance, the more significant is the role of background elements, special

effects and styling. In such a case, it's wise to avoid totally plain backgrounds and bring other elements into the picture, to lessen the viewer's scrutiny of the subject. More lavish background, props and styling, and sometimes more elaborate lighting technique, help to prevent a viewer from giving excessively close scrutiny to the main subject. At the same time, however, a more complex image helps to keep a viewer's attention within the picture.

DETERMINE VISUAL PRIORITIES

How a picture is to be shot must be determined to a large extent according to the intended purpose of the photo. For example, if you photograph a person for a private portrait session, the face is more often than not the prominent factor of the image. If you shoot the same person for a fashion ad, the clothing must be the dominant image component. Pose, lighting and composition would then need to be such that the person takes second or, at most, equal billing to the garments.

Be decisive in establishing your visual priorities and then shoot accordingly. Your photos should make your intentions clear to the viewer—whether your aim is to show off some new fashion styles or to reveal the beauty of a subject's face. Let there be no possible ambiguity which, by confusing the viewer, would destroy the simplicity of your image.

WAYS OF ACHIEVING SIMPLICITY

Occasionally, you'll intentionally want to shoot an image that is far from simple. Some typical examples in my work include group shots that contain a lot of action. The complexity of such images is often intentional and usually planned and choreographed to the last detail. However, when your aim is simplicity—and most of the time this is likely to be the case—you have many tools at your disposal for achieving it.

The way in which you compose, style and light a subject can all determine whether an image will be simple and easy to comprehend or complex and confusing to a viewer. Camera angle, depth of field or a lack of it, and cropping—whether in camera or at a later stage—all play an effective part in the creative process of making direct, unambiguous and uncomplicated photographic images.

Outdoors—A studio offers you virtually total control of your environment. You can include in your pictures what you want and exclude elements you find undesirable. Outdoors, on location, it isn't always that easy.

When shooting people outdoors, choose locations with natural, functional props. Use benches, fences, doorways, fountains and rocks as posing props. Don't introduce props that don't look natural and believable in your chosen location. Also, avoid structures that appear excessively "busy."

If you can't avoid distracting, undesirable elements within the view of your camera by simply changing the general viewpoint, find other ways of eliminating or minimizing them.

For example, suppose you're shooting two beautiful models in swim suits on a beach, aiming your camera in the direction that gives the best background view and most advantageous lighting. In the middle distance, you see a couple of small children building a sand castle. You can't simply ask them to quit and go away. You have several options.

You can use selective focus to obtain depth of field that is so limited as to make the children almost unnoticeable. Or, by adopting a lower viewpoint, you may be able to hide the children behind a small dune or other raised part of the beach. Another alternative is to conceal the children behind some foreground object—or even behind the models themselves.

THE IMPACT OF EYE CONTACT

The single purpose for simplicity in photography is to direct viewer attention to the main subject. When your subjects happen to be people, there's no more effective way to capture and retain that attention than by eye contact from subject to viewer. Naturally, to achieve this the subject has to look at the camera when the photo is made.

In recent years, it has become fashionable for subjects to look anywhere but at the camera. That's fine in fashion photography where, as I explained earlier, the prime purpose is to direct viewer attention at the featured garments. However, in portraiture, the main feature in the picture is the person being depicted.

I love eye contact, as you'll readily see when studying my photographs. The eyes never lie. Because I'm able to establish a good rapport with my subjects, I enjoy depicting that relationship graphically for the viewers of my images. Furthermore—just as in real life—a viewer learns most about the character of a subject when there is direct eye contact.

Besides the above reasons, however, I love eye contact in photos because it introduces the simplicity that concentrates a viewer's attention immediately on the theme of the image—the person depicted.

CONTRAST AND BRIGHT AREAS ATTRACT ATTENTION

Two graphic conditions help to draw viewer attention to the part of an image where you want it. One of them is contrast. A contrasty area will nearly always draw attention more readily than an area with less decisive tonal differences. The second condition is related to contrast, but isn't quite the same thing: Viewer attention tends to be drawn to brighter areas within a darker general background.

You can bring these conditions into play by the way you position the subject, by the background and foreground you choose, and by appropriate lighting.

6-A

BACKGROUND CONTROL

As I indicated in *Secret 4,* I like backgrounds that are compositionally strong. I tend to use backgrounds that are either uniform in tone or have decisive, dynamic shadows and patterns. The wishy-washy in between background that is almost uniform but not quite, having weak, barely discernible shadows or patterns, is not for me.

The exact background you select must depend on the nature of the subject and the effect you want to achieve. The aim, again, is to concentrate viewer attention where you want it—generally on the person or fashion featured. By concentrating attention in this way, you make viewing of the image easy and unambiguous. In other words, as the secret discussed in this chapter suggests, you "keep it simple."

Uniform Background—Because a totally uniform background lacks shadows, patterns and dimensional depth—whether apparent or real—it concentrates total viewer attention on the subject. It takes a beautiful face, strong character or otherwise interesting subject to stand such concentrated scrutiny. A more mundane subject is generally best photographed against a graphically more interesting background.

A background of medium tone flatters a face best. Against white, a face tends to look dark. A very dark background, on the other hand, tends to make a face appear pale. I discuss the effect of background colors on a subject in the next section.

Rich Background—A background that is varied in tone, pattern and content can be useful in conveying a variety of moods. Once you introduce a variety of elements into the background, it adopts its own character, becoming more of a back *scene* rather than a mere back *ground.* Through the choice of background, you can, for example, convey wealth and luxury.

By the use of shadows and patterns, you can convey the illusion of three dimensions on a flat backdrop. Or, you can use a background that is really

three-dimensional. By appropriate lighting, you can enhance the effect of depth.

Background Must Be Appropriate—To keep an image harmonious and unconfusing—in other words, *simple*—be sure its content is appropriate for the subject depicted. For example, don't portray a woman wearing expensive clothing and jewelry against a background consisting of a metal garage door—unless you're shooting a fashion series in which you deliberately want to use an eye-catching shock effect. Similarly, don't feature a rugged man, in typical outdoor clothing, in front of a delicate, lacy backdrop.

Highly Reflective Backgrounds—I love highly reflective and flexible backgrounds. Suitable mylar and aluminum materials are inexpensive and readily available. By changing the shape of such materials and lighting them in different ways, you can achieve an infinite variety of exciting background effects. However, you must watch out for unwanted specular reflections toward the camera lens.

Lens Choice and Background—On location, I often like to shoot with a long lens, such as a 300mm. It enables me to get a soft, out-of-focus background that does not distract viewer attention from the main subject but still establishes the character of the location. The long lens, together with the accordingly greater camera-to-subject distance, also makes the background appear larger in relationship to the subject—an effect that is sometimes desirable.

HOW TO USE COLOR

Unless a special need dictates otherwise, I suggest you keep the colors and their coordination in your photos simple and harmonious. Generally, I avoid lively patterns and "loud" colors unless I'm photographing a subject for whom such treatment is appropriate—such as a lumberjack in plaid shirt, against a rustic background.

If you are assigned to shoot clothing that contains several bright and contrasting colors as well as, perhaps, some wild patterns, keep the remainder of the image as free from excessive colors, color discords and distracting patterns as possible.

When you are free to select the colors you want, choose colors that flatter your subject. This applies to colors in wardrobe and background, as well as props. Be particularly careful with people of pale complexion. Don't use a black background, which would emphasize the pallor of the subject. Also, avoid red or other warm colors because they would only serve to emphasize the lack of warmth in the skin tones. Light skin tones lend themselves well to high-key treatment. Use white, or pastel shades of color, in background and clothing.

A dark, well-tanned face, or one with healthy, warm skin tones, can stand backgrounds of greater variety, including red ones.

THE PHOTOS IN THIS CHAPTER

I had been assigned to photograph Jackée Harry, a truly sparkling actress, for a fashion layout in *Black Elegance* magazine. Each of a series of pictures showed Jackée in a different outfit. All photos except one showed a man's arm extending into the picture, offering Jackée a different gift. The final image (Photo 6-A) shows her holding the gifts she received.

The key to graphic continuity throughout the series was the simple background. We constructed a wall of wooden slats, painted it white and hung it in the studio. The background is deliberately non specific, showing no particular location but bringing to mind, in a general way, a warm weather location. The location might be a beach house, a whitewashed fence, or even the siding of an old ship.

The clean, horizontal lines provided the magazine's art director an ideal way for adding copy. The brightness of the wall not only provided a summery look but also made the colorful subject stand out dramatically in each of the images in the series.

I had been asked to photograph Alex Acuna, celebrated drummer (Photo 6-B), for two purposes: for an ad for Yamaha drums and for a poster.

The music room at Acuna's home was full of the charming clutter you would expect to find in an artist's work area. The ceiling was only about seven feet high. To give me the space I needed, I decided to shoot outdoors, in Acuna's driveway.

I needed a plain background to graphically separate and emphasize the drummer and his instrument. I had brought with me a nine-foot wide roll of seamless background paper and a couple of stands to support it. (Remember *Secret 3: Be Prepared!*)

The sun was high, behind Acuna. It's light skimmed over the top of the seamless background, highlighting the drummers' hair. The main light, an electronic flash, was in front, near the camera position. I based my exposure on the flash.

To get some action into the image, I set the camera shutter to the relatively slow speed of 1/30 second. There was sufficient ambient light to blur the moving drumstick and hand slightly.

The final shot was perfect for both of its intended purposes. It might well have been taken in the best-equipped studio, instead of in a driveway. Once again, the key to success was the elimination of unwanted clutter—in other words, in keeping it simple.

Sometimes, I'm asked to shoot a series of photos for a continuing ad campaign. For example, I once shot a series of ads for designer Jean-Paul Germain. The campaign lasted for five years. The continuity of the campaign, entitled *Winners*, was ensured by the fact that each photo depicted an eminently successful personality giving a "thumbs-up" sign.

The image of the young lady with the rope (Photo 6-C) was part of an ongoing campaign, shot each season for designer Christian DeCastelnau. Christian always allows me a tremendous amount of artistic freedom and personal selection. This image featured the white dress.

6-B

6-C

6-D

The rope happened to be lying in my studio. It caught my attention, and I decided it would form a great connecting link for this particular campaign. I shot a series of images, featuring a variety of garments, using the rope in a variety of compositional ways. A simple device, very effective in providing continuity in a series of images.

Only rarely do I shoot people pictures that don't show faces. The shot of the hands and the bouquet (Photo 6-D) is a rare exception. The purpose was to advertise the bracelets, designed by Aldo Cipullo, for Revlon. This image was part of a series, each photo showing only hands. One photo featured hands with a tennis racket, another pouring champagne, a third with a baseball bat, and so on. There was a total of about 50 concepts to advertise the bracelets.

Each image was as simple as the one reproduced here. However, this did not prevent the overall campaign from being very varied. On the contrary, the simple basic concept helped to give the images a readily recognizable continuity.

CONCLUSION

Several years ago, I shot a sensuous photo of Kay Sutton York for the cover of a record album entitled *Body Shine*. Kay's outfit consisted of a simple piece of fabric, taped and tied to her for a very specific effect. It was an outfit that was inexpensive and modest in the extreme. Yet, the way Kay styled the fabric, and the way it was depicted photographically, was so effective that we subsequently got literally hundreds of letters asking "where that wonderful outfit" could be purchased. It was an excellent example of succeeding by keeping it simple!

DEFINE THE PURPOSE OF THE SESSION

When you take photographs for your own pleasure, the purpose of photography is, essentially, just that—your own pleasure. However, once you begin to take photos to suit someone else's needs and requirements—whether you do it professionally or as an amateur—you have to be aware of the precise purpose of the session before you start.

The purpose of a session in my photography is almost always specified by a client. The client may be the person in front of my camera, as is often the case in a private portrait session or when I'm photographing a celebrity. Or, the subject before my camera may be a professional model, hired by a client to dramatize a product or service.

Often, I do not deal with the client directly but rather with an art director, usually employed by an independent advertising agency. No matter whom I deal with, before I begin shooting I must have a clear picture in my mind of the purpose of the photographs I am to make.

Once I accept an assignment, my personal purpose is, first and foremost, to satisfy my client. If I do not totally agree with my client's esthetic approach, I must attempt to satisfy his needs while, at the same time, infusing my own esthetic sense into the session—but in a manner that will be acceptable to the client.

Often, client, art director and I will have several different concepts on how the assignment should be shot. We'll discuss these and reach a consensus. When time permits, I'll shoot it several different ways.

HOW THE PURPOSE IS EXPRESSED

In a commercial shoot, there are often multiple purposes. For example, I am

instructed by my client or art director what response or emotion the image is to evoke in the viewer, and also how the image is to be composed in order to fit a predetermined layout.

In a private portrait session, it isn't enough to know that I'm expected to take a portrait. In order to provide the kind of portrait the client wants, I must know where the picture is to hang or be published; what its *purpose* is to be. A sensuous portrait for a bedroom wall will be very different from an executive portrait that's to hang in a board room. A portrait of an actor or actress taken for publicity and promotional purposes may be quite different from one taken for the celebrity's family.

Elicit Emotion, Don't Order It— The purpose of a photo need not always be to portray beauty. A perceptive photographer records more than just faces—he portrays emotion. Many varied emotions, including sadness, pensiveness, sultriness and even defiance, can be the raw material for fine portraits. The art of good directing is, of course, to elicit the desired emotion from the subject.

It's no use saying simply, "Look sad," or "Be defiant." That would lead to a phony, artificial expression in the photo. You must use your skills as director and your ability to draw on your subject's acting ability, such as it may be, to get the image that satisfies the purpose of the shoot. When all is said and done, achieving the desired attitudes and expressions from your subjects lies in your ability to communicate and in the rapport that is established as a consequence of that communication.

COMMERCIAL AND PORTRAITURE ASSIGNMENTS

The basic difference between the purpose behind commercial people photography and personal portraiture is best expressed like this: The essential purpose in commercial photography is to sell a *product;* in portraiture, the essential purpose is to sell—or satisfy—the *subject.*

Commercial Session—Defining the purpose of a commercial session is usually more precise than determining the manner in which a portrait session should be shot. The needs of an advertising or fashion client tend to be very specific. What is to be shown, and how it is to be depicted, is pretty well predetermined. The layout is often specified—either exactly or with little scope for variations.

It's interesting to note that, until approximately 10 years ago, advertising fashion photography in the United States was much more rigid and precise than its European counterpart. While photographers in France, Italy, Germany, Australia, South America and Great Britain had been able to approach their advertising fashion work with a loose style approximating that of the photojournalist, American photographers were expected to use a much more clinical approach, concentrating on precision of detail, sharpness and pose.

Such stringency gave birth to the phrase *catalog look.* To my delight, the apparently spontaneous and candid style of the Europeans has finally become a keynote of American commercial fashion photography as well.

Personal Portraiture—When you take a personal portrait, your first aim is usually to satisfy the person before your camera. However, you must remember that the subject wants your photos to satisfy two needs—to please the subject himself or herself, and to please other viewers of the portrait.

Therefore, you must establish what the ultimate use of the photograph is to be. Does the subject plan to present the portrait to her father, to her boyfriend, or to have it used to publicize a theatrical production in which she is appearing? Does the subject intend the photo for his wife, his sports club newsletter, or the walls of the board room of his company?

NEVER ASSUME WHAT A CLIENT WILL LIKE

Never guess what a subject may expect from, or like in, his or her portrait. People do not see themselves the way others see them. This causes a subject's preferences to be somewhat enigmatic—even to a seasoned people photographer. For this reason, I like to shoot as much variety as possible.

I encourage my private portrait subjects to bring several outfits to the shooting session. In addition to shooting them in different clothing, I vary lighting, background, composition and a subject's position as the shoot progresses. In addition, subject hairstyling and makeup may be changed as many as three or four times during a session.

To get as much variety as possible without getting the subject bored or tired, work fast. This is where technical competence and skill are invaluable. Be decisive—know what you're after. No matter how rapidly you shoot, each exposure should be made decisively and purposefully. There's a lot of difference between shooting with a motor drive, simply allowing exposures to follow one another as rapidly as possible, and shooting fast but *selectively.*

MEN AND WOMEN REQUIRE DIFFERENT APPROACHES

Where style, fashion and appearance are concerned, women are generally more aware than men. Women look more critically at photos, and probably also look at more photos, than men. They study clothes, styles, settings and personal expressions. They are more aware of current trends.

It isn't unusual for a woman to bring to a session a selection of tear sheets from magazines, to show a photographer how they want to be shot. A man generally doesn't know exactly what he wants—he just knows that he needs a portrait.

I keep in my studio a permanent display of a sampling of my photographs. While both men and women notice them and comment on them, women usually relate more personally to what they see. They will often point to one image or another, and tell me that this

is the way they see themselves—and the way they would like to be depicted.

The different characteristics I've just described mean that, while you can simply *tell* a man what you intend to do, once the direction of the session has been established, with a woman you often need a mutual *discussion* of what, between you, you plan to do.

THE RUGGED AND
THE ROMANTIC CONCEPTS

There are basic esthetic and pictorial differences between photographing men and women. With men, I tend to emphasize those features and elements that give masculinity and strength to an image. For example, I may employ hard, contrasty lighting, brushing it across the subject's face to produce extreme texture and the appearance of ruggedness. With most women, I go to the opposite extreme, wanting them to appear ethereal, soft and "untouchable" in their images. I want them to appear so desirable as to generate the impression that it would be difficult to ever meet such a magnificent creature again. This romantic concept has permeated my photography for the past 20 years—and I don't foresee it changing in the future.

COMMUNICATING
WITH CHILDREN

With young children, it may not be possible to convey the purpose of the shoot in words. It's no use explaining to a six-year-old the exact purpose of an ad and how you plan to get the message across to the viewer.

You must find other ways to motivate children into the appropriate attitude—often relating to them in a childlike manner. Do what you need to do, to gain their confidence and to elicit the expression and attitude you need for your picture. Because they do not necessarily understand the purpose of the shoot, you must give them a purpose they do understand, and one that will result in an image that's appropriate for the purpose of the shoot.

When I have children in a group, I have to devote much of my energy to them. I direct and instruct the adults as to the role I want them to play and then largely depend on their doing so. Because I must devote so much attention to a child, or children, in a scene, I'm adamant that the adults in the photograph are primarily responsible for maintaining their own attitudes.

A child can't hold a pose as long as an adult, doesn't have as long an attention span as an adult, and can't emote as readily as an adult. Therefore, the children need most of my attention. And they need one more thing, if a session is to be a success—they need me to work fast!

ENVIRONMENTAL AND
ACTION PICTURES

The purpose of a photo often demands more than simply depicting the subject. Sometimes it's necessary to include a typical environment associated with the subject. At other times, you must show the subject engaged in an activity for which he or she is known.

Including the Environment—Environmental portraiture offers an additional challenge. Instead of having to deal simply with a subject and a "neutral" background, you have two distinct image elements—subject and environment. You must determine exposure for each, control the color balance for each, and achieve a degree of sharpness—or unsharpness—in the background that's appropriate to the pictorial effect you want.

You can also control the perspective relationship between subject and environment by the placement of subject and camera, in relationship to the background scene, and by an accordingly appropriate lens choice.

Environmental photography dictates the inclusion of background and surrounding elements which give credibility to the subject. Such attempts may be as simple as including part of a piano when photographing a pianist or the inclusion of an entire 12-foot sculpture when photographing its creator.

Including Action—If you're going to photograph a violinist, he might be holding his instrument or, better still, he might be playing it. If you're asked to photograph an aerobics expert, you're likely to get the best images by shooting the actual activity.

It is important to frame and light the scene in such a way that the subject can pursue his activity without leaving the predetermined image area and without moving into unfavorable illumination. Instruct your subject how much scope for movement he has. Then light the area containing that movement in a manner that provides uniformly good lighting, no matter what the subject's movements are. This is, basically, similar to lighting a scene—or set—for the motion-picture camera.

I try to shoot fast but selectively, tripping the shutter when I see an attractive picture. However, if the action is relatively fast, I may also shoot a rapid sequence with a motor-driven camera, selecting the best images when the film is returned to me from the processing lab.

THE VALUE OF OUTTAKES

As I indicated early in this chapter, the prime purpose of my photography is always to satisfy my client's needs. In doing this, I like to provide not only the *required* photo or photos, but a good *selection* of photos. I like to provide *variety*. Producing that variety serves another purpose: It gives me a selection of extra photos, or "outtakes," that I may be able to market for other purposes, at some future time. I may be able to sell such pictures to magazine or book publishers, or to a variety of other possible markets.

Using such outtakes is a delicate matter, requiring diplomacy, good judgment and—not least—permission for usage. I would never dream of using an outtake for a purpose that may in any way be regarded as in direct competition with the purposes of the client for whom the shot was made. Also, I would always be sure to have a signed release from the client or subject to use

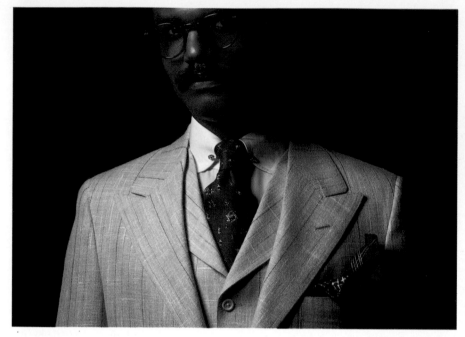

7-A

7-B

the photo for other purposes than the one for which it was commissioned.

RETOUCHING AND ITS PURPOSE

The purpose of retouching photographs is largely misunderstood. To clarify the purpose, it might be useful to start by saying what retouching is *not.* Retouching does not serve to cover up the deficiencies of an unskilled photographer or an unattractive subject.

A still photograph, unlike a motion picture, is a *static* representation of a person's character. When you see people *live,* or in a film, you look into their eyes and deal with their *personalities,* not their *pores!* Your perception of the individual is governed by movement, combined with a variety of attitudes. Minute details tend to go unnoticed because of the animation of the subject.

Were an *individual frame* of a motion picture printed, the result would often be totally unacceptable as a *still* photograph.

Good retouching in a still photograph can help refocus our attention on the mood and overall look of the subject by eliminating those minute elements that would go unnoticed in life or in a motion picture film. Good retouching simplifies the *language* of the photograph, so the viewer isn't distracted by irrelevant detail.

Don't Overdo It— A good retoucher spends as much thought on what *not* to retouch as on what to change or subdue. Not all so-called flaws need to be removed. A well retouched photo which still contains some imperfections will look like an unretouched photo—and that's the ideal to strive for. You need to be selective in what you remove. For example, on a man, a spot may be an undesirable flaw while a scar may indicate character and masculinity. Take out the spot and leave the scar—subduing it a little, if necessary.

In a photo of a man and a woman, it can be very effective to do some retouching on the woman's face and

leave the character lines and wrinkles on the man's face untouched. This will create the illusion that the photo is, in fact, unretouched.

The basic purpose of retouching is to *enhance* character and appearance, and not to *change* them. Don't attempt to make a 65-year-old grandmother appear like a 20-year-old, no matter how attractive she may be. Make her look good at her age. She'll be much more appealing as an attractive, vivacious 65-year-old than an obviously phony 20-year-old.

Think About Retouching at Time of Shoot— There's a close interrelationship between your photographic technique and subsequent retouching. You should consider what retouching might be needed, even at the time you're shooting. Consider what "retouching" you might be able to accomplish by lighting, soft focus, makeup, or subject position and attitude. If "real" retouching should still be necessary, photograph the subject in such a way as to make the retoucher's job as easy and

44

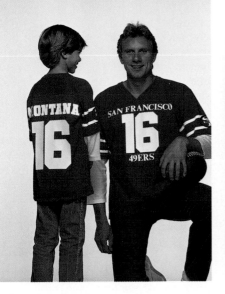

7-C

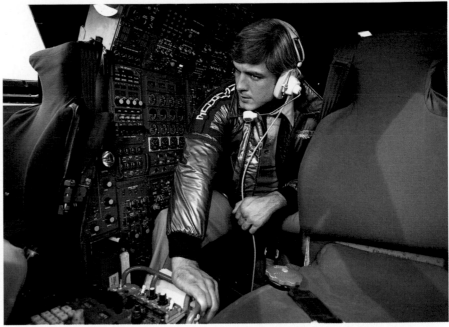

7-D

minimal as possible.

THE PHOTOS
IN THIS CHAPTER

When the purpose of a photo is to feature fashion, the model wearing the clothing must usually play a secondary role. Professional model Renauld White does an excellent job in bringing a mood and intensity to the image (Photo 7-A) without "stealing the show."

As photographer, I had to play my part to effectively direct viewer attention to the fashion rather than the man. By selecting a black model, placing him before a dark background, and deliberately avoiding rim lighting, a viewer's eyes are automatically directed to the illuminated, light-colored suit. I deliberately cropped the image tight at the top, to further minimize the impact of the model.

Incidentally, the "glasses" worn by the model were, in fact, frames without lenses. Using this tactic gives a photographer more freedom with his lighting

and model position, without having to worry about unwanted reflections from glasses. A good stylist can provide frames of various kinds, to suit all kinds of faces and purposes.

Prior to a portrait session with a subject who wears glasses, I ask the subject to visit his optometrist and borrow a pair of frames of the same style as his own—but without lenses.

I had been assigned to feature the studding, or beading, on the shoulder and sleeve of a garment (Photo 7-B). In this case, because the close-up view of the beading alone was somewhat abstract and relatively meaningless, I chose to feature prominently the model wearing the garment. I selected a model with a strong, appealing face and asked her to look at the camera.

The key components of the composition were the beading and the model's eyes—so I had to be sure to record both in sharp detail. To make the image even more eye-catching, I chose to go for a somewhat unconventional pose.

The background was actually the

white cove in my studio. Because the model was about 10 feet from the cove, the only light source I used was much brighter on the subject than on the background. This caused the extremely underexposed—or dark—background in the photo.

I photographed Joe Montana, of the San Francisco 49ers (Photo 7-C), to feature a football jersey for an Avon ad. To feature the jersey in full detail, the art director wanted to show front and back. To do this, I required a second model, wearing a second jersey.

We chose a young boy because his presence created a believable and wonderful human interest story. Commercially, using the young boy also enabled us to show that the jerseys come in sizes for adults and children.

Although the young boy helped feature the garment, it was Joe Montana who was endorsing the product for Avon. For this reason, I had the boy look at Montana, and asked Montana to establish eye contact with the camera.

I couldn't think of a more appropriate setting for photographing a Concorde flight jacket than on a Concorde jet liner (Photo 7-D). I got permission to photograph on the celebrated aircraft during a scheduled landing at Washington, D.C. I was given one hour for my photography.

To get adequate lighting in the model, the jacket and the aircraft's control panel, I used flash. However, I also wanted to register the ambient light. By using a slow shutter speed—1/15 second—I was able to retain the highlights and shadows of daylight in the seats and to record the red lights in the control panel.

Each of the four photos reproduced here was made for a specific purpose. To produce effective images, you must define the purpose of the photography and then find steps to satisfy that purpose. By all means shoot lots of pictures, with a lot of variety—but never forget what, specifically, you're trying to achieve at each shoot.

CONCLUSION

Photographers, like everyone else, don't always find themselves in a perfect world. We may know very well what the purpose of our photography is, and how to achieve it. However, certain things—like time and expense—can work against us. A good photographer should aim for perfection while, at the same time, realizing that compromises may be called for.

If I'm only able to spend a limited amount of time in a shooting location—such as on the Concorde—I'll do what I can in that time. If I have to shoot outdoors in New York in December, instead of being able to fly to the Bahamas, I'll do the best I can with what I've got.

I was assigned to do a shooting session once, involving two celebrities in the entertainment world as my subjects, as well as four art directors. At pre-shoot meetings, it became evident that each had a different view of how the session should be handled—and I had my own views. To satisfy everyone, I would have needed four days of shooting time.

The reality of the situation was that the celebrities were able to give us no more than two hours for photography. We all knew what the *purpose* of the shoot was. What was equally important, we all were aware of our *limitations*. As photographer, I didn't allow the limitations to prevent me from achieving my purpose. No excuses; just good, appropriate photography to satisfy the needs of each client. That's one of the hallmarks of a dedicated, professional photographer.

TAILOR YOUR TECHNIQUE TO THE SUBJECT

The purpose of *Secret 1* in this book was to make you aware that everyone is, indeed, unique. In *Secret 7,* I told you that the success of a shooting session depends largely on your defining the purpose of the session first. Another important lesson, and one that follows logically from the two just mentioned, is that you must tailor your photographic technique to suit each subject.

In this context, the word *technique* refers more to the esthetic side of your photography than the *technical* aspects of lighting, exposure, color control, and so on. The technique you must tailor to your subject includes such considerations as subject position, composition, the use of appropriate wardrobe and background, as well as a resort to more abstract features, such as humor, in your photography, when appropriate.

SUBJECT POSITION AND CAMERA ANGLE

The way a viewer sees a subject depends on two basic geometric considerations: the way the subject is facing, and the camera's viewpoint. The way a viewer *should* see the subject to best effect can depend on various factors.

Subject Distance—A pose and camera viewpoint that look good from one distance won't necessarily yield a flattering image from another distance. Here's a good example to illustrate what I mean. You can photograph a close view of a person—a head and shoulders shot—from a fairly high angle. You need not show the subject's neck. However, if you were to move back and up, to get a full-length view from basically the same viewpoint, the "missing" neck might become a visual problem. In most cases, the subject would look unpleasantly "neckless."

To get an acceptable picture, you might have to change the subject's pose, the

camera angle, or both, in order to show the subject's neck.

Subject's Features—To bring out the best in a face, try to maximize the most flattering features and subdue those features that are the least attractive. As has been indicated earlier in this book, this can be achieved largely by appropriate lighting. However, the position of the camera relative to the face can also play a major part.

For example, a frontal view of a subject with closely set eyes is likely to emphasize that particular feature. A profile will, obviously, eliminate the problem. By adopting an extreme three-quarter view, in which the far eye is centered between the far edge of the face and the bridge of the nose, this characteristic in a subject is minimized. Of course, *geometrically* the three-quarter view brings the eyes even closer together. However, the new *perspective* makes it more difficult to immediately detect the relative positions of the eyes.

By employing a three-quarter or two-thirds facial view, as just described, you can minimize the graphic effect of a nose which is not quite symmetrical. You can use the same technique with a subject who has unevenly placed eyes or who has one eye apparently larger than the other.

If you want to minimize the effect of a prominent nose, avoid profile shots and try shooting from a relatively low camera angle. Use a short telephoto lens. These measures help you to graphically foreshorten the nose. By selecting a main-light position that is on axis with the center of the subject's face, you further reduce the apparent size of the nose by eliminating long shadows below and to the side of the nose. However, your initial question must be, "Do I, in this particular case, *want to* minimize the impact of the nose?"

Before you shoot, you must know what you're trying to achieve in your photography. You don't always want to aim for classic beauty. Often, your aim will be to bring out a specific aspect of the subject's character. In the final analysis, this distinguishes a *classic* portrait from a contemporary, *editorial* photograph.

Jimmy Durante was one of this country's most successful and lovable comedians. His trademark was his very prominent nose. He referred to himself as the "schnoz," and the world knew him as such. Unless a specific pictorial requirement demanded it, it would have been foolish for any photographer to play down, his most famous feature.

While this may be an extreme example, the message is clear: Dramatize those features that are important—be it to emphasize beauty, character, drama, or for any other valid reason.

Expression and Camera Viewpoint—During my many years as photographer, I have studied innumerable expressions and attitudes. The experience has led me to an interesting conclusion: Facial expressions do not exist in a "vacuum"—the *effect* of an expression is often dependent on camera viewpoint as well as, of course, lighting.

An identical expression can have very different effects when viewed from different angles. At the most extreme, a pleasant smile can suddenly become a sneer. While such an extreme change is rare and unlikely, there's a lesson here: When photographing someone, although expression may be the most important thing to watch for and capture, that expression exists within the context of lighting, pose and camera angle. With so many variables, I prefer to do as much as possible of my people photography with a handheld camera. I like to be mobile.

Give Subject Freedom of Movement—I like to be mobile because, basically, I don't like *posing* my subjects unless I absolutely have to. Precision in subject placement certainly becomes necessary when a client instructs me to follow a very specific layout. But even in such a case, I prefer not to *pose* my subject, but rather to *show* him or her the pose I want and then depend on the subject to move naturally into the required position. A *naturally* adopted body position usually looks *best*.

Having explained the purpose of a shot, I ask my subjects to move freely within that context. When I see a position I like, I may ask the subject to "hold that for a few shots," during which time I suggest slight, subtle variations of the pose, bracketing my exposures as I shoot. I never say anything negative to my subject during a shoot but, if necessary, simply ask him or her to "take a break" or to try a different position.

CLOTHING AND BACKGROUND

Tailoring your technique to the subject also means selecting a background that's suitable for the subject. Fabrics that appear soft and feminine, such as chiffon, lace and certain silks, should obviously be avoided when the intent is to depict a strong, masculine subject. There are, of course, exceptions to every rule. A rugged cowboy, for example, may appear quite at home in front of a turn-of-the-century window trimmed with lace curtains. Be selective, and remember the context of the photo, when making decisions as to background and set decor.

Contemporary clothing can usually be worn in a variety of ways, each achieving a different pictorial effect and viewer impression. For example, a busy executive might arrive for his portrait session with but a single outfit consisting of a shirt and tie, well-tailored jacket, neatly pressed slacks, polished shoes, and having neatly styled hair. The look is ideal if the photograph is to hang in his company's board room.

After completing a series of pictures, I'll often suggest a variation on the basic theme. I may have the subject take off his jacket, loosen his tie, roll up the shirt sleeves, and muss the hair. I'll then produce a series of shots depicting a "get-in-the-trenches-and-work" executive, perhaps complete with dangling cigarette.

By manipulating the blend of clothing, background and subject attitude, a wide variety of pictorial effects may be produced with relatively little effort and little change in raw materials used.

TRY THE UNCONVENTIONAL

In creative photography, there are many guidelines and a few rules, but the word "must" is virtually unknown. The only thing you *must* do, is to get the picture you're after—which should, of course, be the same image desired by your client. To achieve the required effect, it may be necessary to break all the rules—even those you've established over many years. If all else fails, however, return to the basics!

Being unconventional can be a risky business. After all, once you remove the "safety net" provided by the rules and principles of the past experience of the experts, you must be extra sure of your foothold. When you decide to free yourself from convention, be sure to do it in the right way, at the right time, for the right reason. The success or failure of your departure from the conventional is always evident in the results.

The rules might tell you that a couple should be photographed close to each other, preferably touching, having eye contact with each other or at least looking in the same direction, and forming a cohesive graphic composition. Yet, you can look at fashion magazines and see very effective images that break all these rules.

For example, you may see a male and female model posing by the Grand Canyon. She may be standing, leaning against a rock, looking at the camera. He is several feet from her, in a crouched position, looking away from her, into the canyon. The image is very eye-catching and effective. If the photographer had wanted to create more "contact" between the couple, he might have had him close enough for her to rest her hand on his shoulder.

Pose and composition depend on what you, the photographer, consider most effective in conveying the mood or message of the situation. Because each situation is different, that choice cannot be spelled out for you. The challenge for you is to find your way across the creative chasm spectacularly and safely—without safety net!

HUMOR CAN BE EFFECTIVE

Graphic humor need not be limited to the cartoon and caricature. It's possible in photography, too. A photograph can be funny for one of two reasons: Either the *concept* is funny or the *subject* is funny.

When the *concept* is funny, you don't necessarily need a funny model. A good example is an illustration that's been used on billboards for years. It's an ad for Coppertone suntan lotion and shows a dog playfully pulling down a small girl's panties, revealing the giveaway demarcation line between tanned and untanned skin. The basis for the success of the picture is a funny concept. The little girl didn't need to be a comedian.

The best funny *subjects* are, of course, comedians. They may yield a humorous photograph by a funny gesture, an unexpected action, or by pulling a funny face.

ACTION IN PHOTOS MUST HAVE CREDIBILITY

Whether you shoot real action or choreograph a situation so it looks action-filled, the end result should be believable. For example, there are two basic ways I photograph a subject who should appear to be walking toward the camera. The first way is to mark start and stop points on the ground—covering a distance of approximately five feet. The subject begins walking toward me and I shoot with a motor-driven camera as the subject approaches.

The second way is to fake a walk toward the camera. This is not simply a matter of asking the subject to pose with one foot forward. That would be too easily detected as a "posed" photograph. Rather, I'll rehearse a single step with the subject, so he rocks back and forth, taking the same step again and again. It's important that the subject's body weight be distributed properly, as if he were actually walking. Regardless of the shooting technique used, the bottom line has to be pictorial believability.

Groups as Compositional Designs— Often, an action photograph is of a group of people. Again, there are two basic approaches: Allow the subjects wide freedom, with some necessary physical and compositional constraints, or choreograph the entire action, much as a movie director would direct a scene. As a rule, I try to keep the subjects close together, unless, of course, a special requirement calls for something else.

When the basic setup and choreography are complete, I shoot quickly—usually using a motor drive or winder—asking the subjects to vary their positions and attitudes slightly between shots.

Remember that model position and physical demands must be tailored to a subject's abilities and limitations. As a rule, comfortable body positions work best. But even if a position is momentarily uncomfortable, it should not *appear* so. Often, a subtle change in lighting or camera angle can make a momentarily uncomfortable pose look natural.

I find that dancers and comedians generally make especially good action models. Both depend on mobility for self-expression and, therefore, tend to be more agile and physically less inhibited than the average person. But during *any* session, I'll always aim for the very best. You would be surprised at the unique theatrical capabilities that lie latent in the average person!

THE PHOTOS IN THIS CHAPTER

Lingerie photographs depict the intimate, vulnerable side of a subject. Whether the context is a private photo session or a commercial shoot, care must be taken to elicit a sensuous mood or feeling without excessively expos-

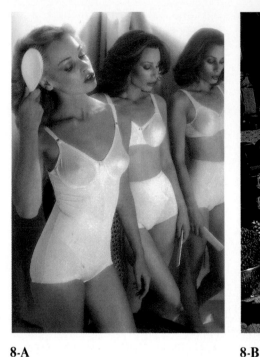

8-A

8-B

8-C

ing the subject. The items featured by these two models (Photo 8-A) were photographed for a catalog for a major department store. The obvious objective was to promote sales. At the same time, I wanted to maintain a feeling of discretion and modesty.

To achieve the desired end, I directed the models into positions that were sensuous but not provocative. To avoid any hint of suggestiveness, I asked the models to avoid eye contact with the camera and, therefore, the viewer. The downward glance of each model adds an extra feeling of innocence and demureness.

I used a mirror to show as much detail as possible in the garments worn by the model on the right. The mirror served a second purpose: It widened the image for a better composition.

This photo is a fine example of how to tailor photographic technique to achieve a result that's suitable for a specific purpose.

The picture of mother and daughter (Photo 8-B) was made to illustrate an

article on quilting and weaving for *Family Circle* magazine. I wanted the largest area of the picture to be occupied by the main subject, the quilting. This was accomplished by using a 35mm wide-angle lens and shooting from a position close to the needlework.

To maintain the human interest provided by the two charming ladies, I made them a secondary point of focus. I did this by dressing them both in white and keeping them close together. By having them both concentrate on the work they were doing, a graphic link was formed between the subjects and the quilting.

I purposely did not use a rim light on the mother to graphically separate her from the dark background. This would have attracted too much attention to the ladies and, accordingly, detracted from the main subject in the foreground.

This is a good example of a photo that has two points of interest, one of which—by virtue of the photographic technique used—is distinctly more

forceful than the other.

For compositional reasons, the distance relationship between people in photographs is often totally unrelated to what's normal in general life. When you see news photographs in newspapers, you'll notice that people who are shaking hands, talking together or presenting awards are standing much closer together than we would normally consider "comfortable." The reason for this is compositional. If people stood at normal distances, there would be enormous gaps between them and the resulting picture would look half empty, unbalanced, and not visually pleasing.

The same principle applies in the photo of the three tennis players (Photo 8-C). They are standing closer together than they probably would in "real life." The result is a good composition with no unpleasant gaps. By careful posing, the photo can be made to appear quite natural and believable.

It's important not to confuse *portrait* photography with *fashion* photogra-

50

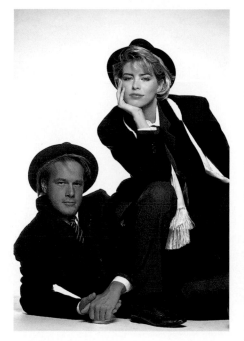

8-D

phy. This is a fashion shot, its main purpose being to feature the tennis clothing. That's why it was permissible to show a semi back view of one model and have a shadow across the chin of another—things that are often less than desirable in portraiture.

Notice the intentional tight crop of this image. Main attention is directed at the player in the middle. The two other models are only partially in the picture. The model on the left serves to feature the vertical stripes on the garments, while the one on the right adds a horizontally striped jersey.

Before I started to shoot, I asked the models to play some tennis. This gave them the slightly perspiring and fatigued look that helped add credibility to the image. I encouraged the models to converse while I shot, and thus captured a variety of different attitudes and expressions.

I used a 105mm lens. Using a short telephoto rather than a standard lens gave me the graphic, two dimensional effect I wanted. In addition, the longer lens helped avoid unpleasant distortion near the edges of the image, where two of the faces are located.

The final picture in this chapter (Photo 8-D) was taken at a seminar I conducted for professional photographers in Washington, D.C. The purpose of the photo was to show the versatility of contemporary people photography. Such an approach is linked closely with a fashion editorial style.

The two models, both from the Washington area, did an excellent job. This is just one image from a series that illustrated to the class the limitless posing possibilities and variations within a single theme.

The nearly full-length framing lent itself to having the heads relatively far apart. Notice that, if the image had been cropped just below the man's chin, the composition would not have worked. The heads would have been too far apart and the image would have been disjointed.

Even in the photo the way it is, I was careful to use a simple graphic composition—using uniformly dark clothing and a plain background—to prevent a viewer's attention from jumping back and forth between the heads.

Notice also that the subjects' attitudes are attuned. Totally different expressions in a photo of a couple generally don't work. There has to be unity and cohesiveness. This is where the photographer's job as director plays an important part.

CONCLUSION

Always attempt to tailor your technique to suit the requirements of the situation, the subject, or the client. This chapter shows several ways in which you can accomplish this. In some cases, the requirements may be very complex. In others, they may involve nothing more than making the image fit a specific format.

Composition and pose are often determined by the way I must frame an image to fill a specified space. For example, when I'm shooting a record album cover, the requirement is usually a square picture. For a billboard, the need is usually for a horizontal, oblong image.

An assignment for Munsingwear active wear depicted celebrated football player Jack Youngblood. Because the shot was to appear on long, horizontal billboards, we asked Jack to lie on the studio set and do situps. I took a shot each time he began to lift his upper torso from the floor, thus maintaining the required horizontal format.

Occasionally, a commercial or private portrait client will ask me to shoot a photograph that I find personally inappropriate or objectionable. Part of a photographer's job is that of problem solver. Therefore, I'll usually suggest variations on a theme, in an attempt to secure an acceptable compromise.

If a compromise can't be reached, I'll refuse the assignment, rather than risk damaging a reputation I've worked so long and hard to establish. In the long run, this works out better for the client as well because a photographer's dedication to a concept is perhaps the most essential factor in a successful session.

DARE
TO
EXPERIMENT

A photographer's pursuit of perfection is a noble cause as long as it is accompanied by the realization that the achievement of perfection always remains beyond our reach. Even if a photographer were occasionally of the opinion that a perfect image had been made, there would still be the verdict of the viewer to consider.

The elusiveness of perfection need not be an inhibiting factor for the creative photographer. Quite the contrary, it can be a tremendous stimulant and challenge. After all, there's always room for refinement and re-evaluation of our technique. In other words, we should always be prepared to try something new—to experiment.

Although my photographs are received with enthusiasm by my clients, there are relatively few images that I am totally satisfied with. It's always possible to see alternate avenues and variations on a theme that could have been taken. The constant challenge remains in the knowledge that things can always be done differently, and often better.

Much of the fun in photography lies in the challenge to improve and enhance that which is already successful. If you're totally satisfied with all the photos you take, you may be selling yourself short by giving yourself nothing further to strive for. Get out of that rut by experimenting.

Every assignment can be photographed with unlimited variation. By all means go on doing the things you have been doing, but also dare to do things differently. Break the rules, even if they are rules you have established yourself. If it looks good, shoot it! That's one basic rule that will put more quality and variety into your photography and add to your enjoyment of the activity as well.

STUDY OTHER PHOTOGRAPHERS

Compare your photographs with the work of top professionals in the field. When studying portraiture, don't limit yourself to the work exhibited in a local portrait studio. Look at current fashion magazines. The world's best contemporary photography is on display each and every month within their pages. Compare

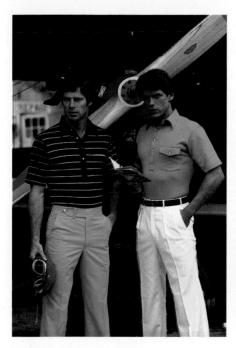

9-A1

9-A2

9-B

the work of contemporary editorial and advertising photographers with the work of portraitists at gallery exhibitions and in books. Each will show you a totally different approach.

Copy the Pros—Don't be afraid to emulate the style of photographers you particularly respect. Believe me, your own individual style will not be compromised in doing so. It's to your advantage to refine your technique to the point that you can easily produce a variety of different looks and effects in your photography. You should remember that, in commercial photography, your job generally involves satisfying the pictorial needs of someone else rather than yourself. You may be asked to shoot a specific subject in one of a wide variety of ways.

Get into the habit of bold photographic experimentation, and you'll be preparing yourself to face just about any conceivable photographic challenge.

THE PHOTOS
IN THIS CHAPTER

A few years ago, I was hired to shoot a series of fashion ads at a World War I airplane museum in upstate New York (Photo 9-A1). At the client's request, I posed my models in front of various planes. To give the images credibility, one model was carrying a flight helmet and the other had a map in his hand.

Because I work fast, I had some time remaining before our scheduled return to New York City. Wanting a variation on the theme, I asked the curator of the museum whether any of the planes on display were actually airworthy. He assured me that they all flew, that he was a pilot, and that he would be happy to fly one of the machines for me.

I asked him to make one very low pass over us as we stood on a grassy runway (Photo 9-A2). The photo shows me taking the picture while the plane zoomed over us at an altitude of no more than about 15 feet.

The pilot was going to make just one pass over us, so I shot with motor drive, bracketing my *f*-stops as I shot. Using an 85mm lens, I exposed an entire 36-frame film.

Although the client went with his original concept for the ad, my ex-

perimentation worked and produced an exciting image. Another client might well have chosen it in preference to the initial concept.

Shortly after my move from New York to California, I shot an editorial fashion assignment for *Sport* magazine. Editorial assignments generally give a photographer greater freedom than commercial assignments. In spite of the artistic freedom granted me, I usually begin an editorial session with the most direct pictorial approach.

I posed three models dressed in sportswear "hanging out" on a basketball court. Once I knew that I had the required shot, satisfactorily depicting the garments, I opted for a variation on the theme.

Lying flat on the ground with my wide-angle lens pointing straight up, I asked the models to jump high in the air—as if going for the ball—in my close proximity (Photo 9-B). The job was no less dangerous than the preceding one of the aircraft!

As the models made several jumps, I shot with motor drive, bracketing *f*-stops as I shot. When the processed

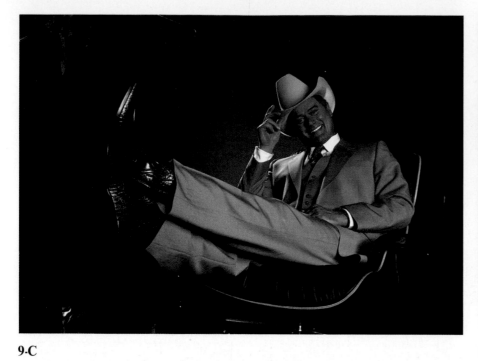

9-C

9-D

film came back from the lab, I selected the best image—in the safety of my studio!

Because the client was interested in showing the shoes and socks, this made not only a striking but also a useful image.

My first shoot with Larry Hagman was for BVD. The picture (Photo 9-C) was to run across a two-page spread. The client had specifically asked that the boots occupy about the same space on the left page as the head and body on the right page. This required introducing some deliberate distortion into the image.

I used my 24mm wide-angle lens, shooting from very close to my subject. While causing the distortion I wanted, I had to avoid facial distortion at any cost. I achieved this by keeping the head well away from the picture edge.

This photo is also a good example of experimentation that led to an unusual, striking image.

The photo of Kay Sutton York (Photo 9-D) involves a different kind of experimentation, in the form of high-contrast printing and hand coloring.

I had made a high-contrast black and white negative from a color slide and printed that negative. On the print, I subtly hand-colored the eyes and lips with magic marker.

When I was quite young, I sold a lot of portraits I had hand-colored in this manner. Very recently, I have produced another hand-colored portrait. This time I used oil colors. The purpose of the image was to advertise the new *Elizabeth Taylor's Passion* fragrance line for Parfums International.

CONCLUSION

One of my private portrait clients commissions me to photograph her family every three years. A couple of years ago, she telephoned me to tell me a tragic story. Her home began to burn in the middle of the night. She, her husband, and the children were able to escape unhurt. She told me that, next to the safety of her family, her first concern was for the safety of the photographic portraits that hung on the walls in the home. As she escaped from the house, she grabbed every portrait she could carry. Such is the emotional value of the photographic portrait.

Photographers can contribute something very precious—the recording of special moments and their permanent preservation. Our ability to do this in a wide variety of ways is largely dependent on our willingness to try new things—to experiment.

DISPLAY YOUR PHOTOGRAPHS FOR GREATEST IMPACT

Each of the nine secrets discussed so far deals with an aspect of making dynamic photographs. The ultimate purpose of a photograph, however, is that it should be seen. In this, the tenth secret, I reveal how photographs may be complemented by effective display treatment.

There are many ways of showing photographs, ranging from the simple snapshot album to a display in a gallery, an editorial spread in a magazine, a commmercial advertisement and the production of a commercial portfolio. To a large extent, the purpose of the photo dictates the manner of presentation. There are some basic display guidelines that can help enhance the look of photos for maximum impact.

PERSONAL PHOTO ALBUM

To many readers of this book, the personal photo album will not be the most important display vehicle. I begin with it here simply because it is perhaps the most basic method of picture presentation. The pages of an album are not, in essence, greatly dissimilar from those of a professional's portfolio or from a magazine layout.

Buy a Quality Album—It doesn't make sense to produce high quality pictures and then display them in a less-than-ideal manner. The quality of presentation should always be the best possible. Even a so-called *personal* album is generally kept so photos can be shown conveniently and attractively to *others*.

My early family photographs were placed in a quality leather album containing matte-board pages. The pictures were dry-mounted with pressure-sensitive adhe-

sive. Each photo was printed and cropped to fill the 8x10-inch page.

More recently, I have switched to looseleaf notebook binders for family shots. Acetate cover sheets hold the photos in place. By simply raising these sheets, photos can easily be rearranged or removed and replaced.

PROFESSIONAL PORTFOLIO

During the past 20 years, I've seen a variety of techniques used to present commercial photography to prospective clients. During the time I worked in New York, I mounted my enlargements on 16x20-inch matte-board. The finished boards were carried in a collapsible sheet-metal case. Although the presentation was attractive, it was expensive and heavy.

From the mounted enlargements in sheet-metal cases we went to 24x30-inch zippered portfolios. The portfolios looked wonderful for a week or two, until the plastic sleeves containing the photos chipped, scratched or cracked, often damaging the prints.

For a short time, I showed prospective clients duplicate color slides. However, duplicating original transparencies proved both costly and less than an ideal form of presentation.

Mini Book—Today, advertising agencies and clients are generally prepared to accept the *mini book*. This book—usually 5x7 inches in size—contains mylar sleeves that are open at one end for easy insertion and removal of photos. Images can easily be changed so that the selection can be updated or adapted for a specific presentation.

The mini book was popular in Europe long before it became accepted in the United States. Today, mini books are produced by many companies. Mine are made by Bookitt, Inc ; Dallas, Texas.

Each of my mini book portfolios has my studio logo printed across the front cover. Each book has 36 mylar sleeves for either prints or reduced tear sheets. The books are mailed to my various agents around the world.

The mini book is a portfolio that effectively depicts a photographer's range of talents in an inexpensive, easily portable and yet impressive way.

Keep Your Portfolio Up-To-Date—The ability to remove pictures from your portfolio in order to add others is very important because you should show each prospective clients only pictures that relate to his activities. For example, you don't want to bore a prospective client who is selling men's wear with photos of women's cosmetics or jewelry. You also shouldn't show images that look old because of dated hairstyles or fashions.

No matter what precise form your portfolio takes, mylar sleeves enable you to change the display you are going to present in an easy and quick manner.

Tear Sheets—Tear sheets are printed ads or editorial layouts, taken from the actual publications they appeared in. They form an important part of a professional photographer's portfolio. They prove that you were commissioned to take the photographs, were able to perform under pressure, and produced results the client used.

For the above reasons, a tearsheet is often much more powerful in selling your talents than an immaculate original photographic print. An art director may admire the original photograph, but he won't know how long it took to make or how often you had to try to get the final image. The tear sheet, on the other hand, proves that you were able to perform under professional conditions.

CREATIVE PRINT MOUNTING

Many photographers compete in local and national photography contests. Such competitions usually require a specific mount size—often 16x20 inches. A large mount offers a world of creative possibilities for enhancing a photo's impact.

Double Mounting and Keylines—One of my favorite techniques during my photo-competition days, and one I still use today for mounting special prints of family, friends and personal

portrait clients, involves the use of double mounting and keylines.

Regardless of whether you're using wet mounting or dry mounting, cut a sheet of colored paper so that it extends around the photographic image in the form of a keyline. The color of the paper will depend on the colors in the photo, the color of the mounting board and, of course, on personal taste.

The precise keyline thickness depends on the size of the photo and the size of the mount. Use personal judgment. You may want a keyline of approximately 1/8 inch width for an 8x10-inch print on a 14x17-inch board. A larger print on a larger board will call for a wider keyline.

Neutral Keylines and Foil Papers—I find color keylines to be inappropriate for most black and white images. Even a pastel color tends to overpower the subtleties of the black and white print tones. Consequently, I use black, gray or, when appropriate, white keylines. The background matte must contrast in tone with the keyline.

Another technique—appealing with black and white and color images alike—involves the use of metallic foil papers as an undermount keyline. Metallic foil—silver, gold or some other color—can set off an image beautifully. As I've already mentioned, the thickness of the keyline must be determined by personal taste, bearing in mind that reflective foil tends to "vibrate" and appear thicker than its nonspecular counterpart.

FRAMES AND OTHER WALL DISPLAYS

Any good framing company can help you select frames and mounts for your photos. There are also excellent display methods that do not use frames. The method you choose will depend on the type of photograph involved, the display location and on personal taste.

The finish of a photograph has a bearing on the choice of frame. My personal preference in framing black and white photographs and color photos with a smooth surface is the

classic gallery frame of chrome and glass. Such frames, produced by many companies, provide a clean, contemporary picture enclosure in silver, gold, bronze or pewter.

The same style of frame is also available in an almost limitless range of designer colors for gallery framing of color photographs of all kinds.

The use of a gallery frame does not preclude the use of selective mounting and the use of keylines.

Mounting for Wall Display—Many photographs in my home—black and white and color—are mounted on thick artboard, masonite or plywood, depending on the size of the image and the structural stability needed.

The image "bleeds" to the four edges of the mount. The thick mount edges are painted a color that complements the color of the wall receiving the display. Usually, the edges are painted either black or white.

To cause the photograph to hang in relief from the wall, I affix blocks of wood—anywhere from about one to four inches in thickness, depending on the size of the image—to the back of the mount. The result is a clean, contemporary and dramatic effect, giving the illusion of a "floating" image.

Mats—A mat is a card with a rectangular or square aperture cut from it for the picture to show through. A mat "frames" the image. The outer dimensions of the mat fit the frame.

To establish a solid graphic base, a mat should have about 25 to 30 percent more space at the bottom than the top. The three other borders should normally be of equal thickness.

To create an eye-catching, dynamic effect, you can break the basic rules. Try, for example, leaving more mount width on one side than the other. You may even want to enlarge and cut the image in such a way that part of it extends beyond the picture rectangle, into the wider side of the mount.

TEXTURING

Special photo emulsions that can be transferred to canvas or other flat surfaces are available. For example, the majority of the large color photographs I produce for the homes of private portrait clients are printed on such a canvas base. The emulsion layer is stripped from its paper base and bound, under extreme pressure, to cotton canvas.

The canvas can be stretched on a wooden frame to make an attractive, rustic display, or it can be mounted on masonite. The resulting texture gives the image added visual "weight," allowing the use of heavier and more ornamental framing, if desired. The canvas prints are finished with a high-gloss spray, giving maximum detail rendition and color saturation.

An easier and less costly way of texturing an image is to simply print it on a textured paper. However, I find the results less than satisfactory and prefer to use either a smooth paper base or real canvas texture.

It's important to limit texturing to prints that are reasonably large. When applied to a small print, a relatively coarse texture will tend to degrade the resolution of the image.

LIGHTING DISPLAYED PHOTOS

The spotlighting of photographic enlargements can be very effective and dramatic, especially in an area where the ambient light level is low. However, you should be aware of the fact that light, the very energy that makes photography possible, is also one of its worst enemies. Photos fade in light. Some fade more rapidly than others. Color photos fade selectively, causing an unpleasant change in the color balance of an image.

If you want to spotlight your photos, I suggest you only switch the illumination on when you want to show off your images, such as at special events. Even so, you would be wise, if you can afford it, to make Cibachrome or even dye-transfer prints. They resist the effects of light better than most.

To preserve your images, avoid *all* strong light as much as possible. Direct sunlight will fade regular Type-C or Type-R prints very rapidly. Fluorescent light is nearly as harmful.

If you insist on lighting a picture for extensive periods, or on hanging it in bright daylight, be especially careful to protect the master image. Keep negatives and original slides safely in a dark, dry and cool place. When your displayed enlargements fade, at least you'll be able to replace them.

CONCLUSION

The first "display" of my work a portrait client will generally see is a large proof sheet.

I don't show 35mm contact proofs because they don't do justice to the images and are difficult to look at. Instead, I place six strips of six slides each on an 8x10 negative holder and enlarge the entire 36-exposure film onto a sheet of 16x20-inch paper. This provides my client with a clear overview of all the images I shot.

The enlarged "contact" sheet becomes the client's property once the selection of final images has been made. Some clients have framed and hung these sheets. They can make a very effective and unusual display. The sheets contain all the images I shot, including the unselected "outtakes", as well as the grease pencil directions indicating which images were to be enlarged and how they were to be cropped.

One fascinating aspect of a hung display of a proof sheet is that you can look at it in two entirely different ways. Come close, and you can study the individual images. Move farther back, and you see a fascinating abstract pattern of shapes and colors.

A final word of caution about displaying photos effectively: If an image doesn't have the quality and impact to stand on its own merit, no amount of display artistry or gimmickry will save it. Quality photography must come first. If an image is a failure, go back to your camera, not the framing shop!

PORTFOLIO

1

Subject: Elizabeth Taylor
Location: A rental studio in Los Angeles
Camera: 6x6cm SLR
Lens: 150mm
Lighting: One 1200-watt-second main light; four 800-watt-second background lights
Light Control: One silvered reflector
Film: Ektachrome 64
Exposure Metering: Electronic flash meter in incident-light mode
Exposure: f-8 (shutter at 1/250 second)

Elizabeth Taylor's vital and sparkling eyes reveal a person of great sensitivity. It may seem strange for a photographer like myself to admit it, but it is almost impossible for camera and film to do justice to the real-life look of Elizabeth Taylor. Therein lies a great challenge! I faced that challenge with a mixture of considerable apprehension and excitement.

Because I treat every photo session as a unique entity, I try to go in with no preconceptions. I maintain an open mind about lighting and posing my subjects. People tend to look different on different days, or even from minute to minute, for a wide variety of reasons.

I keep my eyes and sensitivities open, and shoot accordingly. And, I make sure my subject is completely comfortable at the studio and in front of my camera.

Successful portraiture depends on much more than equipment and technicalities. The intangible rapport between a photographer and his subject becomes visibly evident in a photograph. The experience of photographing Elizabeth Taylor, who has been described in *LIFE* magazine as "the profound beauty of the second half of this century," was an absolute delight for me.

I lit Elizabeth with a single main light from the camera position. A silvered reflector, in a low position, lightened the shadow below her chin and added a second catchlight to the eyes.

2

Subject: Robert Wagner
Location: Gary Bernstein Studio, Los Angeles, California
Camera: 35mm SLR
Lens: 105mm
Lighting: Main flash of 1200-watt-seconds in pan reflector; hair light with grid spot
Light Control: Two silvered reflectors
Film: Kodachrome 25
Exposure Metering: Electronic flash meter in incident-light mode
Exposure: ƒ-11 (shutter at 1/60 second)

Besides being a good friend and one of the best non professional joke tellers, "RJ" Wagner is a pleasure to work with. First of all, it should be made illegal for one guy to have this amount of good looks! On the other hand, perhaps not! It makes for a very easy photo session!

This image was made for both personal and publicity use. RJ was sitting on a posing stool and leaning on a second, higher stool.

The main light, in pan reflector, was to the left of the camera and aimed down at an angle of about 45°. It yielded beautiful modeling of the subject's fine features. A hair light with grid spot, on a boom stand above Wagner's head, provided attractive highlighting to the hair. The background was not lit separately. It simply picked up some of the light from the two sources I was using.

A silvered reflector, slightly to the right of the camera, filled in the shadows on RJ's left side. A second reflector was placed just below his face.

The reflectors added two extra catchlights to each of RJ's baby blue eyes. The winning smile, clothing style and casual chic make up the inimitable look of Robert Wagner.

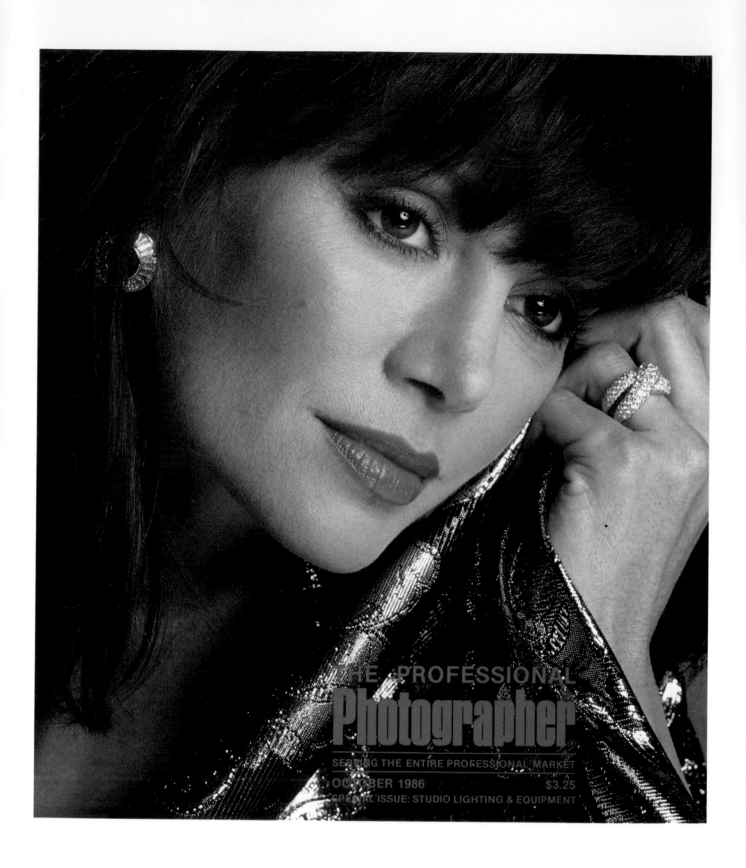

THE PROFESSIONAL

Photographer

SERVING THE ENTIRE PROFESSIONAL MARKET

OCTOBER 1986 $3.25

SPECIAL ISSUE: STUDIO LIGHTING & EQUIPMENT

3

Subject: Victoria Principal
Location: Gary Bernstein Studio, Los Angeles, California
Camera: 6x6cm SLR
Lens: 120mm
Lighting: Main light of 1250-watt-seconds in pan reflector; two 800-watt-second background lights in umbrellas
Light Control: Two silvered reflectors
Film: Ektachrome 64 Professional
Exposure Metering: Electronic flash meter in incident-light mode
Exposure: f-11 (shutter at 1/125 second)

Beautiful Victoria Principal is the subject of this glamour head shot that appeared on the cover of *The Professional Photographer* magazine. I first photographed Victoria many years ago. She was the star of my first major editorial layout for *Esquire* magazine.

Victoria works as well to the camera as anyone I've photographed. Her modeling talents are a rare blend of total emotional control and a physical command of body language. The result produces not only striking images but rapidly moving photo sessions that yield exceptionally consistent results.

For this shot, I used a main light in pan reflector in combination with a silvered reflector below Victoria's face. The reflector softened contrast slightly by filling shadow areas. It also added an extra catchlight to each of her brown eyes.

Victoria's classic features allow tremendous photographic freedom in terms of camera angle and head position. In this view, Victoria's lack of eye contact with the camera yielded a soft, dreamlike image.

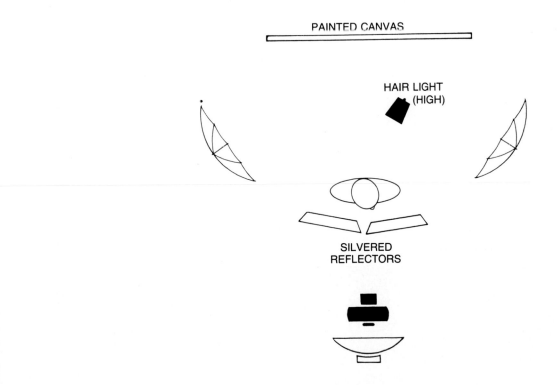

PAINTED CANVAS

HAIR LIGHT
(HIGH)

SILVERED
REFLECTORS

4

Subject: Liz Miller, professional model
Client: Alberto Culver
Ad Agency: Lee King & Partners
Art Director: Sharon Sturgis
Location: Malibu, California
Camera: 35mm SLR
Lens: 55mm
Lighting: Direct early-morning sunlight
Film: Kodachrome 25
Exposure Metering:
Through-The-Lens (TTL) reflected-light reading as well as handheld meter incident-light reading
Exposure: 1/250 second at *f*-5.6 to *f*-8

This image was shot as part of an Alberto VO5 hair spray print campaign that accompanied a *photomatic* TV commercial I had shot a few weeks earlier. A photomatic is usually produced for test purposes from still images that are later dissolved into each other and then scored with music and spoken message. The photomatic technique saves a client the expense of full cine or video production prior to testing the effectiveness of an advertising concept.

This image of Liz Miller—one of my favorite models and a real professional—was to run as a two-page spread, complete with advertising message. The large area of sky on the right side of the image was later to contain the sales message and a rebate coupon from the manufacturer.

Slight head movement from Liz and a bit of a natural breeze account for her windblown appearance.

Using a lens of relatively short focal length—55mm—enabled me to get close to the subject and aim the camera upward, to record a wide expanse of cloudy sky. The early morning sunlight provided flattering illumination at a lighting angle approximating that of refined studio lighting. The low sunlight also gave a healthy warmth to the image.

5

Subject: Linda Evans
Client: Woman's Own Magazine, London
Location: Gary Bernstein Studio, Los Angeles, California
Camera: 35mm SLR
Lens: 105mm
Lighting: Six 600-watt-second flash heads
Film: Kodachrome 25
Exposure Metering: Electronic flash meter; incident-light mode
Exposure: f-11 (shutter at 1/60 second)

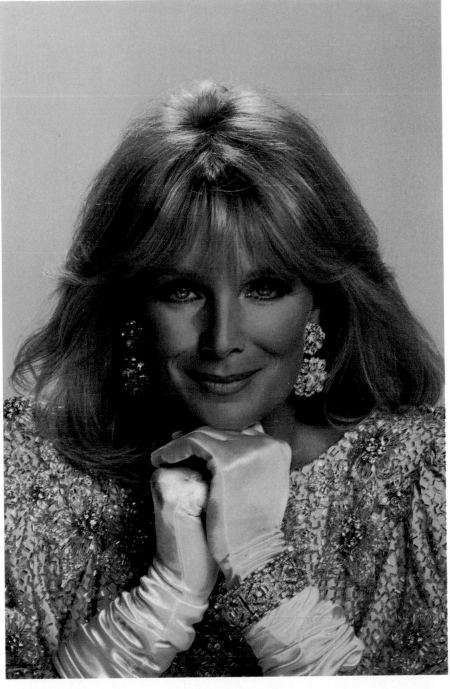

This photo was made at a recent session commissioned by *Woman's Own*, England's leading women's magazine.

At the start of a beauty-photography session, I generally ask my subject's preference in terms of posing and propping. Some feel more comfortable in a soft chair, others on a stool and at a table. Many feel most relaxed posing on the studio floor. In fact, the majority of my head shots are made with the subject seated on the studio floor.

For this photo, Linda Evans was seated on a posing stool, at an adjustable posing table.

The main light, in pan reflector, was

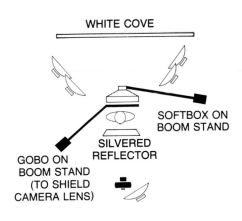

WHITE COVE

SOFTBOX ON BOOM STAND

SILVERED REFLECTOR

GOBO ON BOOM STAND (TO SHIELD CAMERA LENS)

near the camera position. I used four background lights in pan reflectors, two on each side of the subject.

The hair light, high and slightly behind Linda, came from a 1x4-foot softbox on a boom stand. A small silvered reflector below Linda's face lightened shadow to soften the image and added sparkle to the eyes.

I love Linda's chiseled features, her beautiful coloring and her silken blonde hair. This image contains plenty of glitter—not just from the Nolan Miller gown, but from Linda herself!

6

Subject: Linda Russell
Client: Christian de Castelnau, Inc.
Location: Gary Bernstein Studio, Los Angeles, California
Camera: 35mm SLR
Lens: 55mm
Lighting: Three 1200-watt-second flash heads in pan reflectors
Film: Kodachrome 25
Exposure Metering: Electronic flash meter in incident-light mode
Exposure: f-11 (shutter at 1/60 second)

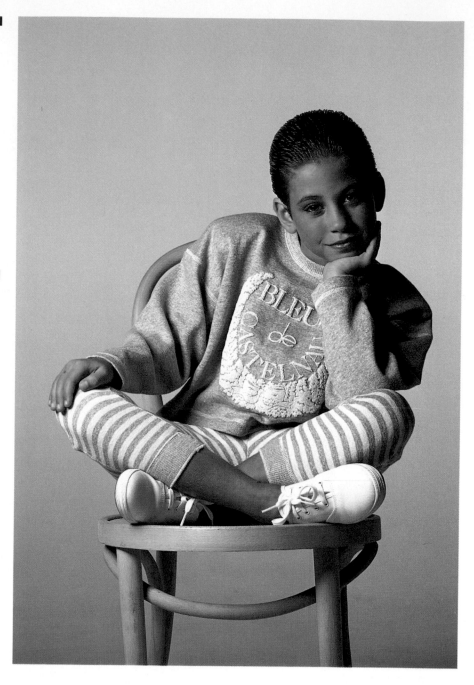

Linda Russell is not a professional model. After a full day's casting session, during which time Christian de Castelnau failed to find the children's faces he was looking for, he decided to pick from his own family and friends. I could hardly believe the beauty of the children he brought to the studio.

This photo, taken to advertise part of a new line of sportswear for children, raises an interesting question: Is it a commercial shot or a portrait? However, it's really a rhetorical question. In the final analysis, a photograph will stand on its own merits rather than on its label or rationale.

In terms of propping and composition, this is a very simple image. Throughout this advertising campaign, we went for a monochromatic effect, with the bluish grays of Christian's de-

WHITE BACKGROUND

signs harmonizing with similar hues in the background. The major contrasting color is provided by the subject's skin tone.

One flash in pan reflector lit the subject and two more similar lights illuminated the background.

Notice the extra room I've left around the composition. It's an effective way of expressing the smallness of a child, especially in a photo with no props that could indicate true scale.

The warmth of this child's expression is truly genuine. I wish all my adult subjects could work so well to the camera.

7

Subject: Caron Bernstein
Location: Gary Bernstein Studio, Los Angeles, California
Camera: 35mm SLR
Lens: 85mm
Lighting: Four 600-watt-second electronic flash heads
Light Control: One silvered reflector
Film: Kodachrome 25
Exposure Metering: Electronic flash meter in incident-light mode
Exposure: *f*-8 (shutter at 1/60 second)

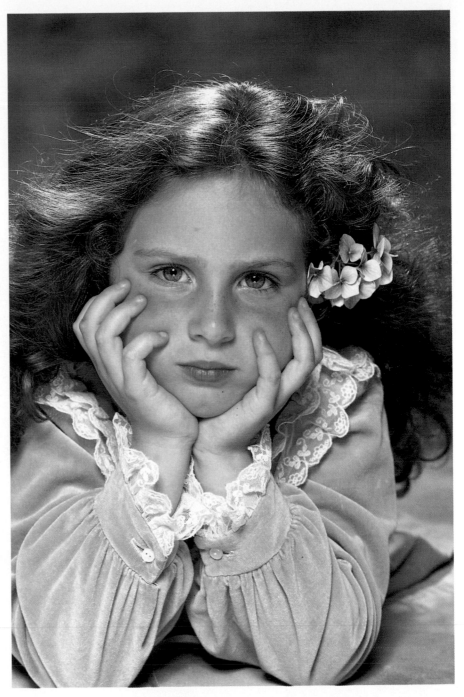

For my daughter Caron's sixth birthday, I made a series of classic, formal portraits. I used them to send to family members and friends. One of the images was reproduced in my book *Pro Techniques of People Photography*, also published by HPBooks. The photograph reproduced here was shot on the same occasion. However, it is a very different kind of shot.

This image is particularly precious because it is a unique "grab shot" that can never be repeated again in quite the same way. There is nothing posed, directed or arranged about it. It depicts Caron exactly as she felt at that particular moment, just after a bit of mild admonishment from her "old man." She responded with a serious look and a subtle pout.

There's nothing wrong with photographing a child's serious side. Quite to the contrary, broad, toothy smiles tend to distort even the most mature faces. Here, Caron's stare is very captivating.

The hands have a character of their own. In this photo, they also serve to graphically draw attention to the eyes and the mouth. In addition, they lend an attractive symmetry to the composition.

To achieve a soft, flattering light, I used a centrally placed umbrella light from a low angle, adding a silvered reflector just in front of Caron's elbows. This lighting also provided double catchlight in the eyes to give them extra sparkle.

I had painted the mottled blue gray background on a large piece of canvas. The color complemented nicely the color of Caron's dress.

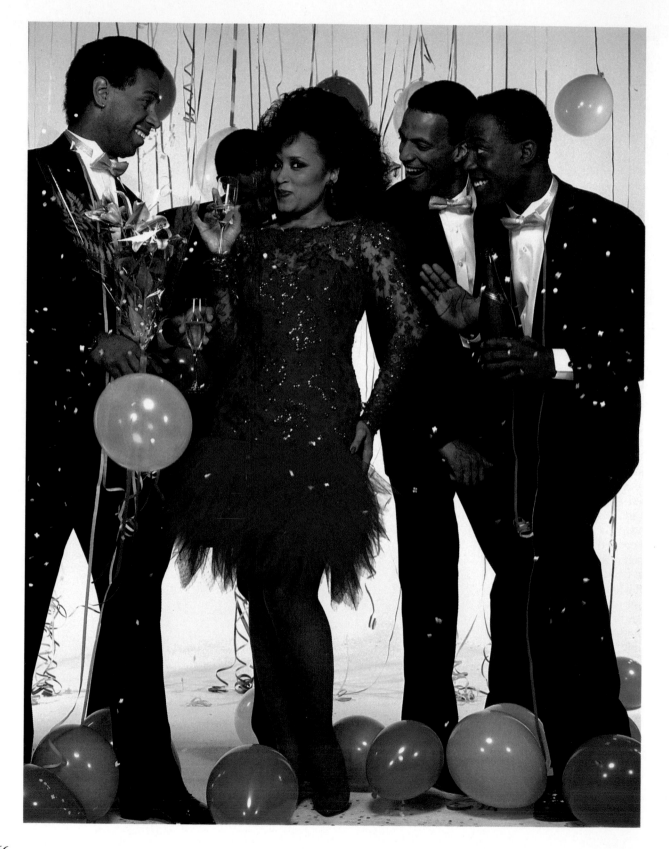

8

Subjects: Jackée Harry and four professional models
Client: Black Elegance
Art Director: John McMurray
Location: Gary Bernstein Studio, Los Angeles, California
Camera: 35mm SLR
Lens: 85mm
Lighting: Main light of 1300-watt-seconds in pan reflector; four background lights of 650-watt-seconds each; two 650-watt-second fill lights in softboxes
Film: Kodachrome 25
Exposure Metering: Electronic flash meter, incident-light mode
Exposure: *f*-16 (shutter at 1/60 second)

Talented and pretty Jackée Harry is the star of this pictorial celebration, taken for the 1988 New Year's issue of *Black Elegance* magazine.

A seven light setup was used and the set was a pure white cove in my studio. The first step was to place a mark for the subjects on the studio floor, about 10 feet from the background. Midway between the mark and the background, I set up two stands, with crossbars at a height of about 10 feet. Balloons and streamers were hung from the cross-bars. A supporting crew stood by with confetti at the ready.

To maintain a uniform white background, I lit the cove with two lights from each side. I deliberately over-exposed the background by one *f*-stop.

The main light was a single source, in pan reflector. To limit the light fall-off on the subjects, from heads to floor, I added two 650-watt-second soft-boxes—one on each side of the main light and each at a height of about four feet. The heads of the softboxes were directed downward somewhat.

I used a short telephoto lens of 85mm on my 35mm SLR. This fore-shortened the perspective slightly.

Clearly, the main ingredient for this dynamic image was Jackée. Other important components comprised upbeat lighting and action, confetti, champagne and a genuine party atmosphere.

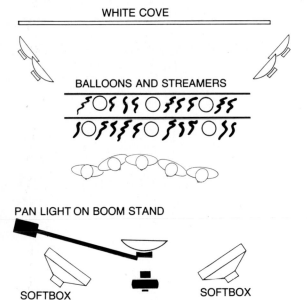

WHITE COVE

BALLOONS AND STREAMERS

PAN LIGHT ON BOOM STAND

SOFTBOX SOFTBOX

9

Subject: Rock Hudson
Client: Rock Hudson
Location: Gary Bernstein Studio, Los Angeles, California
Camera: 35mm SLR
Lens: 105mm
Lighting: One 1200-watt-second flash in 32-inch shoot-through umbrella
Light Control: One small silvered reflector
Film: Kodachrome 25
Exposure Metering: Electronic flash meter in incident-light mode
Exposure: *f*-8 (shutter at 1/60 second)

I shot this photograph of Rock Hudson in April 1984. Before his death, Rock selected this image for the jacket of his autobiography, *Rock Hudson, His Story,* by Rock Hudson and Sara Davidson, published by William Morrow.

Rock was always very uncomfortable in front of the still camera. He explained that, as an actor, he felt natural and at ease projecting the personality of a character he was playing—in front of a motion picture or TV camera. Still photography was very different.

Rock had been a friend for more than two years before he allowed me the pleasure of a photo session. As Rock waited for the start of the session, he recalled that there had been only one successful photo session in his past. It was shot by the brilliant actor—and photographer—Roddy McDowall. As I related in *Secret II: Motivate Your Subject,* Roddy would sing to Rock as he shot. Roddy imitated a well-known singer in a way that made both Roddy and Rock laugh uproariously. In this manner, Roddy managed to evoke real emotion from his reluctant subject.

If the technique was good enough for Roddy, it was good enough for me.

Without hesitation, I broke into my finest rendition of *Melancholy Baby.* In this book, I stress the importance of subject motivation. Use whatever method it takes to get the subject response you want.

Rock laughed merrily at my vocal efforts. We selected this shot, taken at the moment the laugh had subsided, leaving only a hint of a sparkle in those famous eyes. Rock was a warm, wonderful man. I miss him.

10

Subject: Tony Danza
Location: Gary Bernstein Studio, Los Angeles, California
Camera: 35mm SLR
Lens: 105mm
Lighting: Main light of 1250-watt-seconds in pan reflector; two 800-watt-second background lights in umbrellas
Light Control: One silvered reflector
Film: Kodachrome 25
Exposure Metering: Electronic flash meter in incident-light mode
Exposure: *f*-8 (shutter at 1/60 second)

This photo of Tony Danza was made on the day I also shot his formal wedding photographs. When the formal shoot was over, we decided to spend a little extra time producing some publicity and promotional shots for Tony.

My aim was to produce some very informal but strong character portraits. I had asked Tony to lean forward from his seated position and rest his chin on his hand.

The main light was a frontal flash in a pan reflector. A silvered reflector, just out of view below the image, served to lighten shadows. The reflector also introduced secondary catchlights into the eyes. The light on the white, seamless background was balanced with the main light to produce the clean, white background in the image.

I shot a roll of 35mm film—about 36 exposures—of the basic pose shown here, encouraging Tony to change his expression as I shot. I chose to reproduce this specific image in this book because, to me, the pensive look captured an honesty and sensitivity in Tony that's often missed in more commercial images of the actor.

WHITE BACKGROUND

SILVERED REFLECTOR

11

Subjects: Ted McGinley and two professional models
Client: Cone Mills
Ad Agency: Marschalk
Art Director: Barry Pohorence
Location: Pasadena, California
Camera: 35mm SLR
Lens: 200mm
Lighting: Direct late afternoon sunlight
Film: Kodachrome 25
Exposure Metering: Incident-light meter reading
Exposure: 1/250 second at f-5.6 to f-8

I like to provide a client with as much variety as possible. It's much better for him to have a tough time reaching a decision than to be stuck with just one usable shot. The key to such versatility is a mastery of the technical aspects of photography. This allows you to work fast. Then, you can provide an incredible variety of poses and attitudes in a very short time.

When I made this sunlit fashion shot for Cone Mills, I had already shot a series of photos in open shade, with more passive attitudes on the part of the models. My intention for the series of which this photo was a part was to have a little more action and playfulness.

I selected a plain wall as a believable and simple background. I wanted to keep the wall clear of distracting shad-

ows. In the low, frontal sunlight, the only way to achieve this was to make sure the models were far enough away from the wall.

I made two barely noticeable markings on the ground, about four feet apart, to indicate the depth of field and my permissible shooting zone. Each time the group walked toward the camera, I would shoot a rapid sequence with my camera's motor drive. I repeated the sequence several times, bracketing exposures as I did.

I generally like to use incident-light metering. In a situation such as this, especially, it ensures the most accurate exposure. A reflected-light reading would have been affected excessively by the expanse of light wall, leading to underexposure.

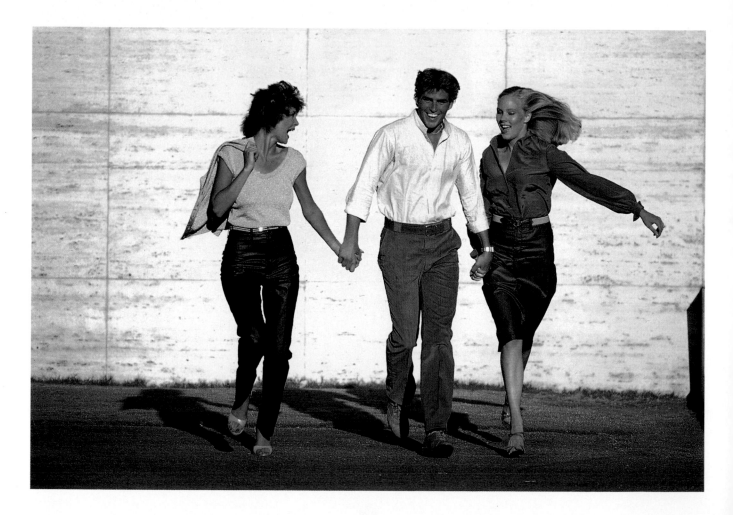

12

Subjects: Professional models
Client: Cone Mills
Ad Agency: Marschalk
Art Director: Barry Pohorence
Location: Griffith Park Train Museum, Los Angeles, California
Camera: 35mm SLR
Lens: 50mm
Lighting: Reflected sunlight
Light Control: One seven-foot silvered reflector
Film: Kodachrome 25
Exposure Metering: Electronic flash meter in incident-light mode
Exposure: 1/125 second at *f*-8

This very realistic-looking railroad station shot was actually made in a train museum, using a train that hadn't run in years. To bring the static scene to life and hide some giveaways that might reveal the true location, I used some special tactics.

The sun was high in the sky and just behind the train. None of its light struck the near side of the train directly. Using a seven-foot-tall silvered reflector, I redirected the sunlight toward the subjects, carefully avoiding the train as much as possible. I wanted to record the train in low key.

Two smoke machines—simulating steam—worked wonders in bringing the old train "to life." The smoke, as well as deep shadows, helped to conceal the points where the train was actually fastened to the track.

This is an eye-catching fashion photograph, in a setting that looks very real. Even the reflection of the sunlight from a low angle gives the illusion of an early morning train departure.

As in most of the photos reproduced in this book, the lessons of several of the Ten Secrets are touched upon. In this case, they include: Use the Versatility of Daylight; Modest Lighting Equipment Is Enough; Keep It Simple; Tailor Your Technique to the Subject. Last but by no means least, this photo dramatizes the good advice: Be Prepared!

13

Subject: Joan Collins
Client: Woman's Own,
London, England
Location: Gary Bernstein Studio,
Los Angeles, California
Camera: 35mm SLR
Lens: 105mm
Lighting: Main light of
1200-watt-seconds in pan
reflector; one 650-watt-second
hair light
Light Control: One small,
silvered reflector
Film: Kodachrome 25
Exposure Metering: Electronic
flash meter in incident-light mode
Exposure: f-8 (shutter at 1/60
second)

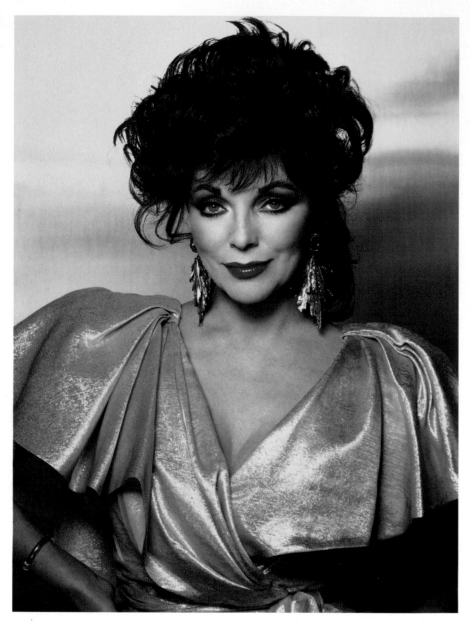

I took this photograph of beautiful Joan Collins for *Woman's Own,* England's largest women's magazine.

The single most important factor in people photography is effective communication between photographer and subject. Joan and I happen to truly see "eye to eye." And, she's absolutely brilliant in front of the camera. We work together almost as a unit—her pacing and body movements are so natural and fluid.

Beyond the purely physical aspects, there is the strength of Joan's emotions and her ability to convey them to the still camera.

The lighting for this photo was deliberate but simple. The main light, in pan reflector, was placed slightly to the left of the camera, at a distance of about six feet from Joan. It provided modeling of medium to high contrast—similar to good theatrical lighting.

A hair light, with snoot for control of light spread, added some highlight to Joan's dark tresses. A small, silvered reflector in front of Joan helped to soften contrast slightly and gave additional sparkle to Joan's foxy blue eyes.

Gold mylar proved the ideal background to complement Joan's gown. But—make no mistake about it—the real eye-catcher is Joan herself!

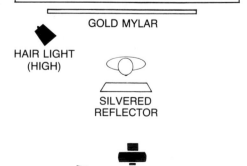

STUDIO WALL

GOLD MYLAR

HAIR LIGHT
(HIGH)

SILVERED
REFLECTOR

14

Subject: Joan Collins
Client: Woman's Own,
London, England
Art Director: Caro Thompson
Location: Gary Bernstein Studio,
Los Angeles, California
Camera: 35mm SLR
Lens: 105mm
Lighting: Main light of
1200-watt-seconds in pan
reflector; four 1200-watt-second
background lights in umbrellas
Light Control: One silvered
reflector
Film: Kodachrome 25
Exposure Metering: Electronic
flash meter in incident-light mode
Exposure: *f*-5.6 (shutter at 1/60
second)

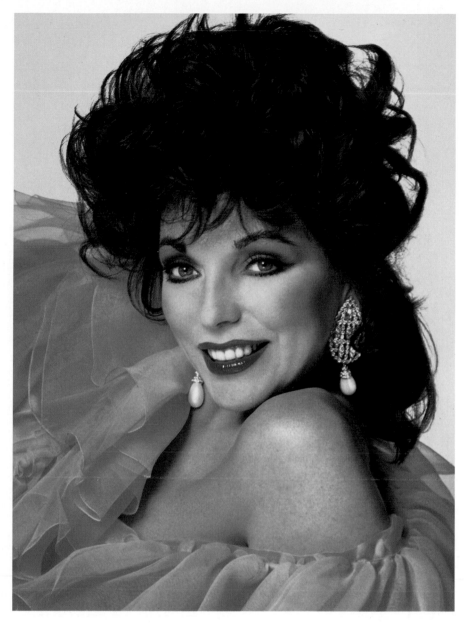

During a conversation at Joan Collins's house recently, I described her as the kind of girl one took home to mother—when mother was out of town. Joan laughed and told me I was being silly. But I rest my case—using this image as prime evidence. Joan is absolutely beautiful and works to the camera like a dream.

The photograph was taken for a late 1987 cover of *Woman's Own,* the magazine with the widest circulation in Britain. The "look" for the shot was coordinated by Joan's management—Jeffrey Lane of Rogers and Cowan (Los Angeles) and Judy Bryer. My confident British editor, Caro Thompson, was thousands of miles away—and as near as the telephone.

This image shows well how an efficient silvered reflector can replace a fill light. I positioned the main light directly in front of Joan at a distance of about five feet. A silvered reflector was just out of camera view, slightly below and to Joan's left. Using the reflector very close to the subject, the highlight-to-shadow ratio on the face was no more than about 2:1.

Four powerful background lights "washed out" the white walls of my cove and lowered overall contrast even more.

There was one more flash. It was provided by Joan—when she smiled!

15

Subject: Jay Leno
Client: General Management Corp.
Art Director: Jerry Kushnick
Location: Gary Bernstein Studio, Los Angeles, California
Camera: 6x6cm SLR
Lens: 80mm
Lighting: One main-light flash in pan reflector; four background flash heads, each in a shoot-through umbrella
Film: Ektachrome 64
Exposure Metering: Electronic flash meter in incident-light mode
Exposure: *f*-8 (shutter at 1/250 second)

Jay Leno is one of the most impressive young comedians to come along in a long time. His many successes have culminated in his appointment as regular guest host on the *Tonight Show*.

This photograph is one of a series I took to publicize a *Showtime* TV special called *Jay Leno and the American Dream*. Besides being used to publicize the show, several photos from the series were used on the actual show as background for the credits.

The flag symbolized the theme of Jay's show—The American Dream. The motorcycle was an equally important symbol because Jay is a great motorcycle enthusiast, owns several machines, and rides one almost everywhere he goes.

The important thing in photographic lighting is not simply the *amount* of light you can throw on a subject but the *relationship* of brightness, character and direction of the various lights you use. You can achieve that relationship with complex studio lights or modest portable lighting equipment although, of course, the portable equipment will limit your total light output.

There was considerable subject contrast between the relatively dark motorcycle and Jay's dark clothing and the bright flag. I wanted to show detail in my subject and his cycle and, at the same time, record good, saturated colors in the flag. To achieve this, the light on the flag had to be considerably less bright than the illumination on the subject.

Jay was a delight to work with. He's an incredibly bright young man and was excellent in front of the camera: Almost every frame I shot was actually usable.

There's just one hazard in shooting with Jay Leno: He's so hilarious that it's necessary to take regular "laughter breaks!"

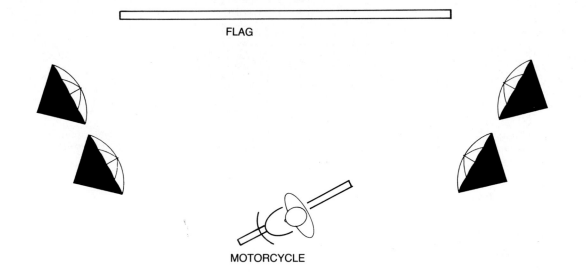

FLAG

MOTORCYCLE

16

Subject: Ricardo Montalban
Location: Gary Bernstein Studio,
Los Angeles, California
Camera: 35mm SLR
Lens: 105mm
Lighting: One 800-watt-second
flash in 32-inch silvered umbrella
Film: Kodachrome 25
Exposure Metering: Electronic
flash meter in incident-light mode
Exposure: *f*-16 (shutter at 1/60
second)

The surest way to a classic photo-graphic image is a subject with a classic face. Such was the case with this study of consummate actor Ricardo Montalban.

Montalban is wonderful in front of the still camera. He makes the photography almost as easy as extracting freeze frames from a motion picture.

One of the secrets revealed in this book indicates that strong, professional images can be made with the most modest of lighting equipment. This photograph is a good case in point. I used just one flash in a silvered reflector.

I lit the face at a sharp angle from the left side of the camera. The interplay of light and shadow was such as to provide excellent modeling on Ricardo's classic face. In addition, the fine delineation of the contours in the face brought out the limitless character in this warm and personable star.

Notice how the angle of the light caused the right side of the background to record light and left the other side in darkness. As a result, the highlights on the hair on the left and the dark, shaded side of the face and head on the right both stand out well against the background.

In spite of the angular lighting, I was careful to get sufficient light into Ricardo's left eye to establish a catchlight.

Montalban and I are both of the opinion that hands possess a character all of their own. In this shot, the hand becomes an all the more prominent feature by standing out so clearly from the dark jacket.

Ricardo is one of the most genuinely kind individuals I've had the pleasure of photographing. I believe the depth and warmth of his personality is evident in this portrait.

17

Subject: Professional model
Location: Winona School of Professional Photography, Mt. Prospect, Illinois
Camera: 35mm SLR
Lens: 85mm
Lighting: Main light of 1300-watt-seconds in narrow reflector; one background light of 650-watt-seconds
Film: Kodachrome 25
Filtration: Deep amber gelatin filter on background light
Exposure Metering: Electronic flash meter in incident-light mode
Exposure: *f*-16 (shutter at 1/60 second)

About six years ago, I gave a five-day seminar at the Winona School of Professional Photography. More recently, I returned there to teach a three-day course. The students are all professional photographers. When I conduct such a class, I use top professional models from agencies in the Chicago and Milwaukee areas.

The photo reproduced here was taken during my most recent seminar at the school.

My background props consisted of a ladder and a 35mm camera on a camera stand. The stand was placed about three feet in front of a 4x8-foot white background on wheels.

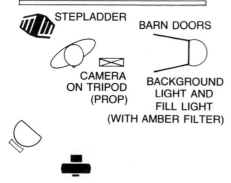

WHITE BACKGROUND

STEPLADDER

BARN DOORS

CAMERA ON TRIPOD (PROP)

BACKGROUND LIGHT AND FILL LIGHT (WITH AMBER FILTER)

The main light was in a narrow-angle reflector and placed about eight feet from the model, creating the high-contrast facial modeling I wanted. To the right side of the camera—behind and to the side of the model—I placed a flash with barn doors.

The barn doors allowed me to control the spread of light. I wanted to light the side of the model's face without having the light strike the camera lens. I opened the rear barn door to illuminate the background surface. A deep amber gelatin filter was taped over the background light. It provided the warmth in the background and in the edge lighting.

This model proved to be an excellent actor who was able to convey strong, believable attitudes.

19

Subject: Linda Evans
Client: Crystal Light
Art Director: Jack Bloom
Location: Gary Bernstein Studio, Los Angeles, California
Camera: 2-1/4-in.-square SLR
Lens: 120mm
Lighting: Four 600-watt-second flash heads;
four 1200-watt-second flash heads
Light Control: Two gobos
Film: Ektachrome 64
Exposure Metering: Incident-light reading
Exposure: *f*-11 (shutter at 1/250 second

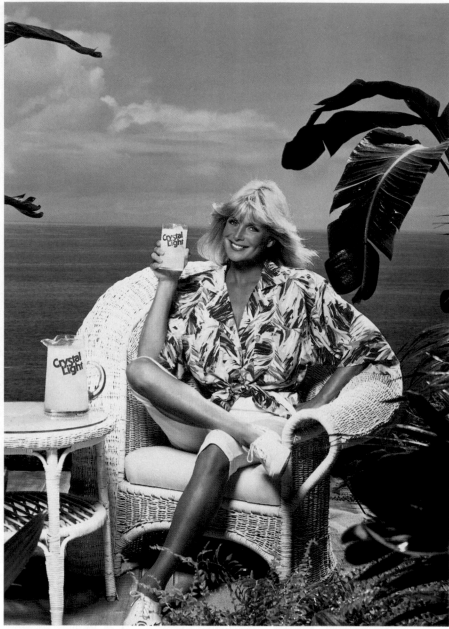

Television spots for Crystal Light, featuring wonderful Linda Evans, had been shot in Hawaii. To shoot my advertising still photographs, I simulated Hawaii in my Los Angeles studio!

My background consisted of a 15x25-foot transparency depicting ocean and blue sky. The background suggests midday sunlight in terms of tonality and color balance. I used four 1200-watt-second flash heads in wide-angle reflectors to transilluminate uniformly the giant transparency.

In front of the background, we built a small deck of beechwood. We scat-

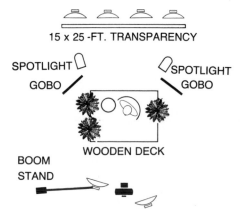

tered sand to add further credibility to the scene. We then added a variety of props and lots of tropical plants and palms. Two 600-watt-second spots lit the plants in a manner simulating midday sunlight. These lights also acted as hair and rim lights for Linda's golden tresses.

Gorgeous Linda was lit with a main light and a fill light. A wind machine added more life and credibility to our Hawaiian scene.

This was a complex shooting session. In spite of the complexity, however, it went wonderfully well. When you have a talent like Linda Evans in front of your lens, and the support of a truly professional crew headed by art director John Bloom, everything seems to "click."

20

Subject: William Farley
Client: Farley Industries, Inc.
Ad Agency: Grey Advertising
Art Director: Nancy Nagy for Farley Industries, Inc.
Location: A rental studio in Los Angeles, California
Camera: 6x6cm SLR
Lens: 150mm
Lighting: Main light of 1250-watt-seconds in pan reflector; four 800-watt-second flash heads in umbrellas for background light
Light Control: One small silvered reflector
Film: Ektachrome 64 Professional
Exposure Metering: Electronic flash meter in incident-light mode
Exposure: *f*-8 (shutter at 1/250 second)

The subject of this image is Bill Farley, chairman of Farley Industries, against the American flag. Bill and the flag were lit separately. The main light, in pan reflector, placed slightly to the right of the camera position, gave illumination of medium contrast to the subject. Shadow areas were lightened by a small, silvered reflector, placed in front of Bill.

To brighten the red in the flag, I adjusted the two background lights on the flag for one *f*-stop more exposure on the flag than the main-light exposure on Bill.

A second pair of background lights was aimed beyond the bounds of the flag, to white out the background.

I used selective depth of field, rendering Bill's image with total sharpness while the flag went slightly soft.

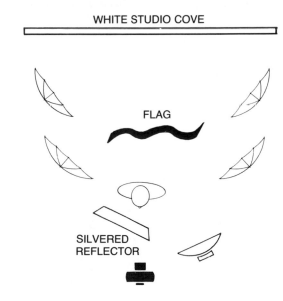

WHITE STUDIO COVE

FLAG

SILVERED REFLECTOR

21

Subject: Jill St. John
Client: Oscar Mayer Food Corp.
Ad Agency: Lee Rich, Inc.
Art Director: J. Bernahl
Location: Gary Bernstein Studio, Los Angeles, California
Camera: 6x6cm SLR
Lens: 150mm
Lighting: Main light of 800-watt-seconds, in shoot-through umbrella; two 400-watt-second background lights; one 400-watt-second hair light with barn doors
Light Control: One silvered reflector
Film: Ektachrome 64
Exposure Metering: Electronic flash meter in incident-light mode
Exposure: *f*-8 (shutter at 1/250 second)

Famous actress Jill St. John is also a well-known food and cookery expert. This photograph depicts Jill as spokesperson for the Oscar Mayer Foods company.

Because many of the photos made during this session were to be enlarged to a considerable size for point-of-purchase displays, I shot on the 2-1/4-inch-square format. Some photos were also made on 8x10 sheet film.

I shot images ranging from full-length to head and shoulders. Because Jill was addressing prospective customers as spokesperson for a product, eye contact with the camera—and the viewer—was essential.

Jill St. John is a delight to photograph. Her photogenic qualities make it easy to light and pose her and yield an exceptionally high percentage of excellent images. The lighting for this photo consisted of a soft, frontal main light and a hair light above and slightly behind the subject. The background was lit separately.

I had asked Jill to be seated on a stool and provided her with a small table to lean on. I made a series of shots, each with a different expression. The aim of each was to create the illusion that she was addressing the viewer.

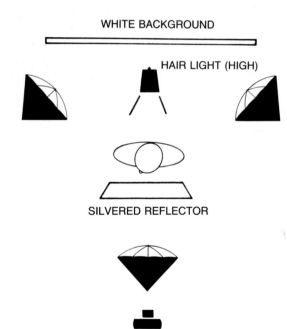

WHITE BACKGROUND

HAIR LIGHT (HIGH)

SILVERED REFLECTOR

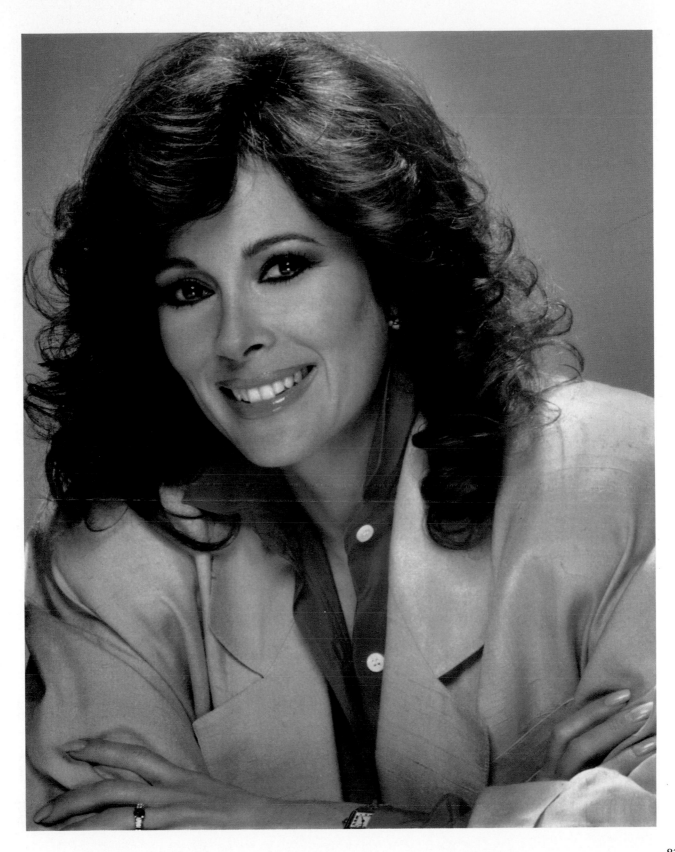

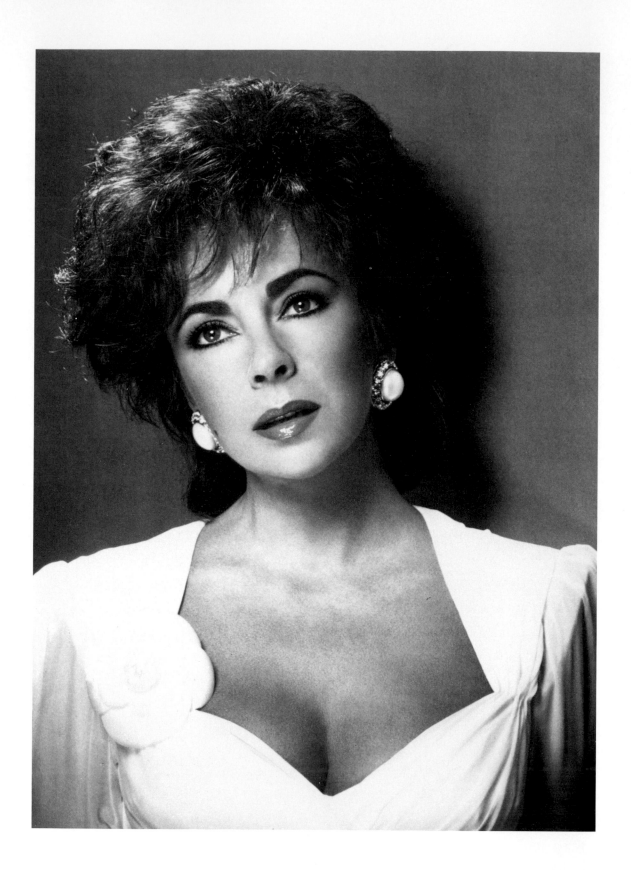

22

Subject: Elizabeth Taylor
Location: A rental studio in Los Angeles, California
Camera: 35mm SLR
Lens: 85mm
Lighting: Main light of 800-watt-seconds, in umbrella; one 800-watt-second hair light, with grid spot

Light Control: One small, silvered reflector
Film: Kodachrome 25, then b&w internegative
Exposure Metering: Electronic flash meter in incident-light mode
Exposure: *f*-11 (shutter at 1/60 second)

As mentioned elsewhere in this book, it is almost impossible for camera and film to capture the incredible appeal of Elizabeth Taylor. Each time I photograph her, it is a personal challenge to try and record her aura and improve on previously made images. It's an absolutely delightful challenge.

The black and white portrait shown here originated as a 35mm Kodachrome transparency. From that slide, I made a black and white 4x5 internegative which, in turn, was enlarged.

The photograph appeared in Dominick Dunne's book *Fatal Charm* and, more recently, was selected for the cover of *Elizabeth Takes Off,* published by Putnam.

The lighting was simple. I used a frontal main light, in umbrella, at about eye level. A small silvered reflector, just below the camera's viewpoint, helped to lighten shadows. A hair light, above Elizabeth on a boom, added sparkle to the hair.

To me, this image captures the incredible softness, sensitivity and timeless allure of Elizabeth Taylor.

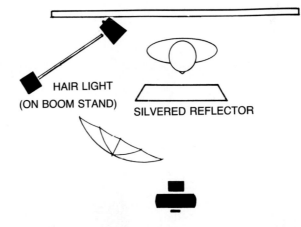

HAIR LIGHT
(ON BOOM STAND)

SILVERED REFLECTOR

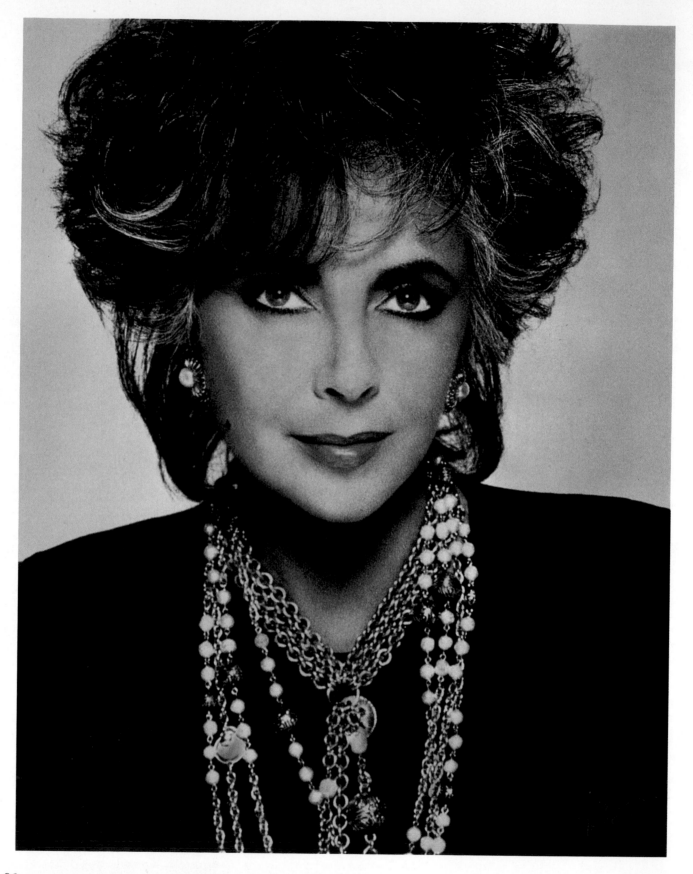

23

Subject: Elizabeth Taylor
Client: Parfums International
Ad Agency: William Esty
Location: A rental studio in New York City
Camera: 6x6cm SLR
Lens: 150mm
Lighting: Five flash heads at 1200-watt-seconds each, each in a medium-angle reflector
Light Control: One large, silvered reflector; two 7-foot gobos
Film: Kodak Plus-X
Exposure Metering: Electronic flash meter in incident-light mode
Exposure: *f*-8 (shutter at 1/250 second)

I had shot this image in black and white for the press kit announcing Elizabeth Taylor's new fragrance, *Elizabeth Taylor's Passion*.

I was also asked to provide large prints for point-of-sale displays around the country. I wanted these to have a very special quality and appeal. The client had shown great interest in a personal black and white photo I had hand-tinted for Elizabeth Taylor and asked me to give the same treatment to the display photo.

The original black and white negative was printed through an etching screen to give it its textured appearance. I delicately hand tinted the enlargement with oils. The resulting image was copied onto 4x5 color-negative sheet film which was enlarged to make Type-C display prints. The prints were box-framed for display at their various locations.

For the purpose of this book, I copied the hand-tinted print onto 35mm Kodachrome 25 film. The reproduction was made from the Kodachrome slide.

To make the original black and white portrait, I used a main light from near the camera position, a silvered reflector to lessen contrast, and four background lights.

As the small inset photo shows, I also gave the hand-tint treatment to the shot of the product being publicized.

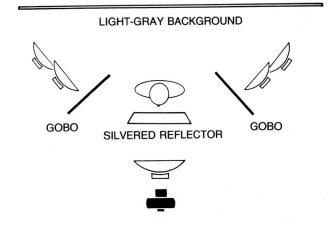

LIGHT-GRAY BACKGROUND

GOBO SILVERED REFLECTOR GOBO

24

Subjects: Kay Sutton York and her father, B.J. Sutton
Location: Gary Bernstein Studio, Los Angeles, California
Camera: 35mm SLR
Lens: 105mm
Lighting: Main light of 1200-watt-seconds in pan reflector; four 800-watt-second background lights in shoot-through umbrellas; one 1200-watt-second grid-spot hair light
Light Control: One silvered reflector
Film: Kodak Plus-X
Exposure Metering: Electronic flash meter in incident-light mode
Exposure: *f*-16 (shutter at 1/60 second)

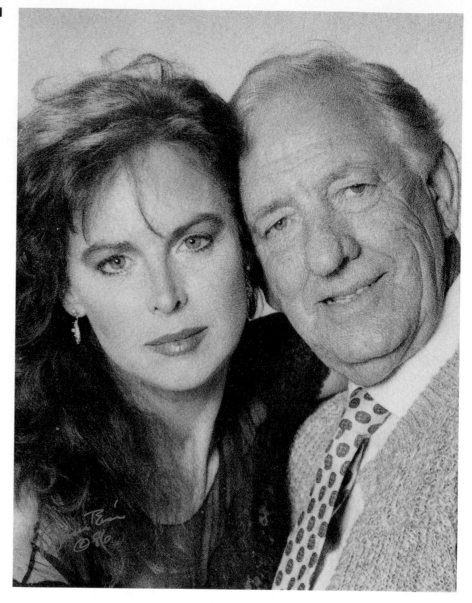

This is one of many delightful images I shot of Kay and her father during a wonderful private photo session in my Los Angeles studio. B.J. Sutton was sitting on a stool. I asked him to have Kay on his lap and cuddle her close to him. This physical closeness helped to enhance the already evident emotional closeness between father and daughter.

This is a typical example where black and white film can yield an im-

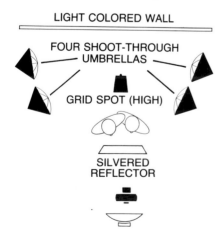

age of great impact. The need for color seems almost superfluous. The impact from the photo comes from the beauty and character in the faces and the warmth of the interrelationship.

To give an ethereal and painterly quality to the portrait, I added a random screen pattern. I did this by placing a large etching screen on the 16x20 enlarging paper when making the exposure.

I could have sandwiched a similar but much smaller screen with the negative in the enlarger. This would have been considerably less costly. However, the screen would have been enlarged along with the image, giving too large and coarse a texture for my taste. In the image reproduced here, the texture of the screen was not enlarged. The result is a texture pattern that is very evident and yet also quite subtle.

25

Subject: Caron Bernstein
Location: Coldwater Park,
Beverly Hills, California
Camera: 35mm SLR
Lens: 105mm
Lighting: Daylight, open shade
Film: Kodachrome 25
Filtration: 1A skylight filter
Exposure Metering: Through-The-Lens (TTL) reflected-light reading
Exposure: 1/250 second at *f*-4

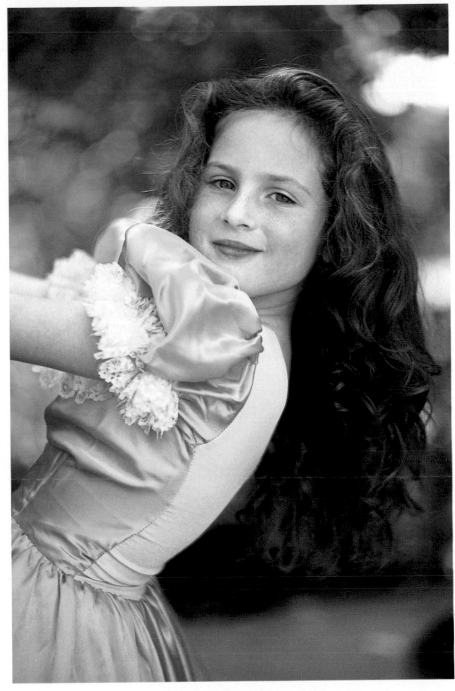

I had gone to the park to play with my daughter Caron but was also considering taking some photos of her. She had chosen the dress she wanted to wear that day. When we began to think of taking pictures, she also told me what pose she wanted to adopt. As you can see from the image reproduced here, she displayed good taste!

Caron was standing on the first rung of a jungle gym and leaning back, swinging from side to side, as this photo was taken. Every time she swung, her long hair would fly out. I shot a series of pictures with my motor-driven camera.

The soft illumination came from open shade on a sunny day. The sun was concealed behind some tall trees. To eliminate some of the excess blue that comes from open shade, or from an overcast sky, I used a warming 1A skylight filter.

A lens aperture of *f*-4 limited the depth of field sufficiently to record the foliage in the background pleasantly out of focus. Being somewhat transilluminated by the sun, the foliage displayed an attractive green glow and some pleasing but not distracting highlights.

26

Subject: Robert Wagner
Client: Columbia Pictures/ABC Television
Ad Agency: McCaffrey & McCall
Art Directors: Barry Weintraub and Dennis Fitch
Location: A rental studio in Los Angeles, California
Camera: 35mm SLR
Lens: 55mm
Lighting: Main light of 800-watt-seconds in 32-inch shoot-through umbrella; large softbox, with two 1200-watt-second flash heads, on boom stand; 800-watt-second background light in umbrella
Light Control: One white reflector
Film: Kodachrome 25
Exposure Metering: Electronic flash meter in incident-light mode
Exposure: *f*-11 (shutter at 1/60 second)

This photograph of Robert Wagner was taken to promote a new television series. Few people look better in a tuxedo than Robert Wagner. With the fashion styling set, we added one appropriate prop—a beautiful, new Rolls Royce. By keeping the rest of the composition uncluttered, viewer attention is centered on Wagner.

This photo is a good example of how the controlled use of contrast can *attract* attention to an image without *detracting* it from the main subject. Wagner's white jacket draws attention to him against a background of a monochromatic bluish gray.

I lit Wagner frontally with a 32-inch shoot-through umbrella and used a white reflector card to lighten shadows from below. The extensive highlights on the car and the hairlight were provided by a large softbox, suspended from a boom stand and aimed downward.

The background was lit unevenly. This enabled the later introduction of dark lettering on the left side or "dropped-out," reversed lettering on the right side.

The pleasant, thoughtful expression of the incomparable "R.J." was the ultimate contribution to a fun session that resulted in fine, strong images.

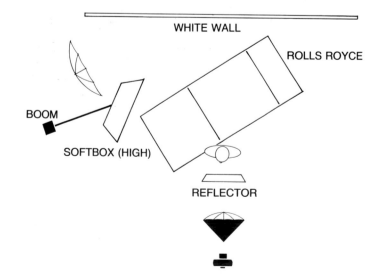

WHITE WALL

ROLLS ROYCE

BOOM

SOFTBOX (HIGH)

REFLECTOR

27

Subjects: Rene Russo, Scott MacKenzie, John McMurray, Matt Collins, two youngsters, a cablecar brakeman and conductor
Clients: Gant Shirtmakers and Classic Magazine
Art Director: Helen Klein
Location: San Francisco, California
Camera: 35mm SLR
Lens: 55mm
Lighting: Daylight; overcast
Film: Kodachrome 25
Filtration: 1A skylight filter
Exposure Metering: Incident-light reading
Exposure: 1/125 second at *f*-5.6 to *f*-8

All the people in this photo, with the exception of the cablecar brakeman and conductor, are wearing Gant clothing items. I took a series of photographs for *Classic* magazine, to illustrate an editorial spread designed to advertise Gant's products.

I had use of the San Francisco cablecar, at the end of its route, for about thirty minutes. To produce the required photos within this time span, and under difficult circumstances, called for good preparation and fast work.

Because I had to direct the poses and expressions of several people, and had to watch out for constant pedestrian traffic at the same time, I shot with my camera on a tripod. Notice that each pose and attitude is different and yet there is a binding unity in the overall composition.

All subjects except the brakeman were lit uniformly from the lightly overcast sky. The sun penetrated suf-ficiently to cause distinct but soft shadows. The lighting was ideal for the job with the exception of the slight blue color cast that's normal from an overcast sky. To minimize this, I used a warming 1A skylight filter.

Once everything was arranged, I shot quickly, bracketing exposures one *f*-stop in each direction. In the soft light conditions that prevailed, this was adequate insurance for good exposure.

The conductor, at the extreme right end of the picture, looks very real in his normal work clothes. However, to make sure that he would not "steal the show," I deliberately hid most of him behind one of the models. The brakeman, in the discreet and believable shade of the cablecar interior, also adds credibility to the image.

Incidentally, the bag on the seat and the one held by the model on the right side were also among the Gant products being advertised.

28

Subjects: Zacky Murphy and Bill Simkins, professional models
Client: La Costa Products
Art Director: William Randall
Location: Carlsbad, California
Camera: 35mm SLR
Lens: 24mm
Lighting: Reflected sunlight
Light Control: One silvered reflector
Film: Fuji 50D
Exposure Metering: Through-The-Lens (TTL) reflected-light reading
Exposure: 1/250 second at *f*-11

I had to fulfill three basic requirements: Advertise La Costa towels and the sunglasses, promote the atmosphere of the La Costa Spa experience, and produce an image with enough "negative space" background for a two-page spread. The final spread featured several product shots dropped into that background.

Because my subjects had to appear in the extreme corner of the image, I used a close viewpoint together with a wide-angle lens, ensuring visual prominence for the subjects. As a result, the pool is somewhat distorted.

Had the subjects been the main feature of the ad or were the photo to advertise the swimming pool, I would have shot the scene differently.

A basic rule states that faces should never be placed in the corner of a wide-angle image because unflattering dis-

tortion will result. I broke that rule when making this photo. However, I positioned the heads in such a way that distortion would be minimal.

When breaking this rule, study carefully in the viewfinder what the image is actually going to look like and make any adjustments in subject position that might be called for.

The subjects were lit from two sides. Direct midday sunlight from the far side of the pool formed the main light; the shadows were filled by a silvered reflector near the camera.

This image is eye-catching for several reasons. The focal point of interest is not where you might expect it to be. The background environment is noticeably but not excessively distorted. The use of Fuji 50-speed film gave a pleasing and appropriate graininess that is readily evident in the enlarged image.

30

Subject: Frank Gifford
Client: Nabisco
Ad Agency: William Esty Company
Art Director: Stan Swensen
Location: A rental studio in New York City
Camera: 35mm SLR
Lens: 55mm
Lighting: Four 1200-watt-second flash heads, two in umbrellas and two in pan reflectors
Film: Kodachrome 25
Exposure Metering: Electronic flash meter in incident-light mode
Exposure: *f*-5.6 to *f*-8 (shutter at 1/60 second)

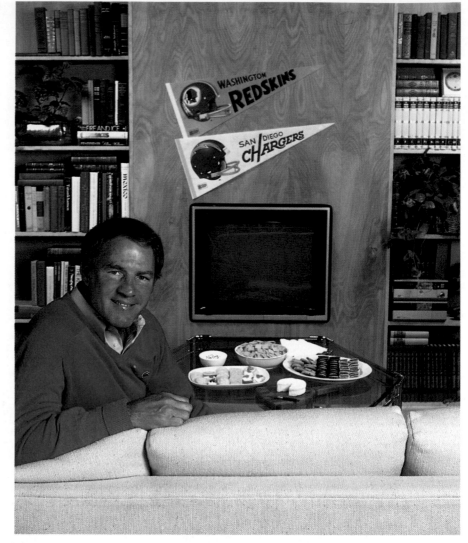

I had been hired to photograph my long-time friend Frank Gifford as spokesperson for Nabisco foods. In a rental studio in New York City, we had a set constructed to simulate a domestic environment. I rented the studio for three days. The first day was used for set construction. On the second day, we shot. On the third day, we reconverted the temporary "home" to its original studio condition.

As photographers, we have the wonderful capability of altering reality. If we do it skillfully, the viewer will believe what we convey to him pictorially. A case in point is the table in this photo, displaying the Nabisco product. Although it doesn't appear that way, the table was tipped up at the far end to give the camera a clearer view of the cookies and crackers. There's nothing wrong with pictorial "cheating"—as long as it can't be detected.

The main light, in umbrella, to the right of the camera, provided modeling on Frank. Three other lights provided uniform illumination over the scene.

31

Subject: Kathy Speirs
Location: Gary Bernstein Studio, Los Angeles, California
Camera: 35mm SLR
Lens: 105mm
Lighting: Three 1200-watt-second flash heads
Light Control: Two 7-ft.-tall black panels
Film: Kodachrome 25
Exposure Metering: Incident-light reading
Exposure: *f*-5.6 (shutter at 1/60 second)

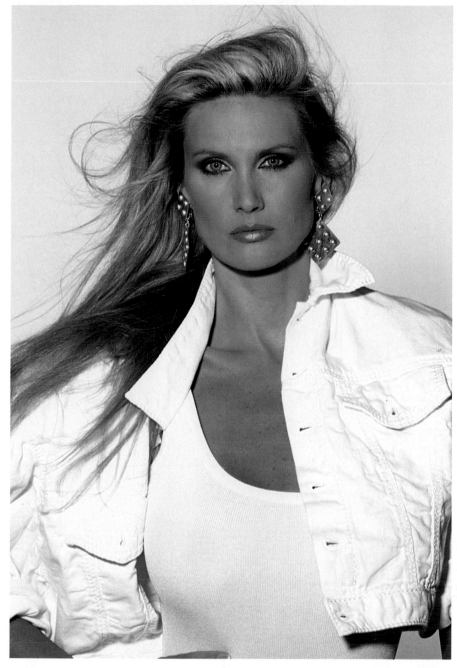

It had been 11 years since I last photographed stunning Kathy Speirs. That was in my New York City studio. At that time, Kathy was already one of the top models in the world for cosmetic products. The photo reproduced here is a very recent one, taken in 1988. From this image, it's clear that Kathy has not lost her looks and her special magic.

In high-key photography, one of the main challenges is to achieve satisfactory overall exposure balance. In this shot, the problem was compounded by Kathy's suntanned skin.

To maintain detail in Kathy's white outfit and separation between the outfit and my white studio-cove background,

WHITE BACKGROUND

7-FT.-TALL BLACK PANEL 7-FT.-TALL BLACK PANEL

SPOT

I used two seven-foot-tall black panels, placing one to each side of the subject. Notice the dark edge that separates Kathy from the background.

The main light was a single spotlight, placed slightly to the left of the camera and at the subject's eye level. The background was illuminated by two additional lights, one on each side of Kathy. Their power output was set to deliver the same *f*-5.6 exposure recorded for the subject's face.

I used a wind machine to blow Kathy's hair and add more life to an image which, thanks to Kathy, was already dynamic!

97

32

Subject: Kay Sutton York
Client: Avon
Location: Gary Bernstein Studio, New York City
Camera: 35mm SLR
Lens: 105mm
Lighting: Two 1200-watt-second flash heads in 32-inch umbrellas
Film: Kodachrome 25
Exposure Metering: Electronic flash meter, incident-light mode
Exposure: *f*-11 (shutter at 1/60 second)

During my first few years in New York, Avon was one of my principal clients. I made this shot to publicize one of their perfumes. The photo was ultimately used as a point-of-purchase card and for direct mail catalog advertising. The large empty space on the right side was left for the insertion of a product shot and for copy.

Because the background material occupied most of the picture area, it was particularly important that it be appropriate for the shot. I selected material that complemented—and thereby emphasized—the dress material and, at the same time, allowed the dress to stand out graphically.

Kay was lit almost frontally. The background was illuminated by a sepa-rate light, to the right of the camera. This second light also served to lighten shadows on Kay.

Kay's right arm was resting on a posing cube which was covered with the same fabric as the background. The pose, and the folds in the dress, were arranged to show the character of the material to best effect.

Notice the position of Kay's hands. They look graceful, being positioned to show her long, slender fingers. I always check arm and hand positions before I release the camera shutter. I've learned the hard way that, no matter how beautiful a face or figure might look, just one clumsily posed hand can spoil an image.

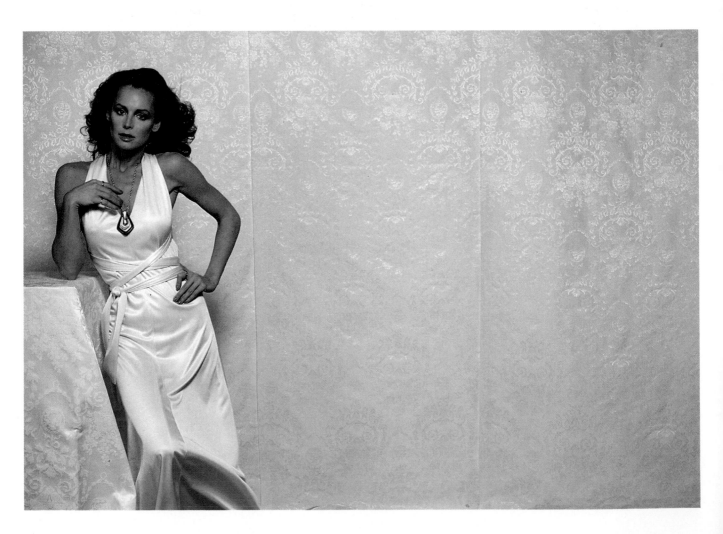

33

Subject: Kenny Rogers
Client: Karman Western Wear
Location: Burbank Studios, California
Camera: 35mm SLR
Lens: 85mm
Lighting: Hazy sunlight, bounced by reflector
Light Control: Seven-foot silvered reflector
Film: Kodachrome 25
Exposure Metering: Incident-light meter reading
Exposure: 1/125 second at *f*-8

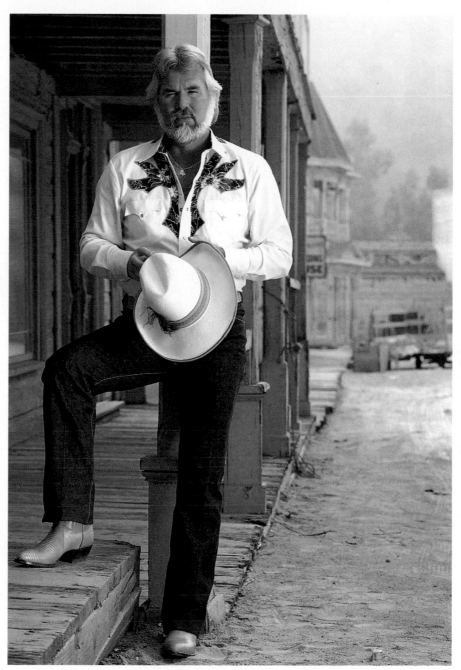

The best pose is usually a natural pose. Having chosen the location for Kenny Rogers, I showed him, basically, the kind of pose I was after. I then invited him to adopt a position that felt natural and comfortable but was within the basic concept we needed to feature the clothing. As I shot, I asked Kenny to alter his position and attitude slightly.

I had asked Kenny to hold the hat in front of him and casually play with it, adjusting the rim and the band, and so forth. By having him hold the hat rather than wearing it, I avoided the problem of getting light under the brim to light the face properly. Besides, it seemed a shame to hide that famous silvery hair.

The prevailing light was hazy sunlight. The sun was high in the sky and to the left of the camera. From camera position, it was hidden by the building. The sun, nonetheless, serves as main light. I reflected it toward Kenny from the right side by means of a large silvered reflector.

I took an incident-light meter reading from Kenny, pointing the meter's sensor toward the main light—the reflector, not the sun!

As the photo shows, the lighting gave excellent modeling to Kenny and also to the scene on the Burbank Studios set, with the sunlit street and background and the shaded overhang on the left.

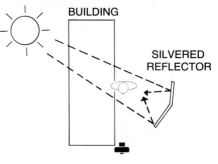

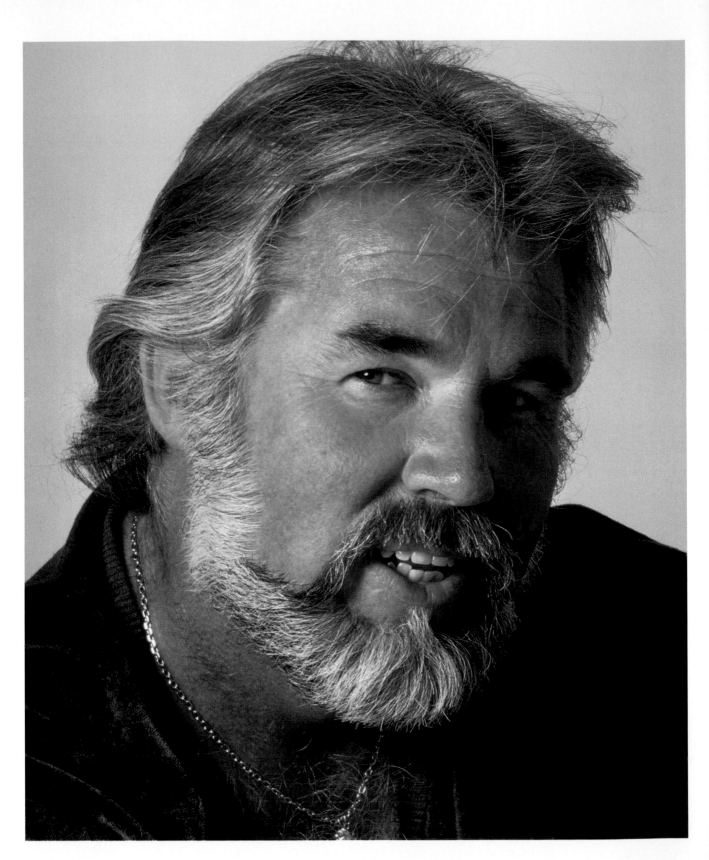

34

Subject: Kenny Rogers
Client: Jean-Paul Germain, Ltd.
Art Director: Randy Mogg
Location: Gary Bernstein Studio,
Los Angeles, California
Camera: 35mm SLR
Lens: 105mm

Lighting: One 1200-watt-second
flash in pan reflector
Film: Kodachrome 25
Exposure Metering: Electronic flash
meter in incident-light mode
Exposure: *f*-11 (shutter at 1/60
second)

I've photographed Kenny Rogers many times over the past 10 years. This shot was taken after we had completed a session for the Jean-Paul Germain *Winners* campaign which featured numerous celebrities wearing Jean-Paul Germain fashions and giving a thumbs-up sign.

Kenny is very comfortable in front of the camera. He has a wonderful feeling for what works and what doesn't. Being a photographer himself, his knowledge of posing and lighting surely comes into play.

The majority of celebrities are not comfortable in front of a still camera. Being used to moving and emoting in front of a movie or TV camera, the thought of shooting stills is often a chilling one.

The photographer must play the part of psychologist, determining what will best put his subject at ease. In order for this "therapy" to work, however, the photographer must first be totally comfortable with the situation himself. That comfort is dependent on self-confidence, based on a complete understanding and control of the photographic situation.

The more the technical aspects of your photography become like "second nature," the more you'll be free to dedicate yourself to the subject before your camera.

Incidentally, the V-neck sweater is an ideal garment for man and woman alike because it tends to graphically lengthen a subject's neck. Circular collars, by contrast, tend to shorten the neck—an effect that is rarely flattering.

This shot of Kenny was taken with just one light, in a pan reflector.

WHITE STUDIO COVE

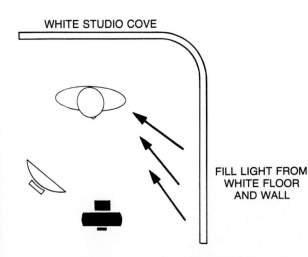

FILL LIGHT FROM
WHITE FLOOR
AND WALL

35

Subject: Darlanne Fluegel
Client: Del Laboratories
Location: Gary Bernstein Studio, New York City
Camera: 35mm SLR
Lens: 105mm
Lighting: Two 1200-watt-second flash heads in umbrellas
Film: Kodachrome 25
Exposure Metering: Electronic flash meter, incident-light mode
Exposure: f-11 (shutter at 1/60 second)

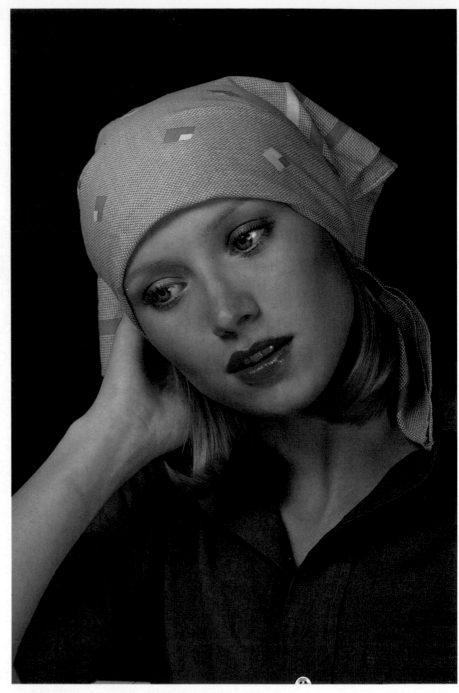

I made this photo for a point-of-purchase display card for FlameGlo lipstick, to be used in conjunction with a counter display holding the actual product.

For many years, Darlanne Fluegel has been one of my favorite models. She possesses not only striking, classic features but the emotional ability to portray an endless variety of attitudes in front of the camera. Her versatile talents have led to a rapidly expanding career in television and motion pictures.

This ad for FlameGlo was taken many years ago, when the company was in its infancy. I was instructed to shoot a series of beauty shots that would appeal to "middle America."

During my early years in New York City, I produced most of my beauty photographs using a basic two-umbrella light setup, as used here. The lights were of equal intensity and quality. For soft rendition, the lights would be placed at approximately an equal distance from the camera, one on each side of the subject. For more contrasty, dramatic lighting, one light would be placed closer to the subject than the other.

In this photo, I went for a monochromatic theme in blue. The blue serves to enhance and warm the skin tones as well as emphasizing the lip color. The next photo shows Darlanne 13 years later—and perhaps even more beautiful!

36

Subject: Darlanne Fluegel
Client: A book publisher
Location: Gary Bernstein Studio, Los Angeles, California
Camera: 35mm SLR
Lens: 105mm
Lighting: Main flash in pan reflector; two softboxes; hair light with grid spot; four background flashes in umbrellas
Light Control: Two seven-foot gobos; one silvered reflector
Film: Kodachrome 25
Exposure Metering: Electronic flash meter in incident-light mode
Exposure: *f*-11 (shutter at 1/60 second)

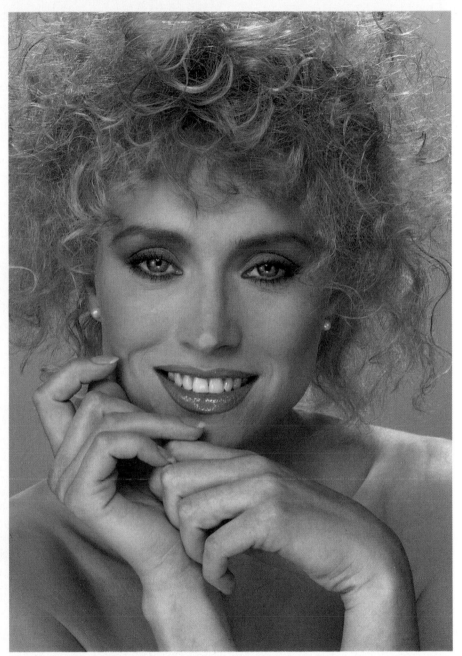

This photograph of lovely Darlanne Fluegel was made nearly 3,000 miles away from the location of the previous shot—and 13 years later. It was shot for the cover of a beauty book.

Because no product was involved with this shot, no particular feature needed pinpointing. What was needed was a good, appealing head shot. In this case, eye contact was important so that immediate rapport would be established with the viewer.

As shown by the lighting sketch, the lighting for this shot was somewhat more complex than usual. There were two distinct reasons for this. First, the addition of secondary lights and reflectors created very soft facial modeling. Second, the additional

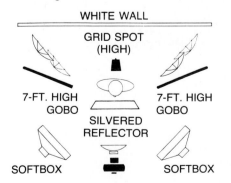

lights and reflectors were responsible for the plentiful sparkling catchlights in Darlanne's eyes.

Darlanne is a pure professional, working incredibly well to the camera. The wonderful hand pose, for example, was spontaneous on her part and needed no direction. A photographer isn't always so fortunate as to have such talent in front of his lens.

Had I been working with a less talented subject, I might have posed and reposed the hands several times over. If hands are to appear in an image, they should look as beautiful and graceful as the rest of the image.

37

Subjects: Beverly Saunders and Barry Michelon
Client: Arm & Hammer
Ad Agency: Kornhauser & Calene, Inc.
Art Director: Dan Routh
Location: A rented house in Burbank, California
Camera: 6x6cm SLR
Lens: 80mm

Lighting: Three 800-watt-second flash heads in pan reflectors
Light Control: One seven-foot white reflector
Film: Ektachrome 64 Professional
Exposure Metering: Electronic flash meter in incident-light mode
Exposure: *f*-11 (shutter at 1/250 second)

This photograph presents a good opportunity to relate some typical stages involved in producing an ad. It also represents, in a dramatic way, some of the "secrets" discussed in this book, including the importance of defining the purpose of the session in advance, the use of subject motivation, and the necessity to tailor the shooting technique to suit the subject matter.

We were looking for a bright kitchen with white walls, a light colored refrigerator with door opening to the right, and a work island in the center of the room. There are professional location finders who are equipped to satisfy

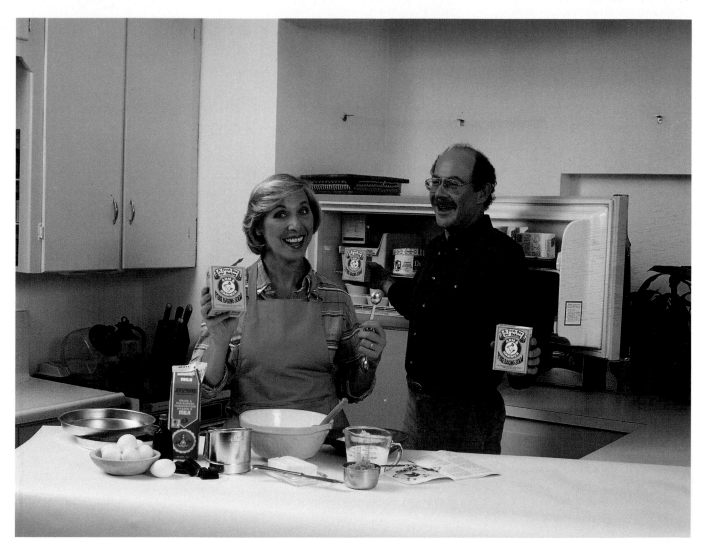

such specific needs. They have knowledge of a wide variety of available locations of all kinds and usually have photographs on file for prospective clients to inspect.

We paid such a service to find our location. We got pretty nearly what we wanted. Although we didn't get a work island, we easily constructed a makeshift one, using wooden blocks and white seamless paper. We also had to remove some utensils and decorative materials from the wall to give us the blank space we wanted.

We were offered two other locations that were as good as the above, but one was too far away and the other too expensive to rent.

Three light sources provided soft, overall lighting of the subjects and the scene. One light was reflected from a seven-foot, white reflector and the other two were bounced from the ceiling. Of course, it was necessary to have a white ceiling because bouncing light from colored surfaces introduces a color bias into the scene.

The two images reproduced here show how a photo is converted to an ad and, indeed, how a photographer must consider the final ad in the composition and framing of the original image. As you can see from the two images, we experimented a little with subject positions and poses in the course of the shooting session.

Good motivation is evident in this photograph. Good professional actors, such as this couple, possess motivation. Where self-motivation is lacking, however, the photographer's directing talents must come into play.

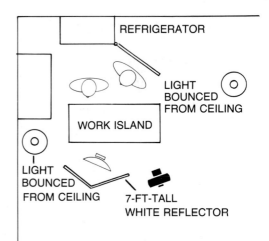

REFRIGERATOR

LIGHT BOUNCED FROM CEILING

WORK ISLAND

LIGHT BOUNCED FROM CEILING

7-FT-TALL WHITE REFLECTOR

105

38

Subjects: Non-professional models
Client: Sport Magazine
Art Director: Max Evans
Location: Santa Monica, California
Camera: 35mm LSR
Lens: 200mm
Lighting: Direct sunlight at mid-afternoon
Film: Kodachrome 25
Exposure Metering: Through-The-Lens (TTL) reflected-light reading as well as separate incident-light reading
Exposure: 1/250 second at *f*-8

The art director for *Sport* magazine decided to use nonprofessional models for this editorial feature on sportswear. He felt that experienced professional models would look too slick and less believable. A casting session was held to find men with an athletic look and athletic ability.

Although this shot of a group of runners seems very casual, it was carefully planned and choreographed.

I set my camera up on a tripod. I marked on the ground a zone of about 25 feet in depth within which I would shoot the runners. My lens was set to provide a depth of field to cover that zone. I asked the runners to line up about 10 feet behind the 25-foot strip. They would start running from there.

Because the purpose of the layout was to sell sportswear, I directed each runner that he must be visible to the camera at all times. The outfits of primary concern were positioned in the front row. The back row simply provided additional action and color.

Using the motor drive, I exposed frame after frame as fast as possible. I shot as long as the runners were within the predetermined 25-foot zone. We repeated the run several times to enable me to get numerous images and also to bracket exposures.

The runners were heading almost directly into the afternoon sun. This gave the picture a delightful warmth and provided incredible color saturation.

The tight crop deliberately created the impression that the viewer was seeing only a small part of a much larger group of runners.

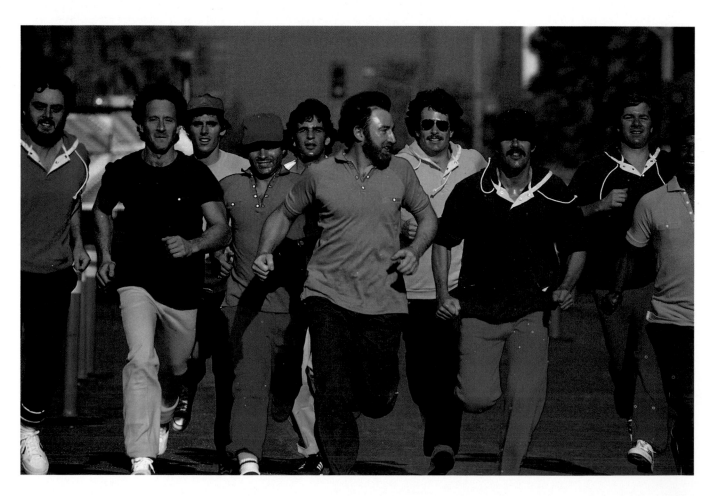

39

Subject: Romé Bernstein
Location: Pan Pacific Theater,
Los Angeles, California
Camera: 35mm SLR
Lens: 80—200mm zoom
Lighting: Late afternoon sunlight
Film: Kodachrome 25
Filtration: Diffusion filter
Exposure Metering:
Through-The-Lens (TTL)
reflected-light reading
Exposure: 1/250 second at f-5.6
to f-8

This is one of a series of photos I took of my daughter Romé, just for fun and experimentation. For background, I selected an outside wall of the Pan Pacific Theater in Los Angeles. The building has since then been demolished. The graffiti was genuine, not added by us.

Although I virtually never use a zoom lens in my professional work, I like its convenience and flexibility for my personal photography. This photo was made with an 80-200mm lens, set at its longest focal length of 200mm.

Romé has a wonderful feeling for design, styling and photography. She is, in fact, a recent graduate of the School of Visual Arts in New York City, with a major in photography, and is now beginning her own career behind the camera.

For this photo, I simply told Romé the feeling I was looking for and she did the rest. To soften the image, I used a diffusion filter on the camera lens. The characteristic warmth of the late-afternoon sunlight added to the mood of the shot. To enhance the soft, muted, pastel quality of the image, I deliberately overexposed by about two f-stops.

When I shoot photographs for my-self, I tend to "play" a little more than when I'm shooting for a client. Cost and time constraints on a professional shoot generally rule out sheer "fun" experimentation.

107

40

Subject: Johnny Carson
Client: Hart, Schaffner and Marx/
Johnny Carson Clothing
Art Director: Joe Starzec
Location: Malibu, California
Camera: 35mm SLR
Lens: 55mm
Lighting: One 400-watt-second electronic flash
Light Control: One large silvered reflector
Film: Kodachrome 25
Exposure Metering: Electronic flash meter in incident-light mode
Exposure: ƒ-8 (shutter at 1/60 second)

I've been photographing Johnny Carson for about 10 years. Without question, he's the most genuinely funny individual I've ever worked with. I can always count on my stomach muscles hurting from sheer laughter by the time a shooting session ends.

This photograph was taken to advertise the Carson line of clothing by Hart, Schaffner and Marx. Johnny has a perfect build for modeling clothing. This ideal appearance, together with his total professionalism, makes for an easy and fast shoot.

The image was made in open shade about midday. However, because Hart, Schaffner and Marx are con-cerned with fine resolution that depicts every sartorial nuance, I chose to over-power the daylight with a medium-powered electronic flash. This provided increased contrast and detail. I lightened the shadows with a three-foot silvered reflector, placed low and to the right of the camera.

I remember clearly one of Johnny's typical repartees just prior to the making of this exposure. The situation is clearly evidenced by the classic glint in Carson's eyes. The man is truly wonderful and I'm flattered that he agreed to write a brief Foreword for this book. I hope we'll be working together for years to come!

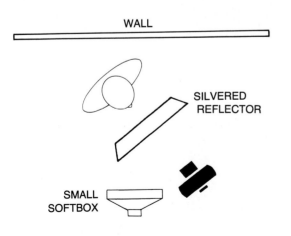

WALL

SILVERED
REFLECTOR

SMALL
SOFTBOX

41

Subject: Steve Shortridge, professional model
Client: Quality Mills
Ad Agency: David Deutsch, Inc.
Art Director: Rocco Campanelli
Location: Upstate New York
Camera: 35mm SLR
Lens: 105mm
Lighting: Direct sunlight
Film: Kodachrome 25
Exposure Metering: Through-The-Lens (TTL) reflected-light and separate incident-light readings
Exposure: 1/125 second at *f*-8

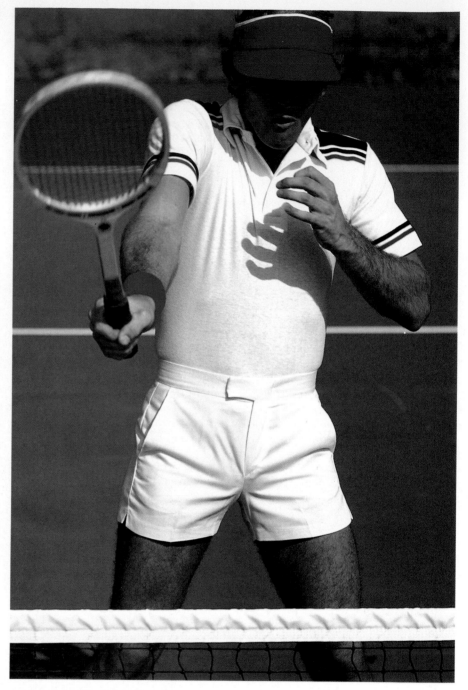

When you're taking shots of fast action, you can't predict precisely what each image will look like. The tennis action photo reproduced here was one of a series shot with a motor drive. I selected the best images when the processed slides came back from the lab. However, even though you don't have total directing control over photos such as this, you can prepare in a variety of ways to ensure that you get something very close to the image you had envisioned.

I like strong graphic elements that give dynamic emphasis to a subject. I made this photo from a stepladder in order to get the green, rust and white court markings into the background. The use of a short telephoto lens foreshortened perspective, making the background more prominent. Only a little of the net needed to be visible in the foreground in order to complete the tennis story.

I had Steve facing toward the sun as he returned balls being thrown to him from across the net.

Because the photo was for a fashion ad for active sportswear, the facial lighting on the model played a secondary roll to the clothing and the activity.

I had planned for some interesting and dramatic shadow play. As you can see, I achieved it. While Steve is barely recognizable in the deep shade under the visor, his open mouth is lit by direct sunshine, dramatizing his genuine effort and concentration.

42

Subject: An athlete at UCLA, Los Angeles, California
Location: UCLA
Camera: 35mm SLR
Lens: 180mm
Lighting: Direct sunlight
Film: Kodachrome 25
Exposure Metering: Through-The-Lens (TTL) reflected-light reading
Exposure: 1/250 second at *f*-5.6 to *f*-8

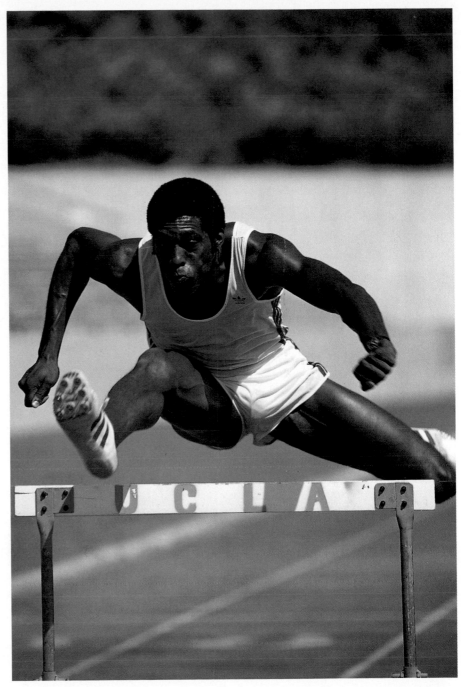

In my early days as a photo amateur I carried my camera everywhere and photographed just about everything in sight. I'm still never far removed from a camera but my times of being a pure hobbyist are few and far between. Surprisingly, therefore, this photo was taken just for the fun of it! My cooperative model was an athlete at UCLA who was, at the time, trying for a place on the U.S. Olympic decathlon team.

I've never liked sharply detailed, green foliage as a background in a photograph. I find it distracting and unattractive. By using a 180mm telephoto lens and a fairly large lens aperture, I was able to limit depth of field to transform the background foliage into an abstract pattern of tones.

Using a medium-long telephoto lens also enabled me to get back far enough from the hurdler to record the white wall in the background comparatively large, making the dark frame of the athlete stand out dramatically against it.

I envisioned the finished photograph in my mind's eye before making the shot. I wanted extremely tight cropping, with just a hint of surrounding track elements. Because cropping was so critical, I placed my camera on a sturdy tripod.

I prefocused on the hurdle. Then, I asked the athlete to make several passes over the hurdle. On each pass, I shot off about six frames in rapid succession with my camera's motor drive. I used the successive passes over the hurdle to bracket exposures.

With this athlete's incredible style, it wasn't difficult to get several very fine images. I found the one reproduced here particularly impressive. Everything seemed to be in just the right place—not only to make a credible action shot, but also a very pleasing composition.

43

Subject: Romé Bernstein
Location: Beverly Hills, California
Camera: 35mm SLR
Lens: 85mm
Lighting: Direct sunlight
Film: Kodachrome 25
Exposure Metering: Incident-light reading
Exposure: 1/125 second at *f*-8

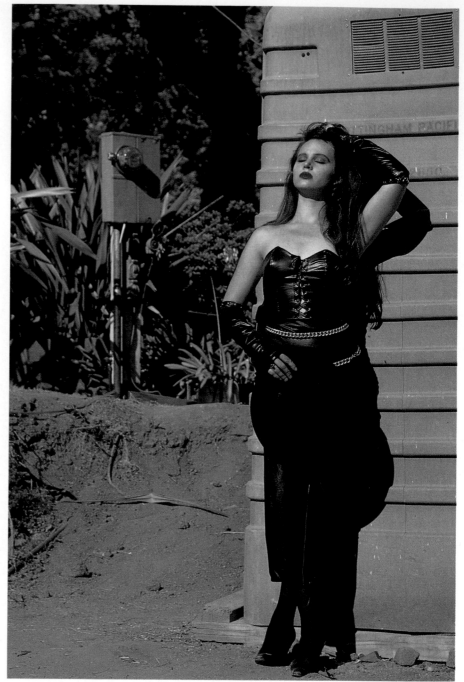

Every individual is unique. A photograph should be designed to reflect that uniqueness. In this case, the subject is my wonderfully bizarre daughter, Romé. Romé has always been avante-garde in terms of styling and fashion. Here she displays a departure into the world of punk and heavy metal—styles that have become so influential in contemporary couture fashion design.

I posed Romé at a construction site against a Port-a-John to add even more humor to the outlandishness of this image. To create further drama and graphic impact, contrast is intentionally emphasized through the use of Kodak Kodachrome 25 film and direct late afternoon sunlight without a fill source.

Spontaneity is at a peak in outdoor available-light photography because the photographer needn't wait for a recycling strobe in the sterility of the studio environment. The subject is free to change attitudes at a rapid rate. It's an opportunity for the camera to act as a candid observer and recorder of the scene.

44

Subjects: Scott MacKenzie, professional model, and young boy
Client: Gant Shirtmakers
Ad Agency: Waring & Larosa
Art Director: Howard Title
Location: Central Park, New York City
Camera: 35mm SLR
Lens: 105mm
Lighting: Daylight; open shade
Film: Kodachrome 25
Filtration: 1A skylight filter
Exposure Metering: Incident-light meter reading
Exposure: 1/250 second at ƒ-5.6

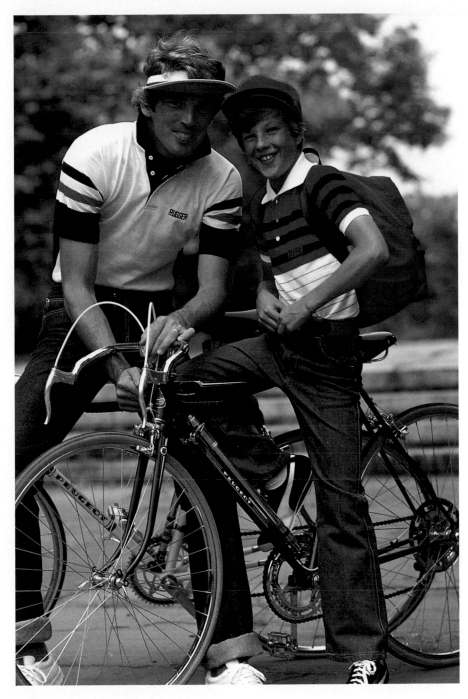

Howard Title is an art director who is astute enough to realize that two things sell a product—first, the product itself and, second, the attitude of those featuring the product in a photograph.

In this image for Gant Shirtmakers, "father" and "son," with heads close together, radiate a feeling of a casual but warm relationship and a great joy of life. This joy translates into an obvious pleasure with which the advertised garments are worn.

The client had requested that these two particular shirts be featured together. A couple of requirements were that the RUGGER logo in each shirt be clearly visible and that the collar design of each shirt was clearly discernible.

The bicycle was an important prop. However, while it plays a prominent part in the "story," it was not permitted to dominate the image. In order to keep viewer attention on the bright shirts and, at the same time, avoid directing excessive attention to the bicycle, we had the models wear dark blue jeans.

To avoid the contrast and unpleasant shadows caused by direct sunlight, I shot in open shade. To eliminate an unpleasant bluish color cast from the sky, I used a 1A skylight filter.

A lens aperture of ƒ-5.6 ensured that the foliage in the background would be recognizable but not sharp and distracting.

45

Subjects: Mary Maciukas,
Randal Lawrence, Michael Wiles
and Joe Macdonald, professional
models
Client: Hunter Haig,
a Division of Palm Beach
Ad Agency: Blaise Associates
Art Director: Art Baum
Location: East Hampton,
New York
Camera: 6x6cm SLR
Lens: 80mm and 150mm
Lighting: Early afternoon sunlight
Film: Ektachrome 64
Filtration: Diffuser
Exposure Metering: Incident-light
meter reading
Exposure: 1/250 second at *f*-8

I had been asked to create the fashion photographs for a brochure that was to be very elegant and well produced. I wanted to use elements that would at one and the same time give the production distinct continuity throughout and be believable in the context of the clothing chosen.

I considered "Gatsby" type settings to be ideal. Beach scenes were used for most of the shots, but some were taken in more pastoral environments. Props such as champagne, binoculars and a fine old automobile helped the illusion along. All of the photos were made in direct, early afternoon sunlight.

To add a dreamlike quality to the images, I used a fairly strong diffusion filter. Before setting out to shoot the entire series, I submitted a variety of test shots, each with a different degree of diffusion and mood, for the client's

consideration.

There's no technical reason for not using a diffuser in direct sunlight. It helps to soften the overall contrast, which can be a help in very hard lighting such as I was working in. However, although the faces in many of the images were in total or partial shadow, it was not essential in this case to record detail in them. The important element in this series was, after all, the clothing.

Although diffused images lend themselves to a greater degree of either over or underexposure, I bracketed my exposures generously to be sure I got precisely the effect I was after in each shot.

Incidentally, image diffusion should not be confused with soft focus. I could not afford to have these images even slightly out of focus because the tex-

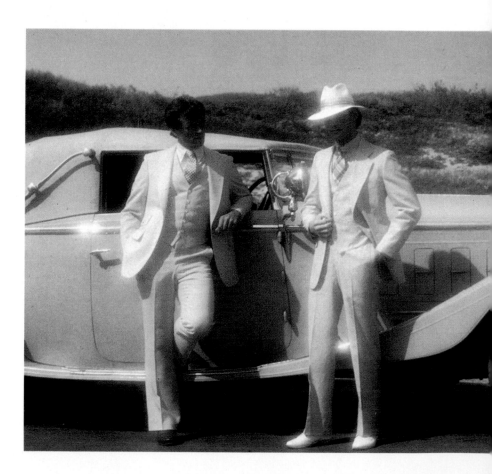

ture, pattern and detail in the clothing were the key elements and had to be shown sharply. Image diffusion simply carries highlight areas over into shadow areas. Look at these images carefully and you'll see all the detail the lens and film could record.

Incidentally, in the bicycle shot the girl wasn't actually riding by as I shot. This would have made my image composition difficult indeed. A couple of assistants, out of view of the camera, held up the bike at the front as the model sat on it.

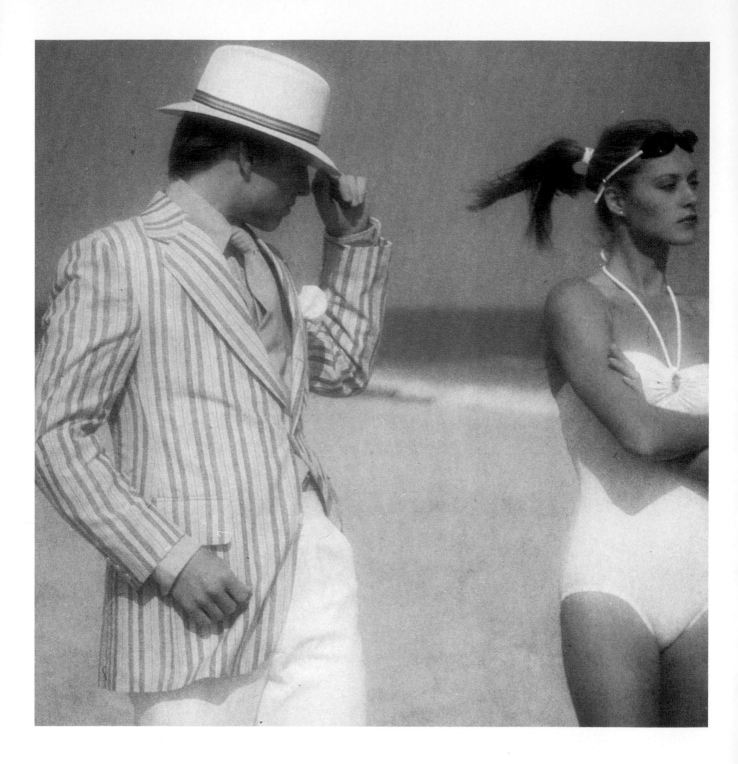

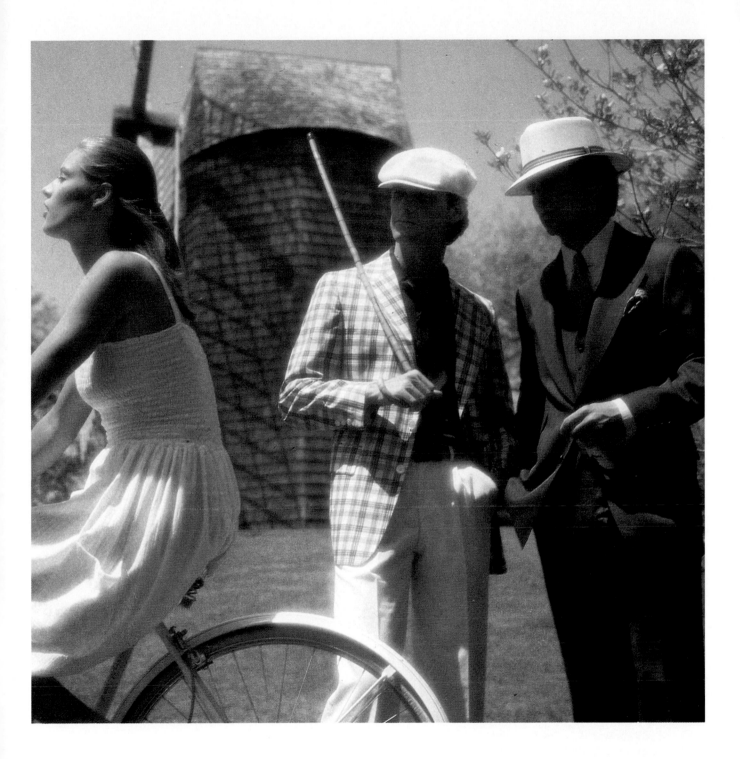

46

Subjects: Elizabeth Taylor and Robert Wagner
Clients: ABC Television/Columbia Pictures/RJ Productions
Ad Agency: Grey Entertainment & Media
Art Director: Chris Pula
Location: A rental studio in Los Angeles
Camera: 6x6cm SLR
Lens: 120mm

Lighting: One 1200-watt-second main light; four 800-watt-second background lights
Light Control: Large silvered reflector
Film: Ektachrome 64
Exposure Metering: Electronic flash meter in incident-light mode
Exposure: *f*-11 (shutter at 1/250 second)

This is one of a series of advertising and publicity photographs I made for the movie *There Must Be a Pony*. The film was a collaboration between Robert Wagner's *RJ Productions, ABC Entertainment* and *Columbia Pictures. Grey Entertainment Media (GEM)* coordinated advertising in general.

Each of the above had their own photographic needs that I had to satisfy. The photograph reproduced here also appeared on the cover of *Professional Photographer* magazine.

This was the first time I had photographed Elizabeth Taylor. I found her even more stunning and beautiful than I had imagined her to be from seeing her movies and photographs. Upon meeting Elizabeth, I was struck by her vulnerable, little girl quality—a quality I desperately wanted to capture in her photographs.

Having totally familiarized myself with what my various clients wanted, I was given the freedom to shoot the session my way. The shoot was an enormous success.

The rapport between Taylor and Wagner was almost electric, as this photo clearly shows. These two special people have an incredible aura about them that truly transcends the documentary capabilities of film.

To get an adequately large image while, at the same time, leaving plenty of room around the image for various client needs, I shot in the 2-1/4-inch-square format rather than my usual 35mm.

The main light was slightly to the right of the camera and a little higher. A silvered reflector from below filled the shadows with light and added a second catchlight to the eyes.

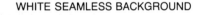

WHITE SEAMLESS BACKGROUND

SILVERED
REFLECTOR

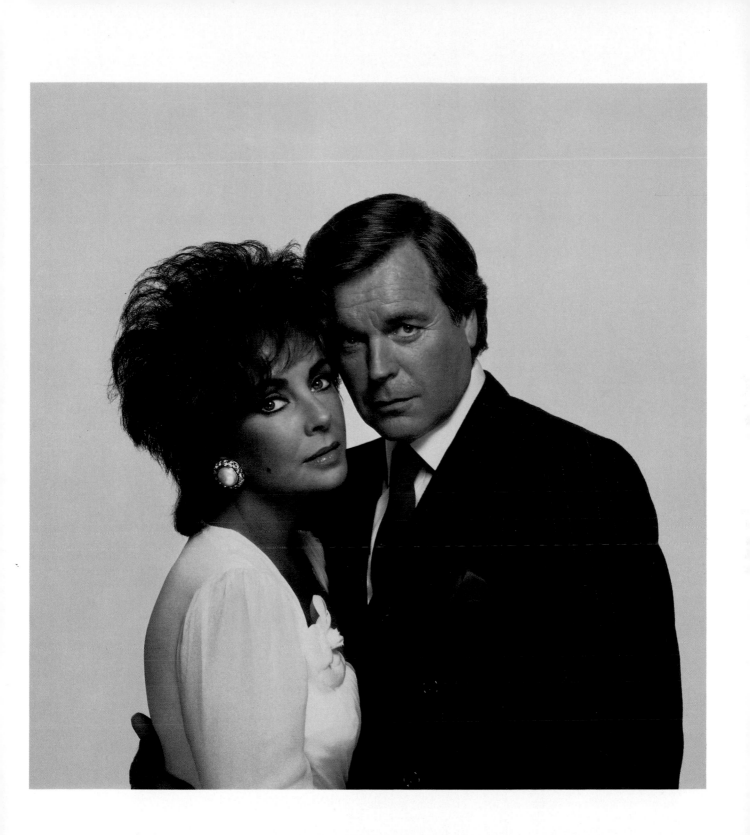

47

Subject: Kay Sutton York
Location: Gary Bernstein Studio, New York City
Camera: 6x6cm SLR
Lens: 80mm
Lighting: One 1200-watt-second electronic flash
Film: Kodak Plus-X and Kodachrome 25 (see text)
Filtration: Orange filter
Exposure Metering: Electronic flash meter, incident-light mode
Exposure: Plus-X b&w image—*f*-16 (shutter at 1/125 second)

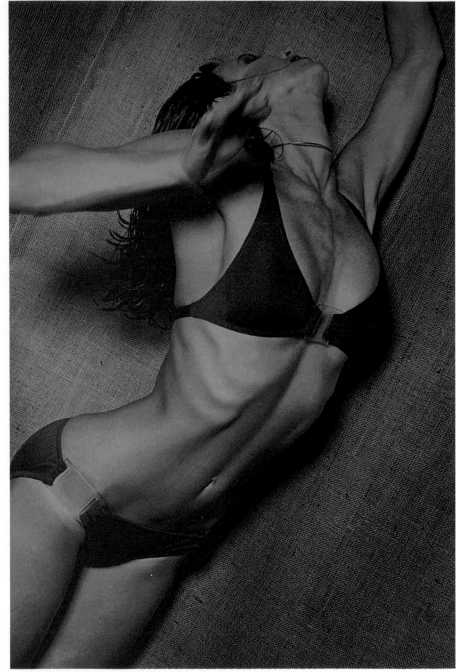

At the time this photograph was made, I was shooting a lot of editorial work for *Esquire* and *Harper's Bazaar*. This image was part of an experimental swimsuit layout I shot with Kay Sutton York, for submission to *Harper's Bazaar*.

Kay's wonderful figure makes her an ideal choice for swimwear. As a top professional dancer before entering modeling, she also possesses amazing body control and the rare ability of knowing precisely how she looks to the camera. Such talent is an enormous advantage to the photographer. Kay is without a doubt the finest model I've ever worked with.

To produce an image that was a little different from the norm, I did a couple of unconventional things. First, I posed Kay standing up but rotated the camera to achieve a diagonal composition. In doing so, I produced an image with a look of vitality and motion.

Second, I shot the original image on black and white film. To get the warm monochromatic color, I copied a black and white enlargement onto Kodachrome 25 film, using an orange filter.

The background was a simple sheet of burlap in a homemade frame. Illumination came from one electronic flash, placed just to the left of the camera.

Kay's right hand is slightly blurred, due to the relatively long flash duration and the bright modeling light on the flash. The effect adds vitality and a sense of motion to the image.

120

48

Subject: Kay Sutton York
Client: A poster company
Location: Gary Bernstein's home, Beverly Hills, California
Camera: 35mm SLR
Lens: 50mm
Lighting: Two portable 100-watt-second flash units
Light Control: Two white seven-foot folding reflectors
Film: Kodachrome 64
Exposure Metering: Electronic flash meter in incident-light mode
Exposure: *f*-4 (shutter at 1/60 second)

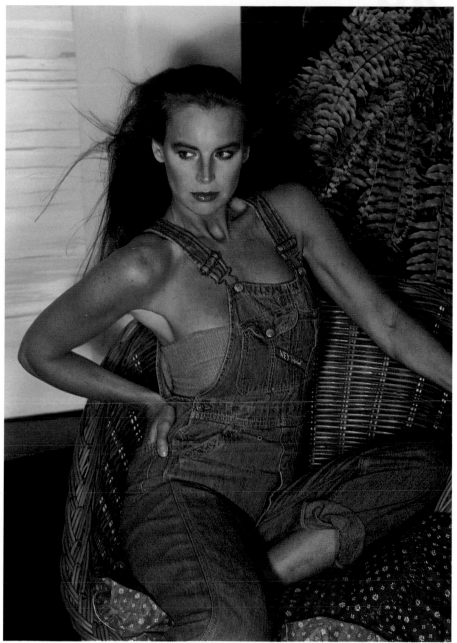

This is a fine example of *Secret 4,* which stresses that excellent images can be made with remarkably modest lighting. Although this shot of Kay Sutton York was made for the country's largest poster company, for international distribution, it was made with just two portable, 100-watt-second electronic flash units.

To achieve a flattering and soft, yet directional light that enveloped Kay, I bounced each flash from the upper portion of a white seven-foot folding reflector, erected in a V-shape. The reflectors were placed to either side of Kay, each about the same distance from her.

By varying reflector distances from a subject and changing the angle of the light in each reflector, a variety of

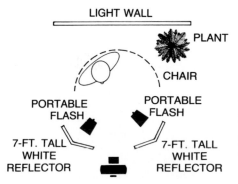

lighting effects can be achieved with two-reflector lighting.

The rustic set is a corner of my "rustic" living room. To graphically separate Kay's dark hair from the background, I shot from an angle that placed a light wall behind her.

I shot a series of images, using two different Kodachrome films. This particular shot was taken on Kodachrome 64, giving nearly 1-1/2 *f*-stops more speed than Kodachrome 25, which I use most of the time. The extra speed was helpful due to the relatively low light output of the two portable flash units.

121

50

Subject: Gabrielle, professional model
Client: Textrend
Art Director: Nancy Goldsmith
Location: Gary Bernstein Studio, New York City
Camera: 35mm SLR
Lens: 55mm
Lighting: One 1250-watt-second flash in pan reflector
Film: Kodachrome 25
Exposure Metering: Electronic flash meter, incident-light mode
Exposure: f-8 (shutter at 1/60 second)

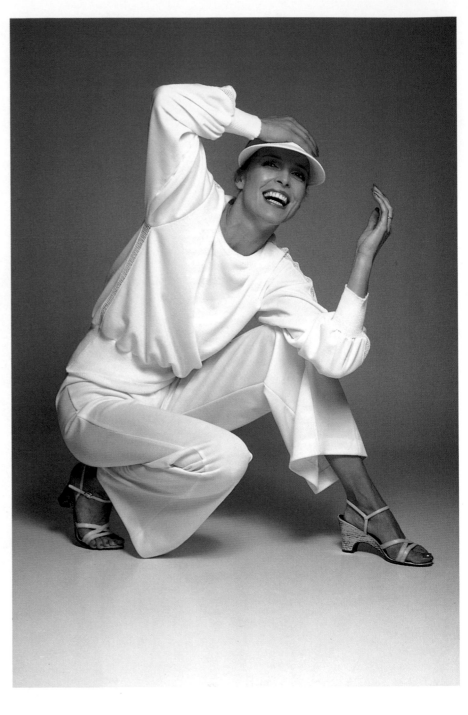

A good model possesses the uncanny ability to make the difficult look easy. Such was the case with this shot of Gabrielle, who held this very difficult position, and variations of it, for as long as it took for me to record all the images I needed.

To show the garment to best advantage in this photo, produced for a fashion ad, my camera position was just slightly above floor level.

The floor was white architectural linoleum. The background was white seamless paper. The paper was curved forward and taped to the floor. Because the depth of field did not extend that far, and because the background recorded fairly dark in that area, the join of paper to floor is not evident in the photo.

The single light source was high and close to the subject. This enabled me to get as much light as possible on the face to get good exposure of the skin tones without burning out the white garment. To get light under the visor, I asked Gabrielle to tilt her head upward.

The background was deliberately underexposed to yield a medium gray, so that the white garment would stand out clearly.

51

Subject: Ben Vereen
Client: Jean-Paul Germain, Ltd.
Location: Gary Bernstein Studio,
Los Angeles, California
Camera: 35mm SLR
Lens: 55mm
Lighting: One 1250-watt-second
flash in pan reflector
Film: Kodachrome 25
Exposure Metering: Electronic
flash meter in incident-light mode
Exposure: *f*-8 (shutter at 1/60
second)

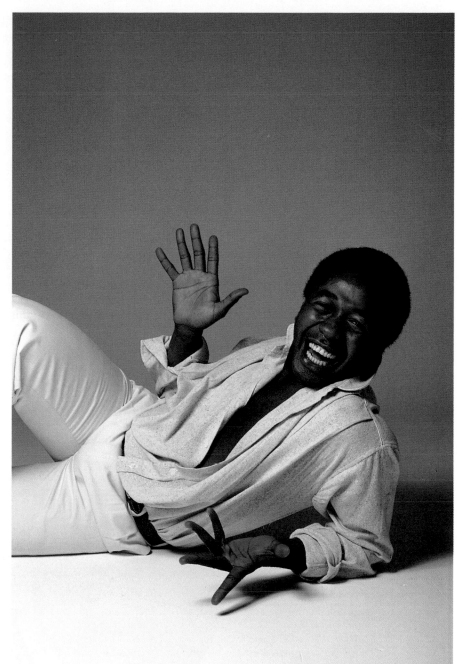

In the Jean-Paul Germain *Winners* campaign, which ran for years, advertising continuity was ensured by use in each image of a symbolic thumb-up sign. I had been shooting vivacious Ben Vereen for the campaign. When I had taken the obligatory thumb-up shots, I asked Ben to remain in position so that I could take some general, personal photos.

Ben is one of the most animated, expressive subjects—both bodily and facially—that I have worked with. He has very expressive hands and it was not difficult, with little direction on my part, to capture natural gesticulations such as depicted here.

As far as the advertising part of this shooting session was concerned, there wasn't a more suitable choice for modeling the casual men's clothing featured than casual, genial Ben Vereen.

The position of the one light source in relationship to the subject and the background was such as to give two *f*-stops less light to the white background than to the subject. This provided a medium gray tone in the background, helping to make the light clothing stand out prominently.

The image reproduced here was one of a large series. Most of them were as successful as this one, thanks to Ben's ever-changing but ever-right attitude.

54

Subject: Karen Velez
Location: Gary Bernstein Studio, Los Angeles, California
Camera: 35mm SLR
Lens: 55mm
Lighting: One 800-watt-second flash in 32-inch shoot-through umbrella, on boom stand; one 800-watt-second flash on background
Light Control: One large silvered reflector
Film: Kodachrome 25
Exposure Metering: Electronic flash meter in incident-light mode
Exposure: *f*-8 (shutter at 1/60 second)

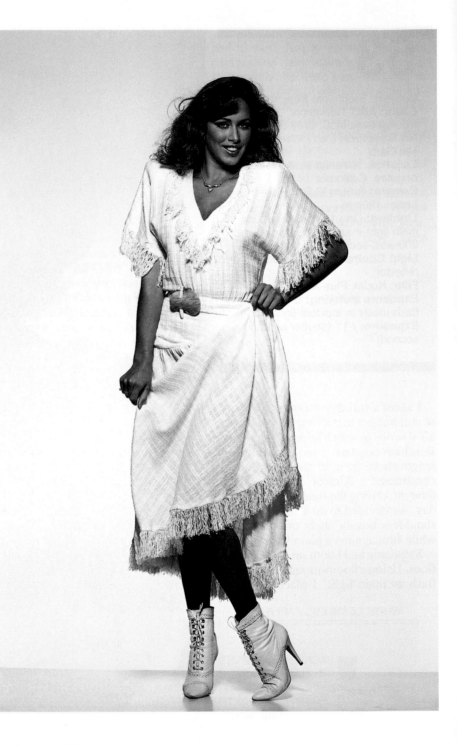

This photograph of Karen Velez, a former *Playboy* Playmate of the Year, was made for her modeling portfolio. I made a comprehensive series of head shots, as well as half length and full length photos, selecting this full length shot for reproduction in this book.

Karen stood in the white, vertical cove in my studio. She was standing on a platform that was high enough to enable me to conceal a background light directly behind and beneath it. This enabled me to achieve a white background with a subtle vignetting toward the corners of the image area.

Pretty Karen is totally adept in front of the camera. She simply moved— and I shot. The use of an electric fan to blow her hair and dress added to the feeling of movement. The direct eye contact with the camera, and hence the viewer, heightens the appeal of the image.

The flattering, medium soft lighting was achieved with a 32-inch shoot-through umbrella, placed above the camera on a boom stand. A large, silvered reflector card, placed just in front of the models' feet, ensured uniform lighting over the subject and bright-ened some of the deeper shadows.

A low camera viewpoint and the use of a lens of relatively short focal length emphasized the elegant stature of my subject.

55

Subject: Mary Maciukas
Client: Truform
Ad Agency: Alten, Cohen & Naish
Art Director: Larry Alten
Location: Gary Bernstein Studio, New York City
Camera: 35mm SLR
Lens: 85mm
Lighting: Main light of 1250-watt-seconds in pan reflector; two 1200-watt-second background lights in 45-inch umbrellas
Film: Kodachrome 25
Exposure Metering: Electronic flash meter, incident-light mode
Exposure: *f*-8 (shutter at 1/60 second)

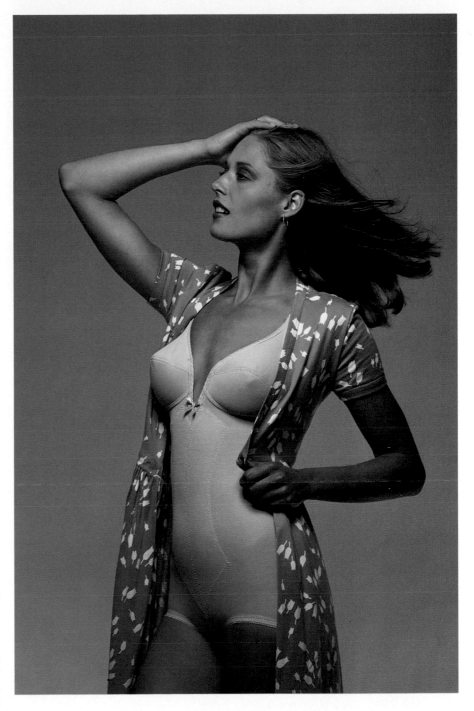

When featuring intimate garments in an advertising photograph, many clients wish to avoid obvious suggestions of sexuality and sensuality. Consequently, it's important to reveal only as much of the model as is necessary to depict and flatter the garment and show its comfort.

To satisfy the above requirements, I have deliberately avoided subject eye contact with the camera. I added an upper garment as an accessory. While in no way hiding the product, it helps to minimize exposure of the model. I deliberately allowed the light to fall off toward the lower part of the image.

To add life to the photo, I used an electric fan to blow the model's hair. The model's left hand is holding the upper garment, pushing it slightly toward the front. This not only prevented the garment from being blown about by the fan but also helped to graphically shape the waist.

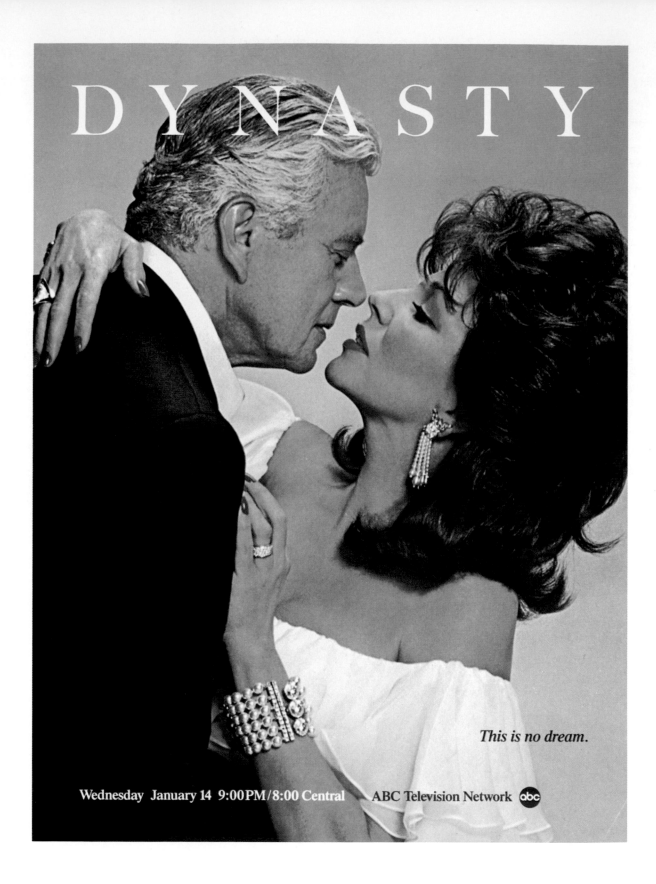

DYNASTY

This is no dream.

Wednesday January 14 9:00 PM/8:00 Central ABC Television Network ⓐⓑⓒ

56

Subjects: Joan Collins and John Forsythe
Client: ABC Television
Ad Agency: Grey Entertainment & Media
Art Directors: Chris Pula, Barry Weintraub
Location: ABC-TV photo studio, Los Angeles
Camera: 35mm SLR
Lens: 55mm

Lighting: Main light of 1200-watt-seconds in umbrella; four 800-watt-second background lights; one 400-watt-second hair light, with barn doors, on boom stand
Light Control: Two 7-foot gobos
Film: Kodachrome 25
Exposure Metering: Electronic flash meter in incident-light mode
Exposure: *f*-16 (shutter at 1/60 second)

I had been asked to produce publicity photographs for two specific episodes of the ABC-TV prime-time show, *Dynasty,* starring John Forsythe and Joan Collins. Individual episodes are not generally publicized so elaborately. The reason for the special attention to these episodes was the fact that they introduced a distinct, if temporary, change in two of the main characters: Blake Carrington (played by John Forsythe) and his former wife Alexis Colby (played by Joan Collins) were apparently rekindling their old love. Hence the loving attitude between the two, as shown in my image—an attitude that appeared highly uncharacteristic of them.

It was important to get real emotion into the image. I asked the two actors to "play the scene" in front of my camera as if they were doing it for the TV cameras. They did a magnificent job. I simply shot the action as it progressed.

Much of the charm and impact of the photo reproduced here is derived from the wonderful profile of Joan Collins. The main light was a soft, frontal umbrella light. The hair light, from above and slightly behind the subjects, acted as a typical profile light, providing a rim of light to Joan's nose and forehead. I used barn doors on the hair light to shield John Forsythe's head which would, otherwise, have lost detail through being burned out.

The background was plain, so that the art directors could easily add copy to the illustration.

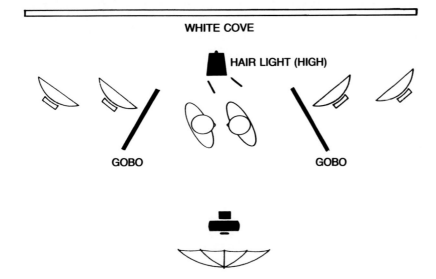

WHITE COVE

HAIR LIGHT (HIGH)

GOBO

GOBO

57

Subject: Kay Sutton York
Location: New York City
Camera: 35mm SLR
Lens: 85mm
Lighting: One 100-watt tungsten bulb
Film: Ektachrome 200 (Daylight)
Exposure Metering: Incident-light reading
Exposure: 1/60 second at ƒ-5.6

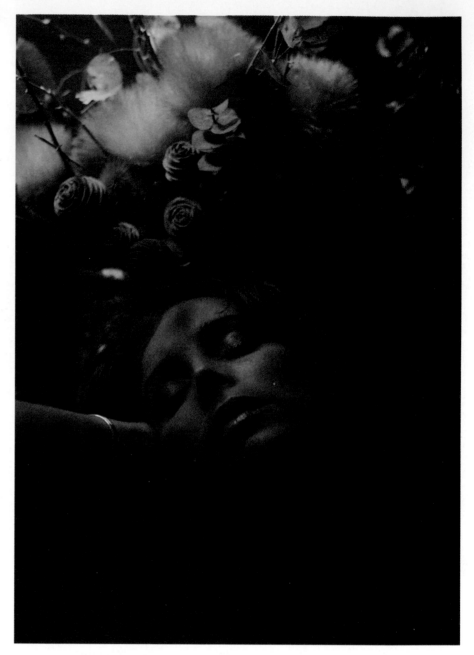

This photo is a good example of photographic experimentation. There is no harm in breaking rules—even several rules at a time—if you achieve the end result you aimed for.

This is one of a series of shots I made for Revlon. For me, it also constitutes a very personal, romantic image.

Lighting came from a common 100-watt household bulb. I used Ektachrome 200 Daylight film, exposing it at a 400 rating. This enabled me to expose at 1/60 second and the push-processing helped to provide the coarse grain that is so suitable for this particular theme.

Although I was using low-wattage tungsten light with daylight film, I intentionally did not use any filtration. This gave the image a beautiful, warm glow.

The low position of Kay's head in the image, and her closed eyes, lend a very restful, serene atmosphere to the photo.

58

Subjects: Danny and Karen Pritzker
Location: Gary Bernstein Studio, Los Angeles, California
Camera: 35mm SLR
Lens: 85mm
Lighting: Main light of 1250-watt-seconds in pan reflector; two 800-watt-second background lights in umbrellas
Film: Kodachrome 25
Exposure Metering: Electronic flash meter in incident-light mode
Exposure: *f*-16 (shutter at 1/60 second)

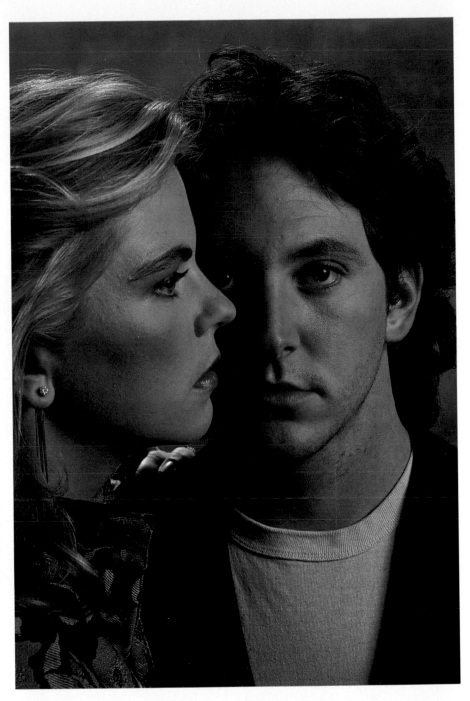

I took this photograph of Danny and Karen Pritzker on the occasion of their wedding. My intention was to make an intimate study of the couple together while, at the same time, producing a strong image of each individual face.

This photo is an excellent example of how masculine and feminine lighting can be combined in one photo, using only one light. The main light was to the right of the camera. It lit Karen almost frontally, giving a soft, flattering light that is ideal for a woman's face. The same light lit Danny at a sharp angle, producing a deep shadow on the right side of his face. This angular, contrasty lighting provided good

PAINTED CANVAS

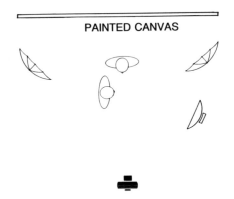

modeling to the face and gave his image a characteristically rugged, masculine look.

Notice that Karen's profile appears against the deep shadow on Danny's face. This provided good graphic separation between the subjects.

Although Danny's right eye is in an area of shadow, I made sure that it would yield a catchlight from the main light. A catchlight in both eyes is important, giving an image of a face graphic balance.

The painted canvas background was lit evenly by two flash heads in umbrellas.

133

59

Subject: Regine Jaffrey, professional model
Client: Leslie Fay, Inc.
Art Director: Barbara Sadtler
Location: A rented town house in New York City
Camera: 35mm SLR
Lens: 50mm
Lighting: One 1200-watt-second flash in 36-inch white umbrella
Film: Kodachrome 25
Exposure Metering: Electronic flash meter, incident-light mode
Exposure: ƒ-11 (shutter at 1/60 second)

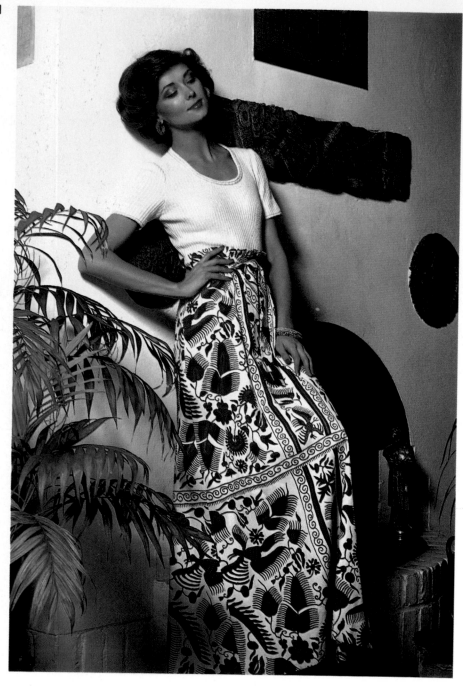

For many years, Regine Jaffrey was one of the top fashion models in New York City. From any photo of her, it's easy to tell why. Regine's wonderful feel for body attitude, her acting ability and her inherent elegance were a combination that was hard to beat.

In this fashion shot, taken for Leslie Fay, Inc., the light, location, camera viewpoint and lens choice were all used in a manner to achieve a specific result.

I elected to use a 50mm lens. It allowed me to shoot from close to the subject. Aiming up from a low position enabled me to emphasize the elegant stature of the model. It also placed me close to the commercially most important part of the image—the skirt. Notice the detail recorded in the patterning of the garment.

Because the image consists basically of a woman in light clothing against a light background, I needed a subtle way of getting graphic separation. The light source was to the left of the camera and at about the subject's eye level. The shadow on the light wall helps to separate the model's left arm from the background.

The model was positioned carefully so the dark fireplace and wall decor made the light clothing stand out. Even the plant on the left of the image was placed carefully so its leaves would outline the skirt.

60

Subject: Swad, professional model
Client: Black Elegance
Art Director: John McMurray
Location: The Four Seasons Hotel, Beverly Hills, California
Camera: 35mm SLR
Lens: 55mm
Lighting: One 1200-watt-second flash in pan reflector plus tungsten light
Film: Kodachrome 25
Exposure Metering: Electronic flash meter in incident-light mode; reflected-light daylight reading
Exposure: See copy

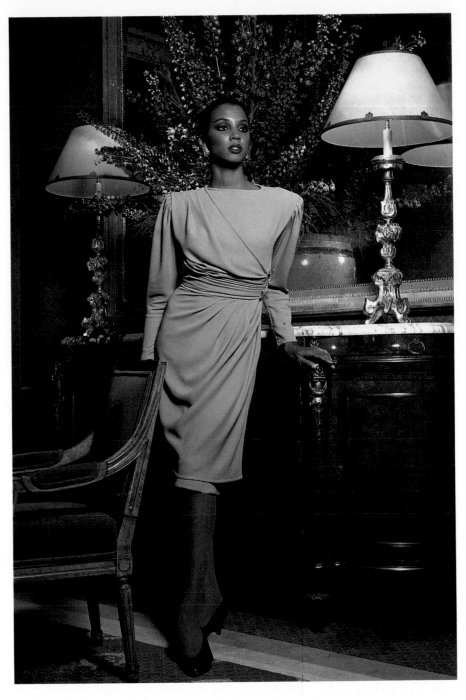

Beautiful Swad from Paris, France—a full 6 feet 1 inch tall—is the subject of this fashion shot, produced as part of a layout for *Black Elegance* magazine. The image was shot with a combination of electronic flash and tungsten light, the latter registering on the film by use of an appropriately slow shutter speed.

I began by positioning Swad between the two table lights rather than in front of one of them. If she were in front of one of the lights, the long exposure time would allow light from the lamp to "burn" into her image.

I metered the tungsten light from camera position. The exposure reading I got was 1/2 second at *f*-8 on Kodachrome 25 film. Next, I set the flash to give correct exposure on Swad's face at *f*-8.

I told Swad that she would have to stay quite still during the relatively long exposure to avoid image blur. My camera was on a tripod. I bracketed shutter speeds from 1/8 second to 2 seconds and lens aperture settings from *f*-5.6 to *f*-11.

When the slides came back from the processing lab, I had a variety of exposures to choose from. I liked the one reproduced here best. It's wonderful to behold how, as photographer, you can totally change the effect of reality, as it appears to the eye, by exposure manipulation.

61

Subject: Kay Sutton York with cat
Location: Aruba, Netherland Antilles
Camera: 35mm SLR
Lens: 105mm
Lighting: Direct late afternoon sunlight
Film: Kodachrome 25

Filtration: Homemade acetate diffuser
Exposure Metering: Reflected-light spot-meter reading
Exposure: 1/125 second at f-8 to f-11

This photograph of magnificent Kay Sutton York was made by direct sunlight, although both Kay and I were indoors. The low evening sun illuminated Kay directly through an open window. The patch of wall directly behind Kay is the inside wall of an atrium. The white atrium walls received only indirect light, similar to open shade. Consequently, the background has a distinctly bluish cast, as opposed to the late afternoon warmth of the sunlight on Kay's face.

Kay was kneeling on a pillow on the floor. Compositionally, by holding the cat in front of her mouth, Kay was able to concentrate viewer attention on the juxtaposition of the two pairs of eyes— Kay's and the cat's. It made for a very captivating image.

The combination of Kay's healthy tan with the reddish glow of the evening sunlight produced a beautifully warm image.

The image was slightly diffused with a homemade diffuser. I made the simple diffuser by sparingly applying a spray-fix to a sheet of clear acetate.

To avoid an erroneous exposure-meter reading because of the expanse of dark background, I took a spot-meter reading of Kay's skin.

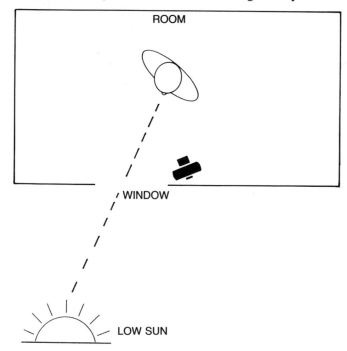

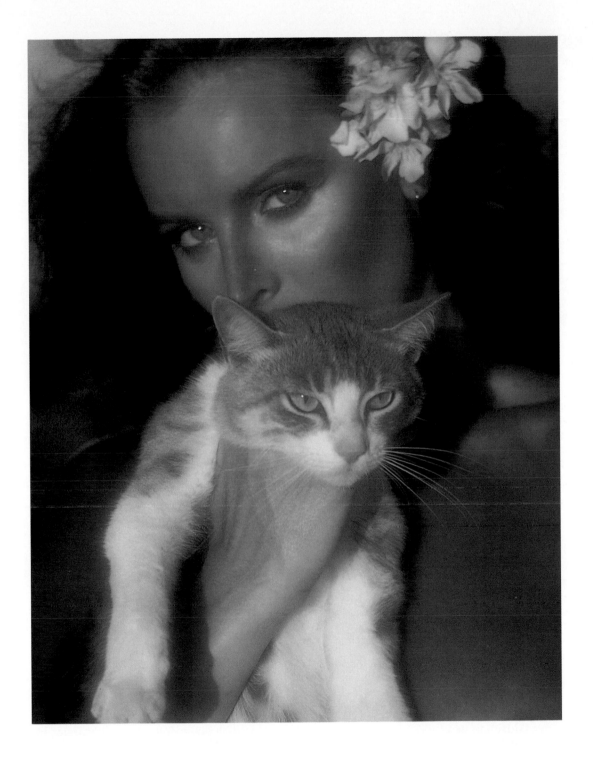

62

Subjects: Robert Leibler and Joseyanne
Client: Esquire
Art Director: Robert Leibler
Location: Gary Bernstein Studio, New York City
Camera: 35mm SLR
Lens: 55mm
Lighting: One 1200-watt-second flash in 32-inch umbrella
Film: Kodachrome 25
Exposure Metering: Electronic flash meter, incident-light mode
Exposure: *f*-8 (shutter at 1/60 second)

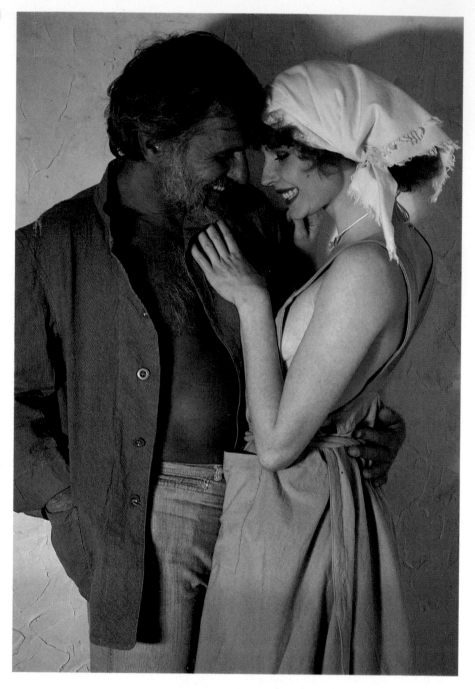

After a hectic day of shooting for *Esquire* magazine, we shot this "fun" picture of art director Robert Leibler and model Joseyanne. She is wearing the outfit we were featuring in the *Esquire* shots and Bob is wearing his own clothing.

I'm reproducing this photo here not only because there's a wonderful, warm feeling between the two subjects but because it enables me to make several interesting points.

The shot is totally natural, with little direction on my part. Although the subjects are looking at each other, they are not looking eye to eye. The downward glance creates a charming feeling of demureness in the image.

Graphically, there is an interesting contrast between his rugged appearance, dark tan and beard and her delicate, soft look and light skin. I positioned the single umbrella-flash main light closer to Bob than Joseyanne. Exposing for the light striking Joseyanne caused Bob to be overexposed by about one half an *f*-stop. This deliberate reduction in subject contrast enabled the film to record detail throughout the entire tonal range better.

The placement of the main light had the secondary benefit of giving crisp, angular modeling to Bob while providing a soft frontal light to Joseyanne.

The photo has a late afternoon outdoor feeling, largely attributable to the low angle of the light. In another, similar shot, I used an amber gel filter over the light source to give the image the warm glow of apparent late afternoon sunlight. The outdoor feeling is reinforced by the stuccoed background.

63

Subject: Donna Mills
Client: Swatch Watch USA, Inc.
Location: Gary Bernstein Studio,
Los Angeles, California
Camera: 2-1/4-in.-square SLR
Lens: 150mm
Lighting: One 1250-watt-second
main light in pan reflector;
four 800-watt-second background
lights in umbrellas
Light Control: One small silvered
reflector
Film: Ektachrome 64 Professional
Exposure Metering: Incident-
light reading
Exposure: *f*-11 (shutter at
1/250 second)

Sexy Donna Mills is the subject of this advertisement for Swatch Watch U.S.A. Because of the abundance of color in the products depicted, I selected a simple, pure white background, and equally simple T-Shirt as Donna's wardrobe. In doing so, the viewer's eye goes directly to talented Donna and the product.

The white background was achieved by double-stacking two wide-angle reflectors bounced into umbrellas to either side of my white background. The background lights metered an *f*-11 exposure at subject position. Because Donna was only about four feet from the background, the intentional background overexposure causes a bit of "flashing"—a cinematic term referencing an overall reduction in transparency contrast.

The addition of a small—but extremely efficient—silvered reflector beneath Donna's face softened contrast even more and added secondary catchlights to her pretty eyes. Donna is one of the busiest actresses in this city, and quite frankly, I've never known her to have quite this much time on her hands!

64

Subjects: Victoria Principal and Uva Harden
Client: Esquire
Art Director: Max Evans
Location: Malibu, California
Camera: 35mm SLR
Lens: 85mm
Lighting: Daylight, overcast
Light Control: One silvered reflector
Film: Kodachrome 25
Filtration: 1A skylight filter
Exposure Metering: Incident-light reading
Exposure: 1/60 second at ƒ-5.6

This photograph is significant for me because it was part of the first editorial layout I shot for a national magazine. I had been in New York for about six months when Max Evans, then Fashion Director and Vice President of *Esquire* magazine, called me about "a shoot in California." It's a moment I'll never forget!

I couldn't have been more fortunate with the models I had for the shoot. Uva Harden was, even then, one of the most successful male models in the history of our industry. His fresh and foxy companion was a young actress by the name of Victoria Principal!

The photos made during the session were for a men's fashion magazine, so Uva Harden was the main subject and Victoria his "backup." For that reason, Uva was positioned to receive the dominant lighting.

The photo reproduced here was part of a series that was directed almost like a scene for a motion picture. The scene I described to my subjects would involve their walking up to a table, sitting down, pouring wine, lighting a cigarette and embracing. I recorded each stage on film, using a motor-driven camera.

Lighting presented no problem because the illumination from an overcast sky is so uniform and "forgiving." Nearly every shot from the sequence was usable.

The diffused daylight came in low under an overhang in front of the restaurant where we shot, providing beautiful illumination on Uva. Victoria, who was facing away from the daylight, was lit by redirected daylight from a silvered reflector.

To add some warmth to the characteristically bluish color of the overcast daylight, I used a 1A skylight filter.

65

Subject: Erin Grey
Client: J.P. Stevens
Art Director: Peg Mathews
Location: Palm Beach, Florida
Camera: 35mm SLR
Lens: 85mm
Lighting: Daylight, overcast
Film: Kodachrome 25
Filtration: 1A skylight filter
Exposure Metering: Incident-light meter reading
Exposure: 1/125 second at ƒ-5.6

Long before talented Erin Grey became a successful motion picture and television actress, she was a very successful model. I loved working with her because she worked to the still camera the same way an actress works to the movie or TV camera—with tremendous emotion, energy and dedication.

The assignment for this photo was from J.P. Stevens, a well-known manufacturer of fabrics. The purpose of the photo, therefore, was to feature the material rather than the finished clothing. My aim had to be to show the texture, color and "feel" of the material to best advantage.

The red clothing of the lifeguard and the red lifeguard vehicle complement and emphasize the neutral color of the fabric. The red areas on both sides also serve to frame Erin effectively, concentrating viewer attention on her.

Erin is the main subject of the photo. The lifeguard is serving simply as an interesting human "prop." That's why he is facing away from the camera, is slightly out of focus, and is partially cropped from the image.

Soft, overcast skylight provided flattering illumination to both Erin and the fabric from which her clothing was made. To warm up the inherent blue cast from the overcast sky, I used a 1A skylight filter.

66

Subject: Sonja Hampton, professional model
Location: Winona School of Professional Photography, Mt. Prospect, Illinois
Camera: 35mm SLR
Lens: 105mm macro lens
Lighting: Two 600-watt-second flash heads
Light Control: One small silvered reflector
Film: Kodachrome 25
Exposure Metering: Incident-light reading
Exposure: *f*-11 (shutter at 1/60 second)

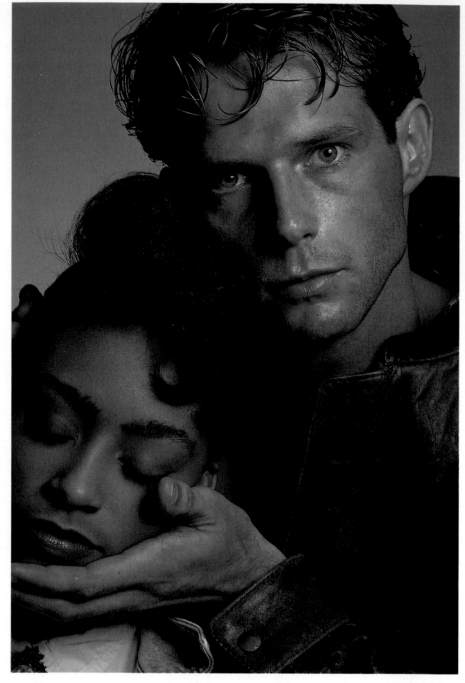

This image underscores the tremendous graphic impact provided by the combination of the resolution of modern lenses and the vibrant colors, fine grain, contrast and resolution of Kodachrome 25 slide film.

I made this shot during a class I was conducting at the famous Winona School of Professional Photography. I had beautiful Sonja Hampton seated on a raised platform. Her male-model partner was asked to stand behind her. His pose and hand position were directed precisely from camera position.

This photograph is a good example of two-light photography. The main light, in pan reflector, was on a boom stand. It was high and to the right of the camera and about four feet from Sonja. The second light, in a narrow-angle spot reflector, was on the floor behind the platform and directed at the white seamless background.

A small silvered reflector was placed below the subjects' faces. It served to soften contrast slightly.

The exposure on Sonja's face matched the exposure on the darker part of the background.

The resulting image is an effective melody of color, texture, and simple but dynamic graphics.

67

Subjects: Scott Hammond and Frances Sheridan, professional models
Location: Winona School of Professional Photography, Mt. Prospect, Illinois
Camera: 35mm SLR
Lens: 105mm macro
Lighting: Main light of 1200-watt-seconds, in pan reflector; two 1200-watt-second background lights
Light Control: Two small silvered reflectors
Film: Kodachrome 25
Exposure Metering: Electronic flash meter in incident-light mode
Exposure: *f*-11 (shutter at 1/60 second)

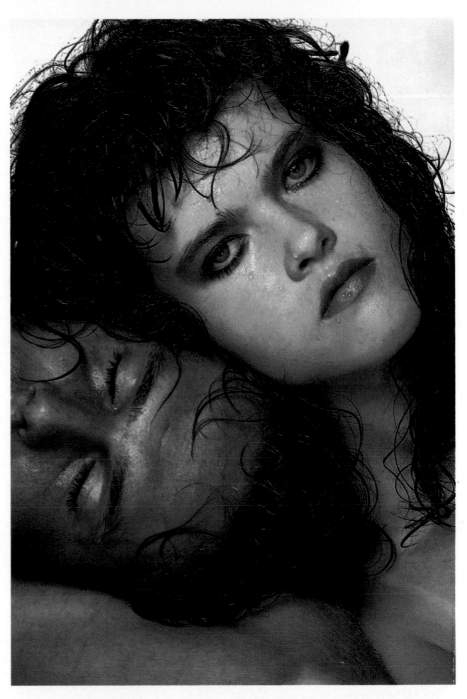

Shot during a three-day class I conducted at the Winona School of Professional Photography, this photo features Frances Sheridan as principal subject, with Scott Hammond as "backup." Dynamic composition was a major factor in the success of this shot.

Frances was only 15 years old when I made this image. It was her first professional modeling job—and she performed wonderfully. It wasn't an easy assignment, with an entire class watching every move.

The main light was about three feet in front of the subjects. To each side of

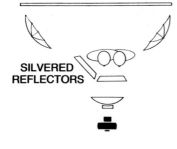

WHITE PAPER BACKGROUND

SILVERED
REFLECTORS

Frances, below her face, I placed a small, silvered reflector. The reflectors softened overall contrast and added catchlights to Frances's eyes.

The 105mm macro lens enabled me to shoot from very close range. There was enough depth of field for me to adjust closeness and resultant crop as I shot. My shooting position was so close that I could actually adjust a strand of hair on Frances between shots without moving.

143

68

Subject: Professional model
Client: Black Elegance
Art Director: John McMurray
Location: Los Angeles County Museum of Art
Camera: 35mm SLR
Lens: 55mm

Lighting: One main spotlight; two background spotlights
Film: Kodachrome 25
Exposure Metering: Electronic flash meter in incident-light mode
Exposure: *f*-11 (shutter at 1/60 second)

The layout for which this photograph was made was art directed by John McMurray, a good friend and one of the best professional models around. You'll see him in photos in this book as well as in other books of mine that HPBooks has published. John is also West Coast editor for *Black Elegance* magazine. At present, we work together nearly every month on editorial assignments.

This photo was shot at the Los Angeles County Museum of Art. You can't beat an art gallery for diversified and sophisticated backgrounds. I could have shot 1,000 photographs there.

I had asked my model to stand before a very "busy" canvas. Through careful spotlighting, the gown complemented the canvas beautifully. I was very happy with the result.

The main spotlight was placed about 10 feet from the model. The background canvas was lit by two spots, one on each side of the painting. I deliberately highlighted the center of the canvas, allowing the light to fall off toward the sides. The lighting created a wonderful feeling of depth in the photo. Use of a standard lens rather than one of longer focal length helped in maintaining this feeling of perspective or depth.

PAINTING ON WALL

SPOT
(ON BACKGROUND)

SPOT
(ON BACKGROUND)

MAIN
LIGHT
(SPOT)

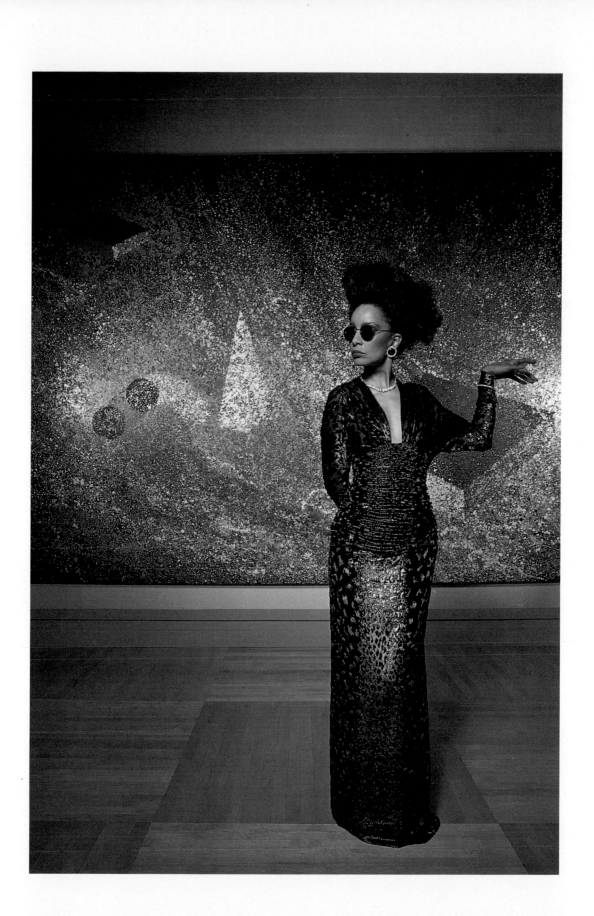

69

Subject: Stephanie Zimbalist
Client: This Week
Art Director: Robert Altemus
Location: Gary Bernstein Studio,
Los Angeles, California
Camera: 35mm SLR
Lens: 105mm
Lighting: Main light of
1200-watt-seconds, in umbrella,
on boom stand; two
1200-watt-second background
lights in umbrellas
Light Control: Nearby white floor
as reflector
Film: Kodachrome 25
Exposure Metering: Electronic
flash meter in incident-light mode
Exposure: ƒ-16 (shutter at 1/60
second)

I photographed pretty Stephanie Zimbalist for the cover of *This Week*, a magazine supplement with many of the nation's Sunday newspapers. The cover heralded an editorial story about Stephanie in the magazine.

I first photographed my subject in formal attire and then in the casual outfit shown here. The photo reproduced here was the one that was ultimately selected to appear on the magazine's cover.

Eye contact is well suited for a cover of any kind. It establishes immediate rapport with the viewer or reader.

The placement of the hair was of compositional significance. The dark hair graphically "contains" the head and figure and separates the subject well from the white background.

Stephanie was lying flat on the studio floor. I, too, was lying down, taking the photograph from floor level. Being so close to the subject's face, the white studio floor made an excellent reflector, especially as the main light was itself only about three feet from the floor.

This was the first time I had ever photographed Stephanie. I found her to be an incredibly warm and sensitive person and I believe those characteristics come across very effectively in this shot.

70

Subject: Pancho Segura
Client: La Costa Spa and Hotel
Location: Carlsbad, California
Camera: 35mm SLR
Lens: 85mm
Lighting: Direct sunlight
Film: Kodachrome 25
Exposure Metering: Through-the-lens reflected-light reading
Exposure: 1/250 second at *f*-5.6

Pancho Segura has been a notable member of the tennis world for many years. He is now resident tennis coach at the La Costa Spa and Hotel in Carlsbad, California. I photographed him there to display sport fashion and also to publicize the tennis facility at La Costa.

I had a wonderful subject in Pancho. His tanned complexion, ready smile and general vitality radiated a feeling of health and well-being.

As I've said many times, direct sunlight from high in the sky is generally not ideal for people photography. However, here, as elsewhere, there are exceptions. In this case, I felt the direct, harsh sunlight complemented nicely the robust, outdoor appearance of Pancho. The shadows in the eye sockets and the distinct modeling in the face show the man exactly as he has become familiar to so many—in the outdoor setting of tennis. To further identify Pancho with his sport, I had him hold a tennis racket.

Notice also that, although the La Costa logo and name in the background are not totally visible and sharp, they are readily distinguishable and recognizable.

71

Subject: Tom Berenger
Location: Gary Bernstein Studio,
New York City
Camera: 35mm SLR
Lens: 105mm
Lighting: One 1250-watt-second
flash in pan reflector

Film: Kodachrome 25
Exposure Metering: Incident-light
reading
Exposure: f-8 (shutter at 1/60
second)

A single light source, well used, can provide an excellent way of bringing out the character in a face. The single source is particulary useful and appropriate for the photography of head shots of actors because it is precisely under such a light—a single spot—that they are often featured on the stage or on screen.

I made this photo of talented Tom Berenger in my New York studio, in the early days of his incredible successful career. The photo was intended for his portfolio and other publicity uses.

This is an unaffected shot of an actor capable of displaying a wide range of expressions and attitudes—a photographer's dream. Tom was wearing his own clothes—styled as he would wear them. We talked as I rolled film. He went through a variety of attitudinal changes and I picked my shots. The result is a strong, direct, masculine headshot.

I metered the exposure for this single-light shot by directing the hemisphere of my incident-light meter from Tom's face toward the light source.

72

Subject: Van Sutton
Location: Gary Bernstein Studio, Los Angeles, California
Camera: 35mm SLR
Lens: 85mm
Lighting: One 1,250-watt-second main light in pan reflector; one 1,200-watt-second grid-spot hair light
Film: Kodak Plus-X
Exposure Metering: Incident-light reading
Exposure: 1/60 second at *f*-11

This is a personal photograph I made of Van Sutton, my wife's brother. His handsome good looks made him an excellent subject.

In classic portraiture class, I was taught that it was inadvisable to photograph a man in a three-quarter view having eye contact with the camera. It can tend to lead to a somewhat shifty expression.

Here, again, I chose to break a classic rule. Van was almost in a three-quarter pose and looking at the camera—and it worked very well. You must watch your subjects very carefully and decide at what point a sideways glance becomes excessive and undesirable.

I lit Van at a sufficient angle to create distinct shadows, good facial modeling, and show some skin texture. These are generally points to aim for when photographing men.

The background consisted of silver mylar, which I had rippled and stapled to the wall at arbitrary angles. It was lit by the main light. The bright and dark patches provide a distinct, suitable background.

Van sat on one posing stool and leaned on another with his right elbow. The casual pose, strong face and gentle expression combined to make an attractive character study.

73

Subject: Margaux Hemingway
Location: Aruba, Netherland Antilles
Camera: 35mm SLR
Lens: 85mm
Lighting: Midday sunlight
Film: Kodachrome 25
Exposure Metering: Through-The-Lens (TTL) reflected-light reading
Exposure: 1/125 second at f-11

I photographed beautiful Margaux Hemingway, wearing a beaded Halston jogging outfit, in the warm sun on a beach in Aruba. The only light source was the midday sun. To compensate for the extremely high position of the light source, I asked Margaux to raise her head to face the sun. This gave soft, gentle lighting to her smooth skin while, at the same time, providing distinct modeling around the jaw line.

Margaux loves the sun and was well tanned. To get the maximum color saturation in the skin, as well as in the cactus and sky in the background, I underexposed the film by 1/2 f-stop.

It's not difficult to keep a viewer's attention on a face such as this. However, to avoid any possible distraction, I used selective focusing and limited depth of field to place the cacti in the background somewhat out of focus.

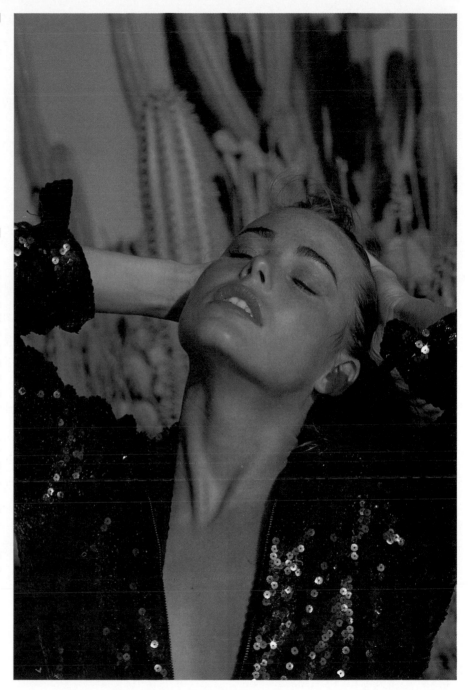

74

Subject: Kay Sutton York and daughters Romé and Caron Bernstein
Client: Hair Magazine
Art Director: John McMurray
Location: Gary Bernstein Studio, Los Angeles, California
Camera: 35mm SLR

Lens: 105mm
Lighting: Three 1200-watt-second flash heads
Film: Kodachrome 25
Exposure Metering: Electronic flash meter; incident-light mode
Exposure: f-11 (shutter at 1/60 second)

This photo almost caused me to go into early retirement! Not only was it a technically difficult shot to make, but words can't describe the challenge of pleasing all three of my incredibly special ladies at the same time!

I had been hired by *Hair* magazine to shoot a layout featuring well-known mothers and daughters. Each of my subjects had her hair and makeup done at the studio. The leather wardrobe was their own.

The more faces you are photographing, the more difficult the job. Blinking eyes are not the only potential problem. You must be sure to get expressions that relate well and that project equal graphic importance. Since the subjects can't see each other, it's the photographer's responsibility to monitor and direct expressions and attitudes.

When shooting a group of faces, lighting sometimes has to be a compromise. I adjust the light positions and the subject poses to get the best possible light on each subject.

The lighting for this photo was quite simple. A main flash, in pan reflector, was at camera position. A background spot was aimed up at the white studio cove from floor level. The hair light came from high and slightly behind the subjects. It consisted of a slim softbox. I shielded the camera lens from the hair light with a gobo.

This photo was a true labor of love and it is very special to me.

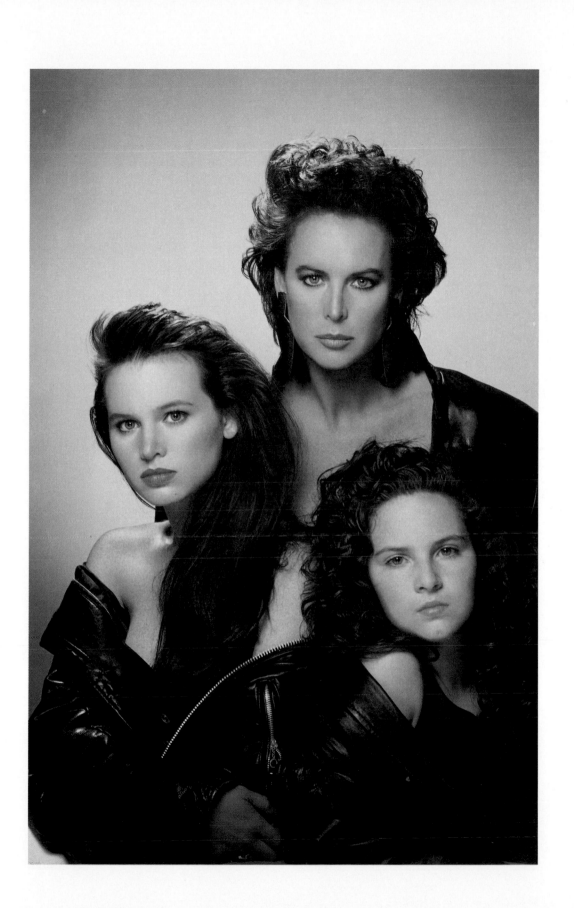

75

Subject: John McMurray and Giles Kirkland, professional models
Client: Jean-Paul Germain, Ltd.
Location: Acapulco, Mexico
Camera: 35mm SLR
Lens: 85mm and 105mm
Lighting: Direct sunlight
Film: Kodachrome 25
Exposure Metering: Incident-light meter reading
Exposure: Various

The six photos reproduced on these pages are just a small part of a series I produced during a two-day shoot at various locations in Acapulco, Mexico. The assignment was for Jean-Paul Germain, Ltd. and the photos were for use in ads and press kits.

When you shoot a series for a specific campaign or brochure, the client usually likes some form of readily-recognizable continuity. That continuity can take various forms. The main thing is that it provides a clear connect-ing link throughout the series.

For example, the continuity in the Jean-Paul Germain *Winners* campaign was provided by the use of the thumbs-up sign by a variety of prominent celebrities. The photos shown under number 45 in this Portfolio, shot for Hunter Haig, had their continuity es-tablished by the consistent "Gatsby" look throughout.

In the series reproduced here, the continuity is provided by the sunlit tropical location, the nonchalant atti-

154

tude of the models, and the intermingling of the models with the local element and passers-by.

When shooting fashion photographs, the most important element is, of course, the clothing. A photographer's creative depiction of the merchandise is expanded or limited as determined by individual client wishes. In the case of Jean-Paul, he told me to "shoot it the way *you* like it!" That's my kind of client!

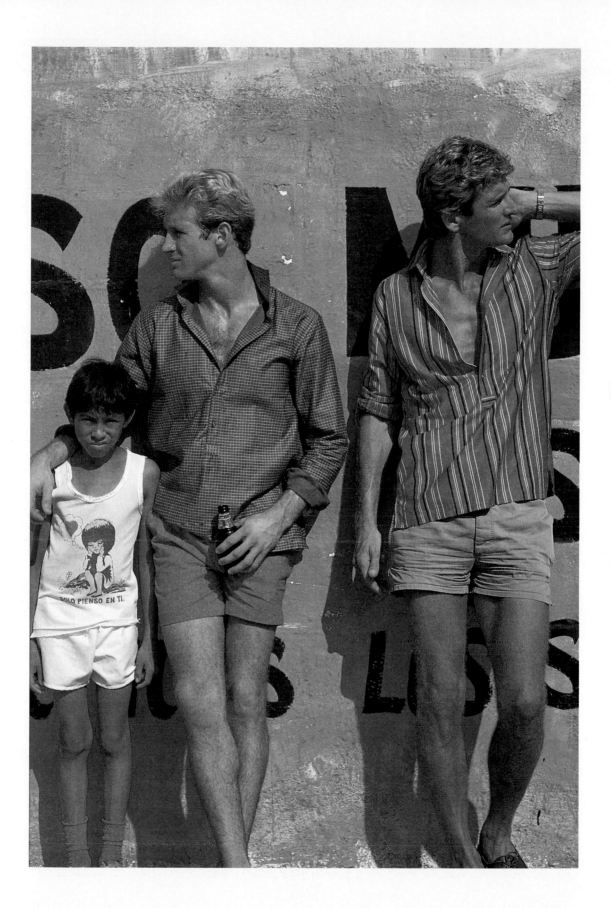

76

This two-page collage seems a fitting way to end my third book for HPBooks. On these two pages, you see many subjects that appear in this and my other two books. However, this collage tells another significant story: The original "peel-apart" Polaroid color films in the pack format, together with a compatible 35mm slide copier, are wonderful tools for producing copy prints of color slides quickly and easily. Polaroid makes a suitable slide copier, and so does Vivitar.

Polaroid color film tends to "soften" an image just enough to produce flattering copies of portraits. The copy prints can be useful for a wide variety of purposes, ranging from "approval" prints for clients and art directors, "proofs" for private portrait customers, or actual giveaway prints for photo albums and other personal uses.

SUPPLIERS' EQUIPMENT

Through the years, I've used equipment from many suppliers. The names listed below are tried and true. They represent the technical basis for producing quality photography with consistency:

Lighting
Reliability, power, fast recycling, and system control are the keys to quality studio lighting. Nothing in my experience even comes close to my Broncolors.
SINAR-BRON, INC.
17 Progress St.
Edison, NJ 08820-1102
201-754-5800

Cameras
Longevity and complete systems operation is essential in a good professional camera. I've enjoyed my Nikons for as long as I can remember.
NIKON, INC.
623 Stewart Ave.
Garden City, NY 11530
516-222-0200

When opting for the 6 x 6 format, I use the best around—and that's Hasselblad.
ERNST HASSELBLAD, INC.
10 Madison Rd.
Fairfield, NJ 07006
201-227-7320

Tripods
I got my Gitzo tripods about 20 years ago. They still work flawlessly.
KARL HEITZ, INC.
34-11 62nd St.
Woodside, NY 11377

Reflectors/Umbrellas
All my reflectors and umbrellas come from Sibern. (I buy my framing there, too.)
SIBERN INTERNATIONAL
RR #3 Monticello Rd.
Rochester, IN 46975
1-800-348-2510

Camera/Film Supplies/Accessories
I like a camera store to provide expert advice and one-stop shopping. Samy's Camera is the most complete professional store I've ever worked with.
SAMY'S CAMERA
7122 Beverly Boulevard
Los Angeles, CA 90036
213-938-2420

Printing/Processing
My Cibachrome display prints and all my black and white work is produced by Paris Photo in Los Angeles—quality control with European pride.
PARIS PHOTO, INC.
1961 S. La Cienega Boulevard
Los Angeles, CA 90034
213-204-0500